GREG WILLIAMS ON SET

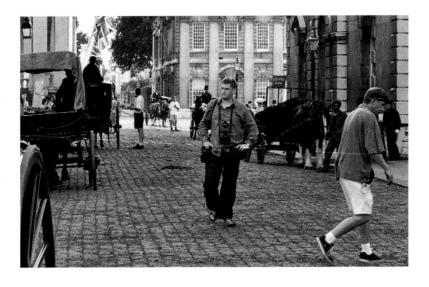

At the age of 19, Greg threw himself in at the deep end as a reportage photographer, smuggling himself into Burma to cover the civil war. The next six years were spent working for many of the world's best magazines, pursuing a variety of news stories and in-depth features.

Greg also spends a lot of his time travelling the natural world, working with artists Olly (his brother) and Suzi, producing art photographs and films of their interactions with nature.

In 1999 Greg became a founding member of the creative talent management and production company Growbag.

BIOGRAPHY
GREG WILLIAMS

I started this project for the same reason I start all my work – because it was something I wanted to have done. Inspired by the set reports in Life Magazine in the fifties and sixties, I could not understand why reportage photography was not being done by photojournalists on set any more. The only response was that 'access is impossible'. Opening that 'closed set' was a challenge I wanted to take up. I gained a commission from the Sunday Times Magazine, whose strong reputation made film companies take me seriously. Rather than concentrating on one movie, I decided to work on four sets for a total of three months, with the booming British Film Industry as a subject. Three years and 42 films later I have completed the first phase of an on-going project on cinema. As my portfolio grew I found it easier to gain set access. The publicists helped more and more and the actors started inviting me on to their next set. As I started documenting the pre- and post-production stages, the film companies who first thought 'do we want to bother with this?' started saying 'do we want to be left out?'

I work in a very simple way. I try to get on with people and I occasionally walk away from a great shot if it will damage relations or affect the film-making process. As my subjects realise my agenda is a positive one they start to trust me and they relax. In this way I am able to take honest, often intimate pictures of them being themselves.

This book is dedicated to my Mum and Dad, Dell and Hugh Williams, for their never-ending support and love.

Greg Williams
London, July 2000

FOREWORD
GREG WILLIAMS

Maybe it's because Greg Williams has worked in war zones like Grozny and Sierra Leone that manœuvring through the minefield of a film set came easy to him. The photographs in this book reflect a wonderful cross-section of the films recently made in Britain or abroad by British crews. He's also captured with honesty and a wonderful painterly eye the magic, complexity, joy, misery and sheer lunacy that make up the strange profession of film-making.

The photographs in this book are remarkable, not only because they're so good, but because they exist at all. For what is a visual art form, curiously, there have been very few outstanding photographs taken of the actual making of films. Even among the seven million photographs in the British Film Industry (BFI) archive – possibly the best in the world, and rich in the distillation of images from the actual films – there are comparatively few stills that manage to really show the illogical wonder of movie-making. Yes, there are the debonair, air-brushed and brilliantined publicity shots and the stiff, perfunctory set photos of the 'seen sharing a joke' variety, but few capture what the master photographer Henri Cartier-Bresson described as 'the truth of the instant'.

This is largely due to the fact that film sets are frankly unwelcome places to outsiders. It's always been a mystery to me why film people, who contrive photographic images for a living, are somewhat chary when it comes to strangers clicking away with their Leicas and nosey Nikons. Also, there is a dictum, started by the old studio system, that still survives: that the set must be protected at all times from prying eyes. Particularly if those prying eyes catch sight of something that they shouldn't. Hence the oft-seen studio sign 'closed set' is merely a reminder, as all sets are technically closed to outsiders. Traditionally, it is the publicists who have policed with great avidity photographic activity on a film set – the kiss of death to reportage photography – with the consequence that very few candid photographs have been released. It was thought that the sight of hysterical cinematographers, manic producers and the garroting of the leading lady by the director were bad for business. Consequently the paparazzi leapt into the void. Their long-lens, out-of-focus shots of actresses tip-toeing out of their trailers in their curlers probably pleased the tabloids, but did little for the aesthetics of photography.

Also, it has to be said that film crews themselves aren't overly helpful. When it comes to set photographers and documentary crews there are no flies on the wall with film folk. They're too canny and too obdurate for that. Hence the taking of any kind of photograph on a film set is seldom made easy, to say the least. For a start, the precious space that surrounds a film camera and its dolly is an invisible, electric no-go area for intruders. Although the rhythms of work on a film set seem rather erratic to outsiders, there are in fact very rigid systems and rules of etiquette, which most crews have followed since the beginning of the movies. I remember attending a charity function once where Prince Philip offered his observation to me that, in his experiences of visiting film sets, no one seemed to be doing much, indeed, no one seemed to be doing any work at all.

This misapprehension, I suppose, is common among visiting civilians. Our shop floor operates like no other, and the alternating nerve-jangling, monastic silences and ear-splitting pandemonium can be very confusing to the casual observer. But within this bedlam there is actually extraordinary discipline. As such, the set photographer has a tricky job trespassing on the creative domain of others and has to move with great stealth – ever mindful of unspoken set procedures. After all, the roll of film going through the movie camera is why everyone is there, and bellicose assistant directors can be quite effective in enforcing this. Whilst filming in New Orleans I once saw a less than elegant stills photographer, a large Greek gentleman, punched out by a camera assistant. Apparently he'd become a little too presumptuous and cosy, slyly invading the sacred camera space and subsequently nudging the assistant whilst he was pulling focus, consequently spoiling the shot. The resultant carnage was inevitable.

The efficacy of the photographs in this book for me is their very familiarity. The worst trait of film people is that in being overly aware of cameras they often compensate for this by hiding behind lighting flags or, worse still, the opposite, by hamming it up. (The latter is understandable among actors, but in my experience it can be excruciatingly embarrassing with electricians or the occasional make-up person.) This collection of photographs has no such artificiality – it shines with honesty and naturalness. It was said of Andre Kertesz that, 'Every time his shutter clicks you feel his heart beating.' When I look at Greg's pictures here it's as if I'd just passed the person that we see photographed, even though it's not even my set that they're on and I'm not even there – such are the universal truths captured: the two boys off camera on Simon Magus, wearing their period costumes, punching the buttons on their GameBoys; Matt Damon with immaculate, slicked-back, Brylcreamed hair, waiting for the shot to be lit whilst reading The Odyssey; or the cheerful optimism from Nigel Hawthorne that the catering truck food might be edible.

The ability to capture 'the truth in an instant' is the way Greg has gone about his business – unobtrusive, undemanding and

constantly affable; it's obvious he has become invisible to his subjects. But in photography, as in film, great moments mean nothing if simply observed but not captured on film and captured beautifully. A set photographer has a hard row to hoe when it comes to composition and lighting. The set is always lit for the film's shot, which is sacrosanct, but Greg has managed to compose his own immaculate and artful images from the available light and sometimes with the almost complete lack of it.

In my non-day job as Chairman of the Film Council I am honour-bound to be a positivist about the British Film Industry, but looking at these images I must say that even without a bureaucratic balaclava on, the cumulative effect here indicates a healthy and diverse industry. Not all films can be successful, and so there will always be the jeremiads that our industry faces imminent demise. But the richness of talent – in front of and behind the camera, busy and expanding studios, investment in bigger and better facilities, post-production and the new technologies – augurs well for a more sustainable film industry.

As the technologies of film relating to both creation and distribution change with a bewildering rapidity, it is also nice to be reminded in these photographs of the people in the trenches who still have to work odd, upside-down hours in very unpleasant conditions, often far from home. I'm particularly fond of the shot from The Talented Mr Ripley of the film crew taking shelter from a sudden downpour in the Piazza Novona. That image struck a chord with me, as I have stood under many a lighting silk, shivering and damp, waiting for a break in the weather (often up to my knees in cow and pig dung in places a good deal less attractive than the Piazza Novona). I'm always impressed by the speed with which camera crews cover up their precious equipment when it rains – and the even greater speed with which the make-up artists and hair stylists get the best places under shelter before anyone else.

With the click of a shutter, Greg Williams has captured the heartbeat of our industry with great artfulness and humanity. The individual captured frames eloquently tell their own stories through the whole deranged process: from the anguish of David Leland writing his script, through to Ray Winstone getting into his role, to Eric Cantona only on take five, to Hugh Grant post-synching, to that glorious absurdity called the Cannes Film Festival.

Movies are illusions, fabrications of life, for which we dig deep into the bones to get to the marrow of reality. These photographs are the 'instants of truth' that represent the struggle for our own images that flicker at 24 frames a second. As a director I've always thought that the effects of making a film was a bit like cerebral liposuction. At the end of the two-year stint that it now seems to take to make one, it can have been very draining. However, looking at these pictures I realise how privileged we are, because the images also exude great joy, making me anxious to get back onto a film set once more.

Alan Parker
London, July 2000

INTRODUCTION
ALAN PARKER

I always start with no script, so we rehearse
for months – over six on Topsy Turvy. Very
creative – improvisations, discussion,
inventing characters and relationships,
research. Everybody always assumes
it is my favourite bit, but it isn't. It's hell.
It isn't making the film, it's only preparation.
The shoot comes as a wonderful release, a
prize at the end of the purgatory. Pure bliss.

Mike Leigh
Director

Writing and directing are opposites. Writing
is working alone, anything is possible, you
can play it by your own rules, call your own
tea-breaks, whatever, as long as it's going
down on paper. Directing is working with
dozens of people every day: if you don't like
people, don't direct.

David Leland
Director

PRE-PRODUCTION

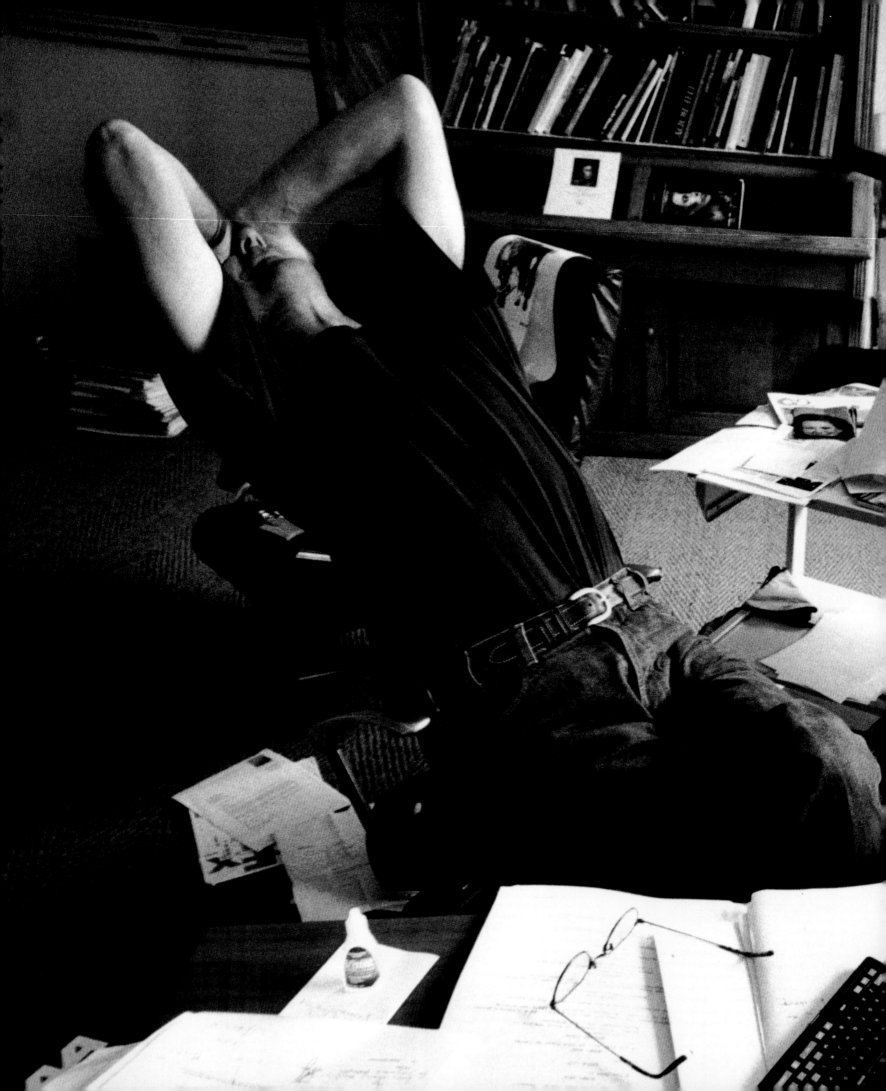

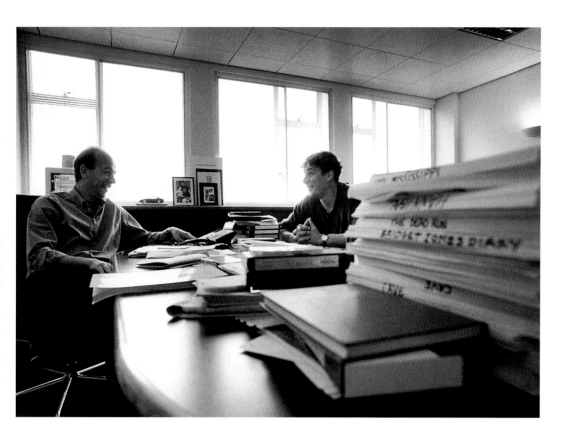

previous:
David Leland

Working Title Films
Producers Tim Beven and
Eric Felner

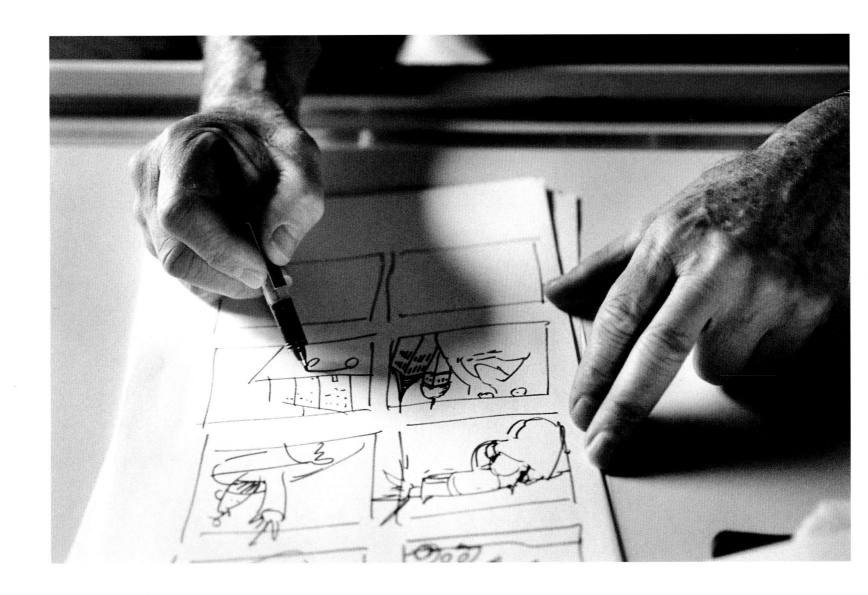

Terry Gilliam storyboarding

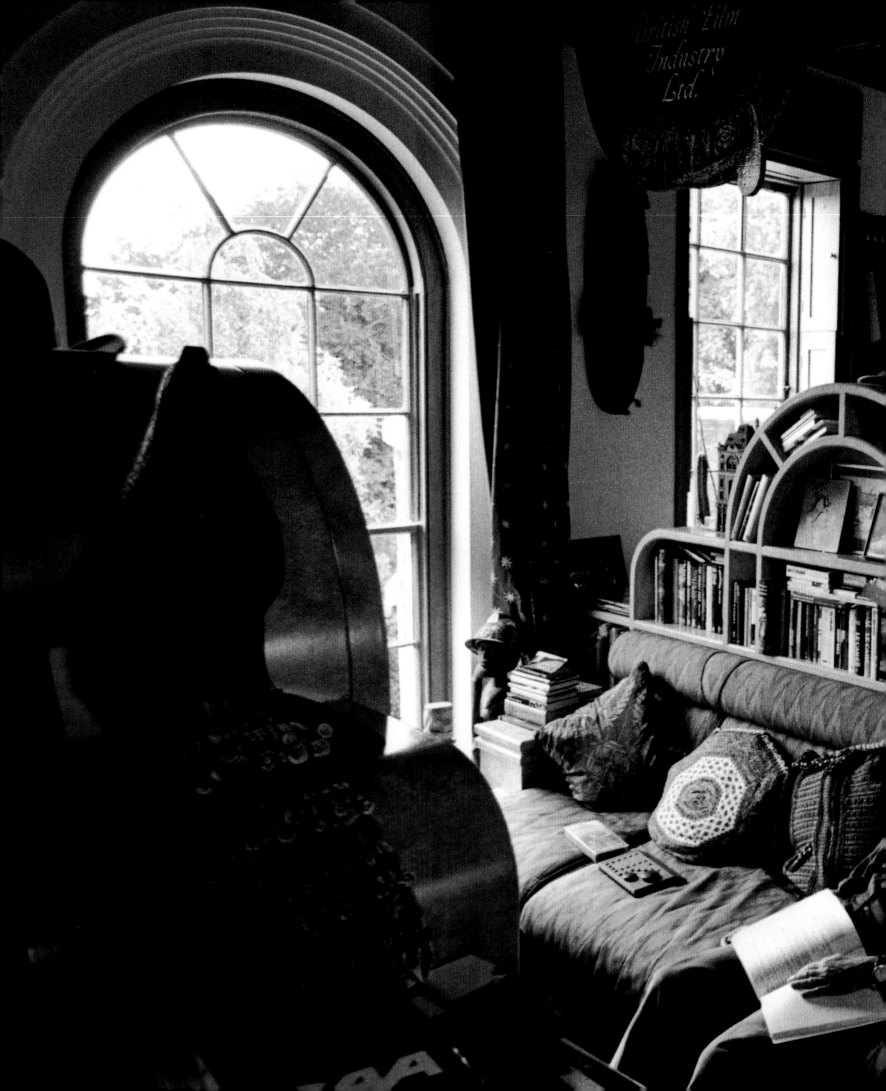

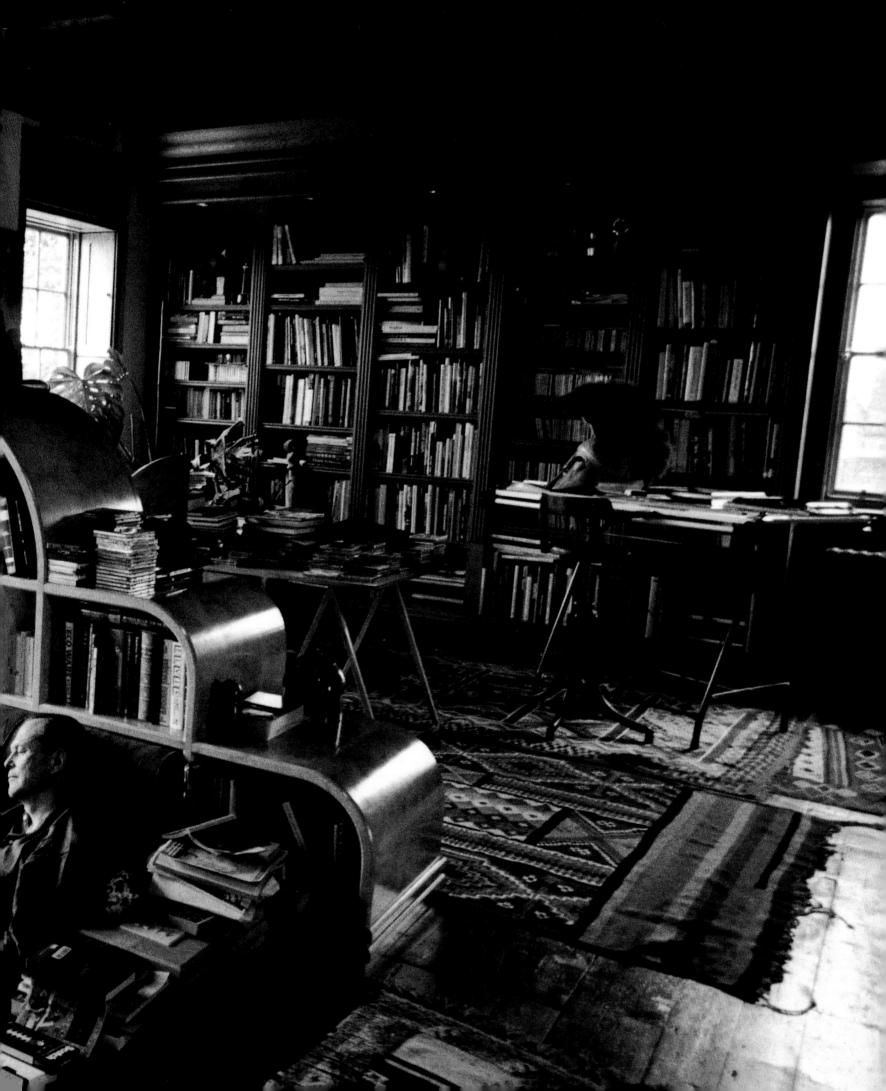

previous:
Terry Gilliam at home

The Talented Mr Ripley
Anthony Minghella on the
way to filming

Some actors have the confidence to walk on to a set without any preparation. They are there, they know their lines, and that is enough. There is a similar school of thought that believes rehearsal of the dialogue can take away the spontaneity available when no one has spoken the lines before.

I get too paranoid to approach a new job without having filled up the weeks or months prior to filming with lessons and study and practice. So when I walk on to a set I feel I can answer almost any questions relating to my character's personality or their world. I like to practise any skills they may be talented in. If the character is an expert on volcanoes I like to know as much about volcanoes as I can. If a character enjoys yodelling then I'll try to learn to yodel. Even if only a detail comes over in the performance, unnoticed by most of the audience, I'll know the detail was correct.

There is also an opportunity in an actor's pre-production to submerge yourself gradually into the mood of the world you are about to live in. Relevant films, books, and pieces of music recommended by the director can help to start create the atmosphere, scenes, and ultimately the director's vision of what you are about to make before you start filming for real. Once filming starts you are at the mercy of a schedule that must be completed, a script that must be shot. Prior to filming is the only chance to move away from the specifics of the story and dialogue and examine beyond what's on the page. This process is an excuse for me to learn skills and study subjects that I otherwise would not have the chance to learn. It has also become one of the main reasons why I enjoy the job so much.

Jude Law
Actor

PREPARING FOR THE SHOOT

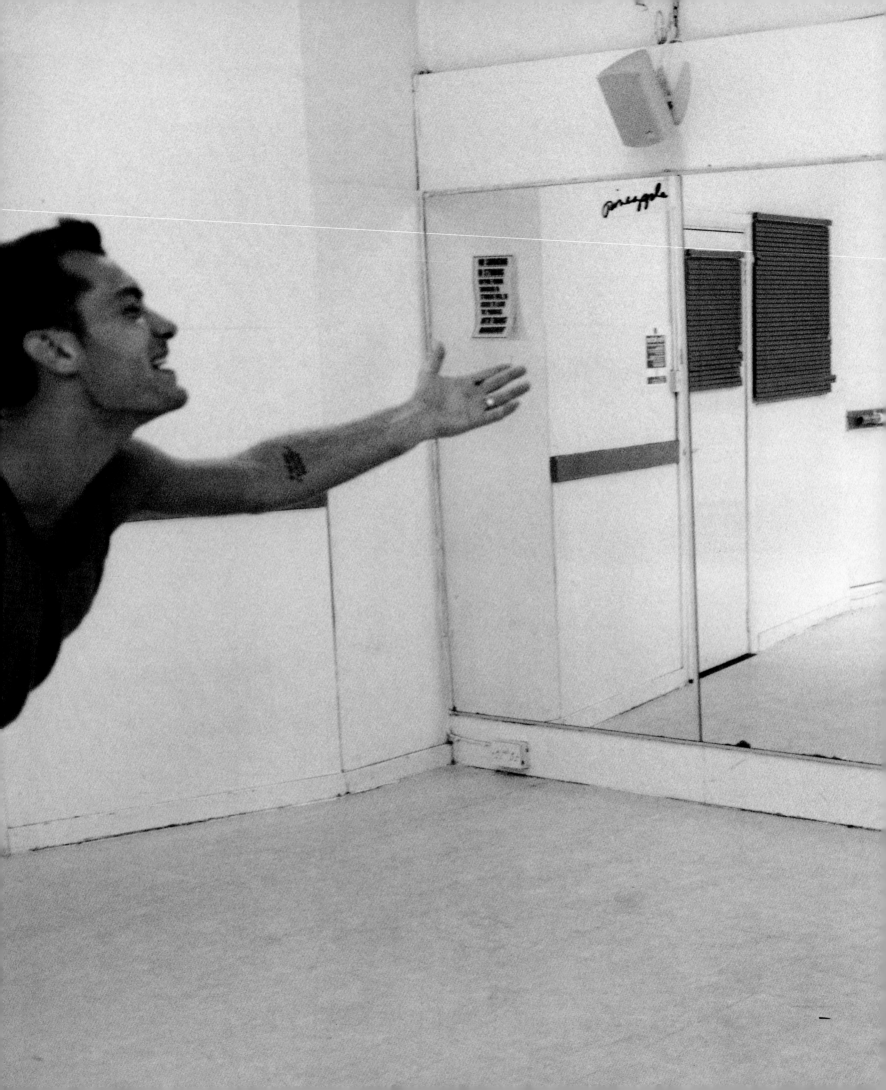

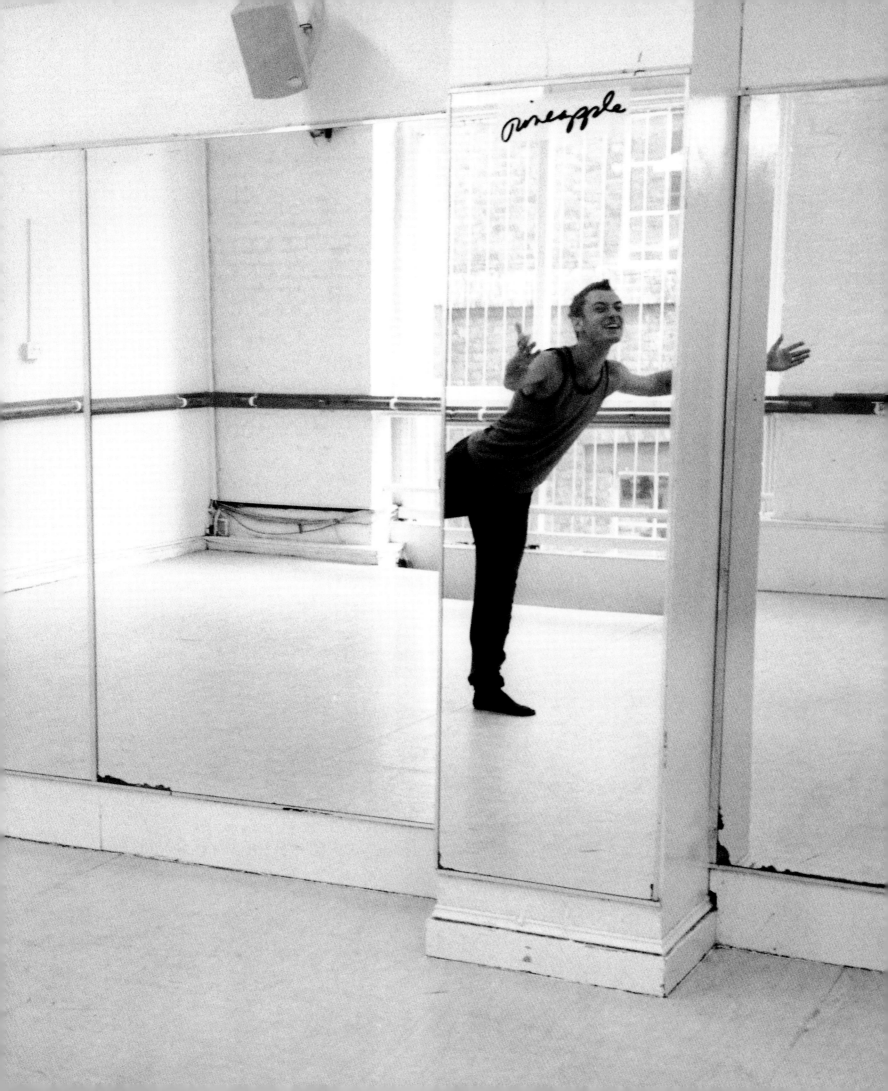

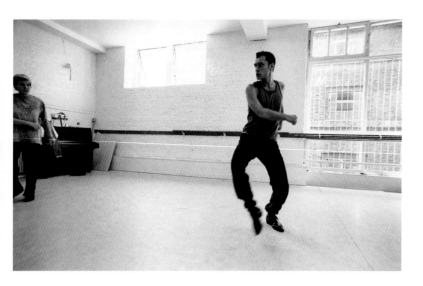

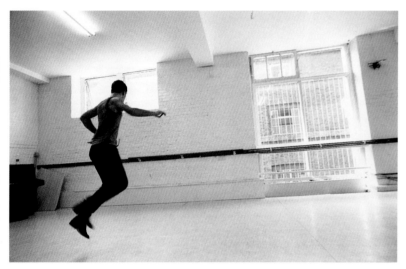

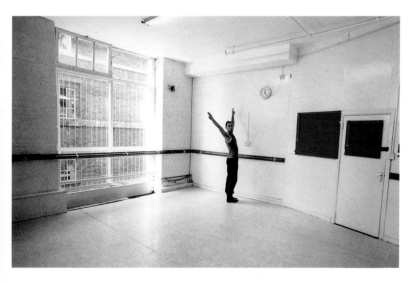

previous, above and right:
Jude Law in dance classes
preparing for role

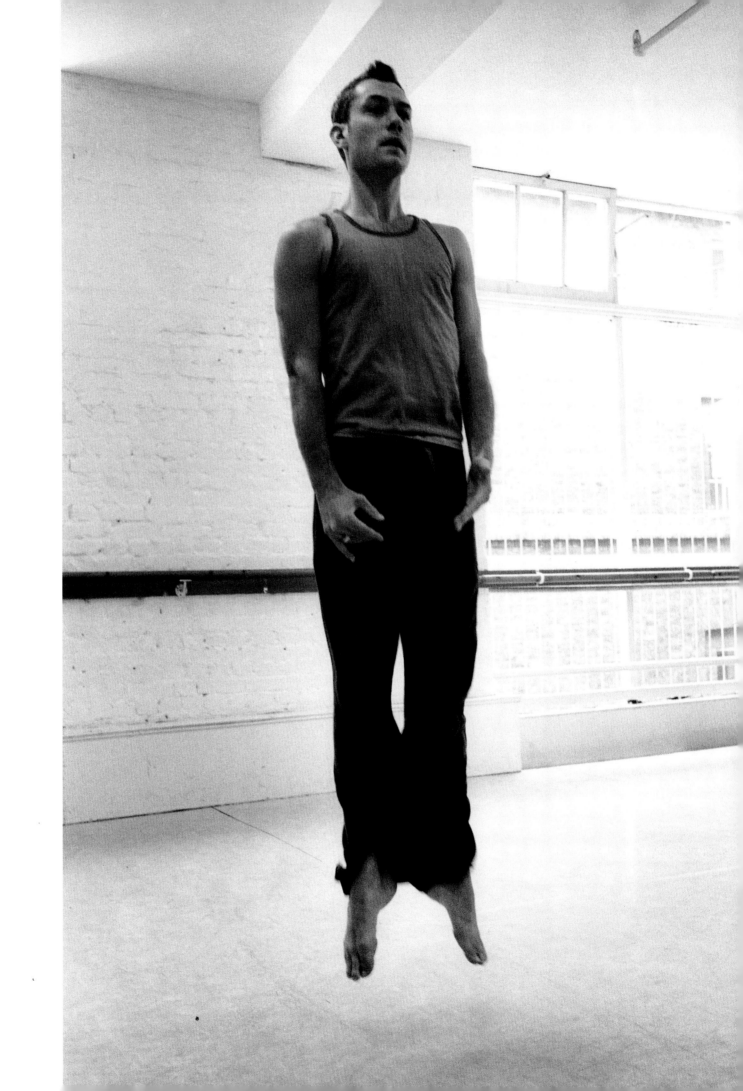

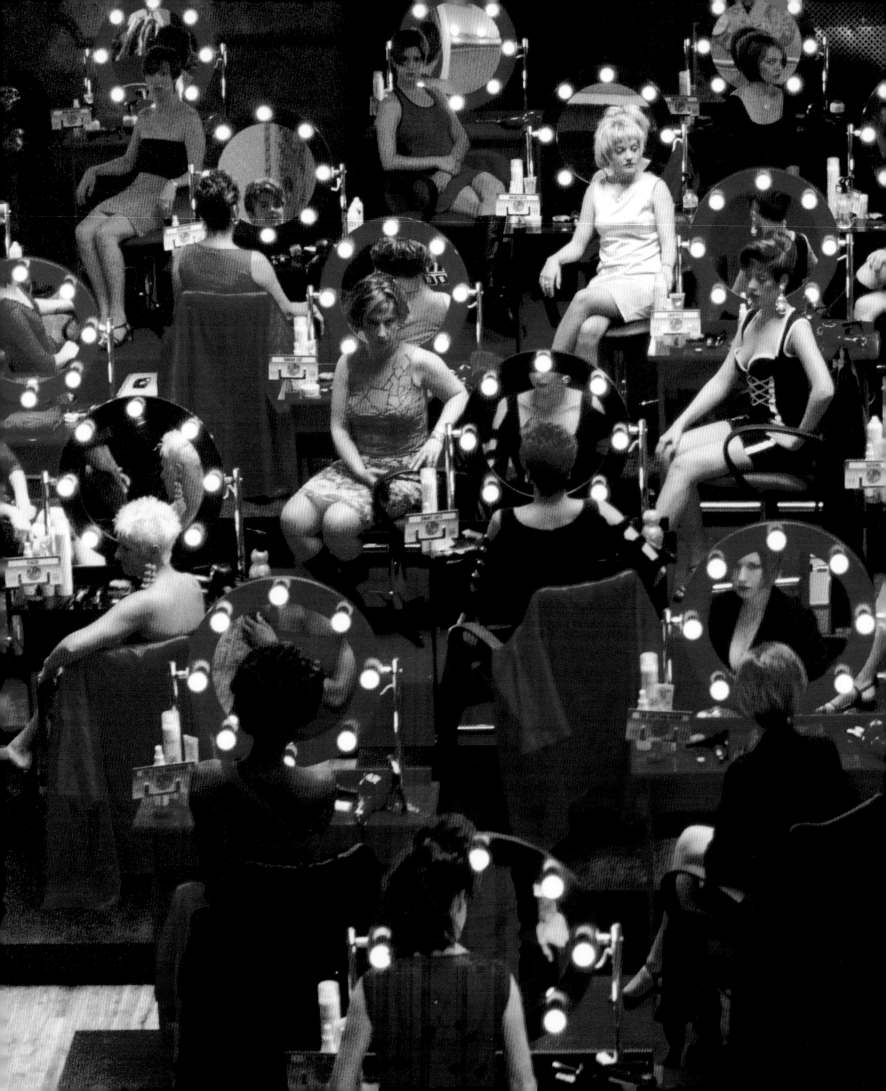

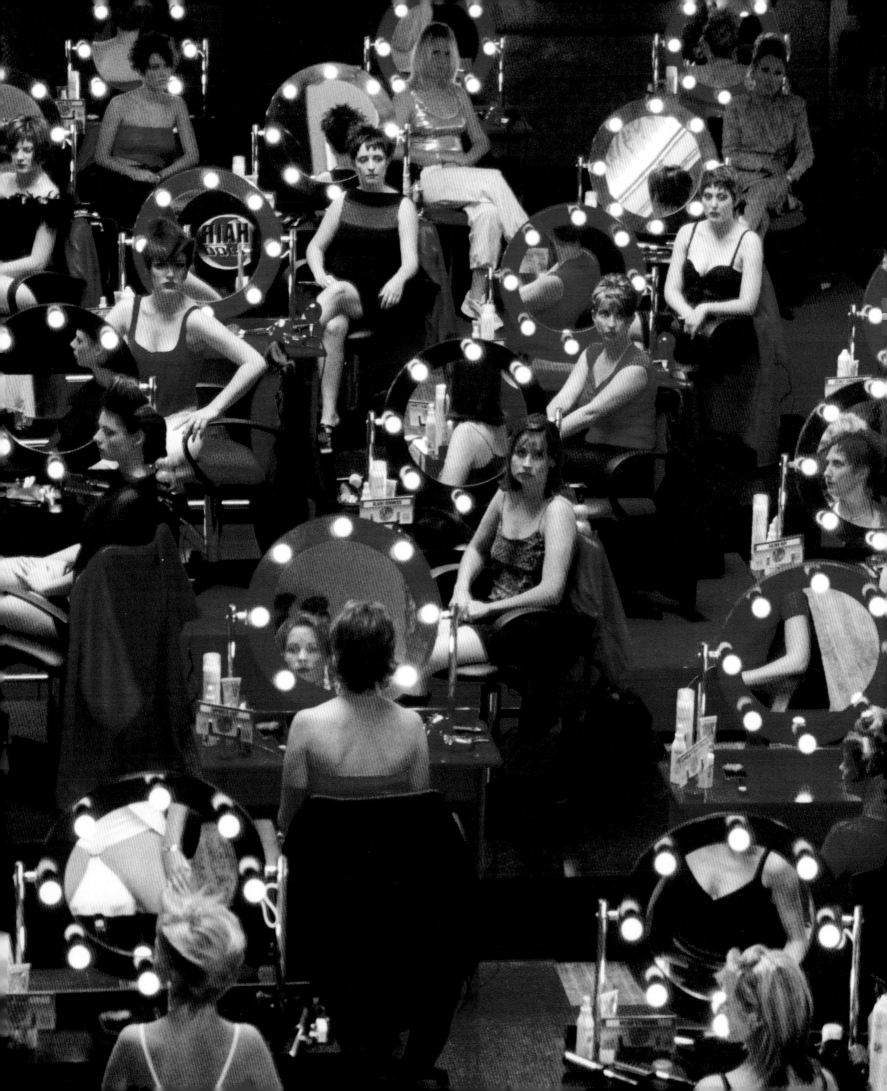

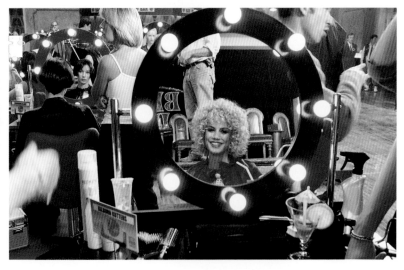

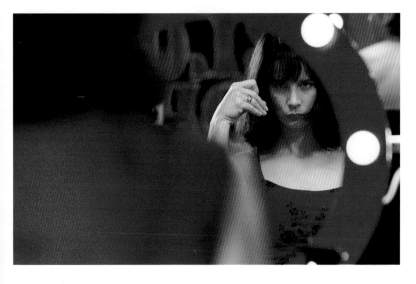

previous, above and right:
Blow Dry

from top:
Natasha Richardson

Heidi Klum

Rachel Griffiths

right:
Heidi Klum

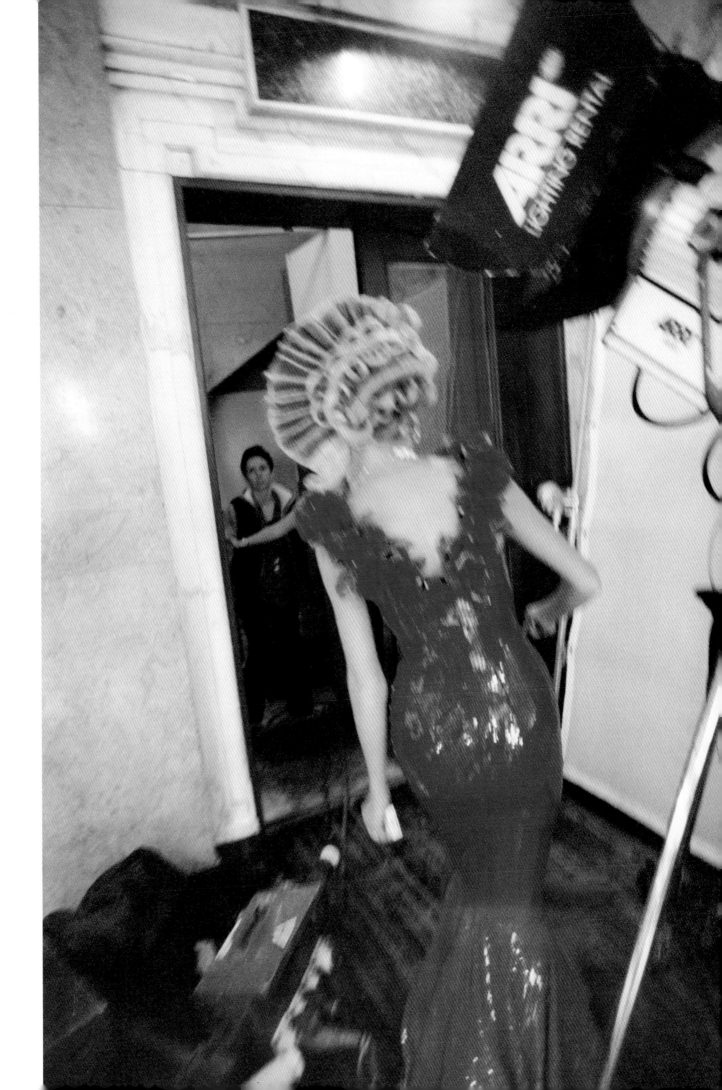

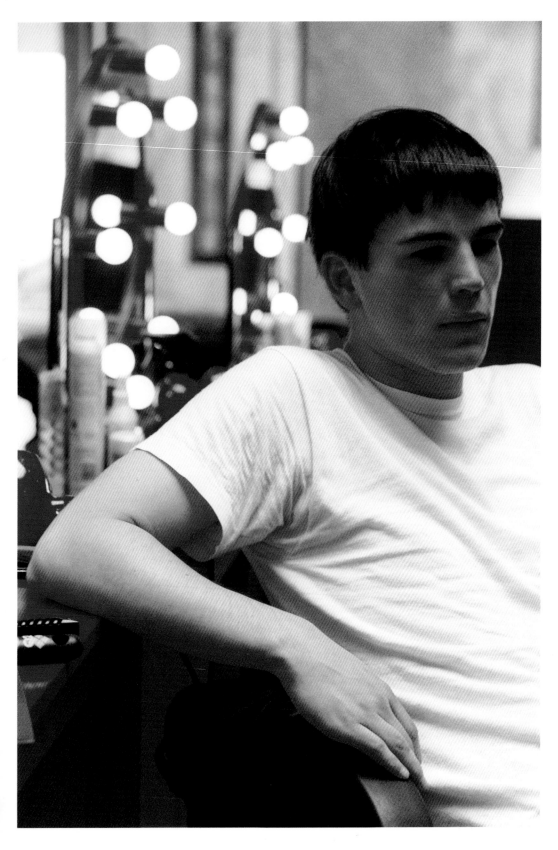

Blow Dry
Josh Hartnett

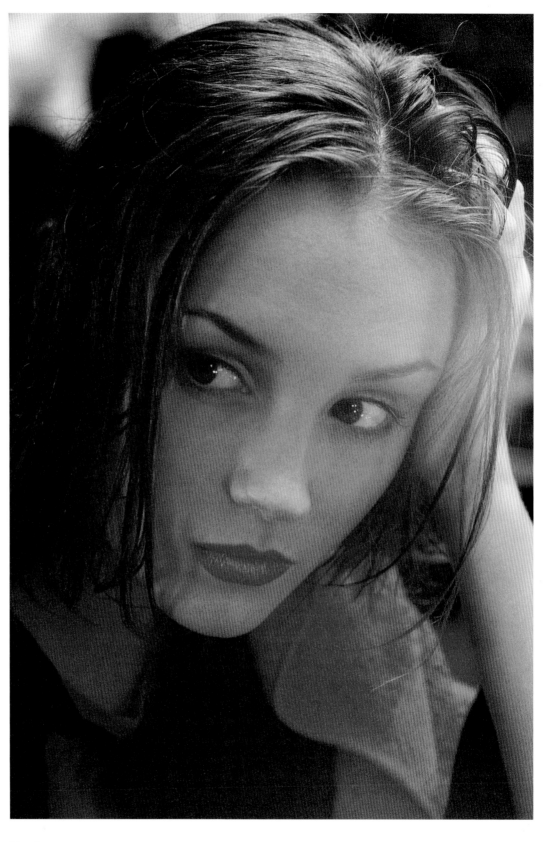

Blow Dry
Rachael Leigh Cook

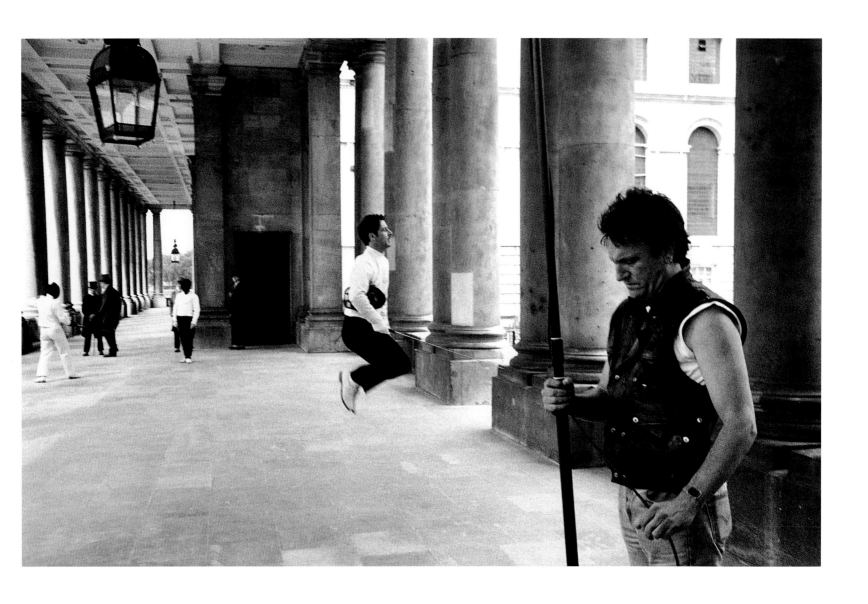

An Ideal Husband
Jeremy Northam warming
up before a take

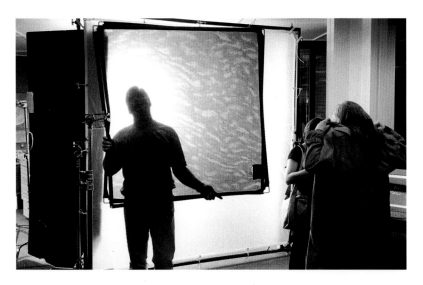

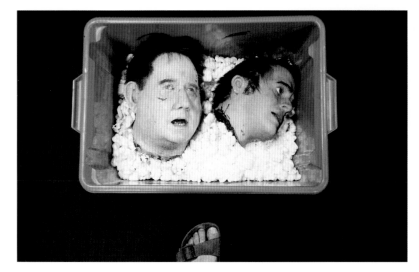
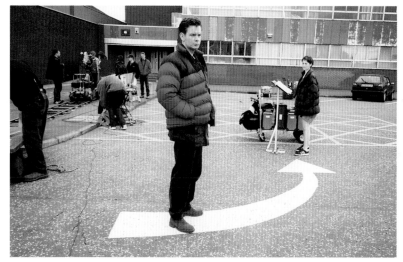

clockwise:
Janice Beard
Lighting crew

Kevin and Perry Go Large
The lorry

Gregory's Two Girls
John Gordon Sinclair

Lighthouse
Heads

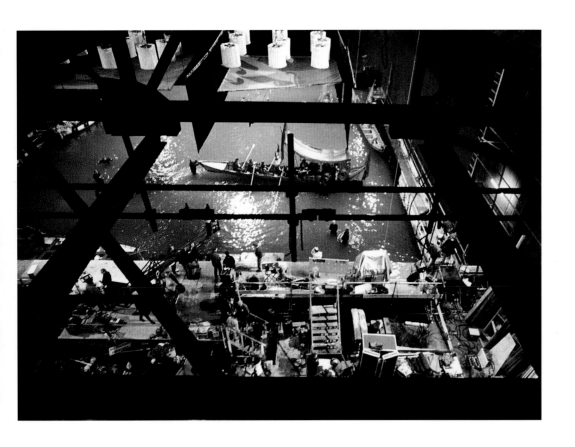

Elizabeth
On set

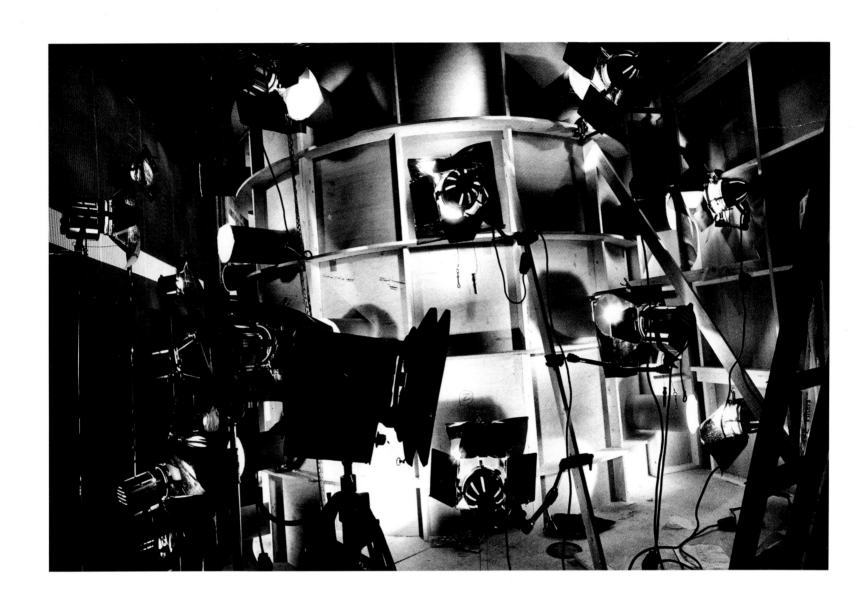

East is East
Off set

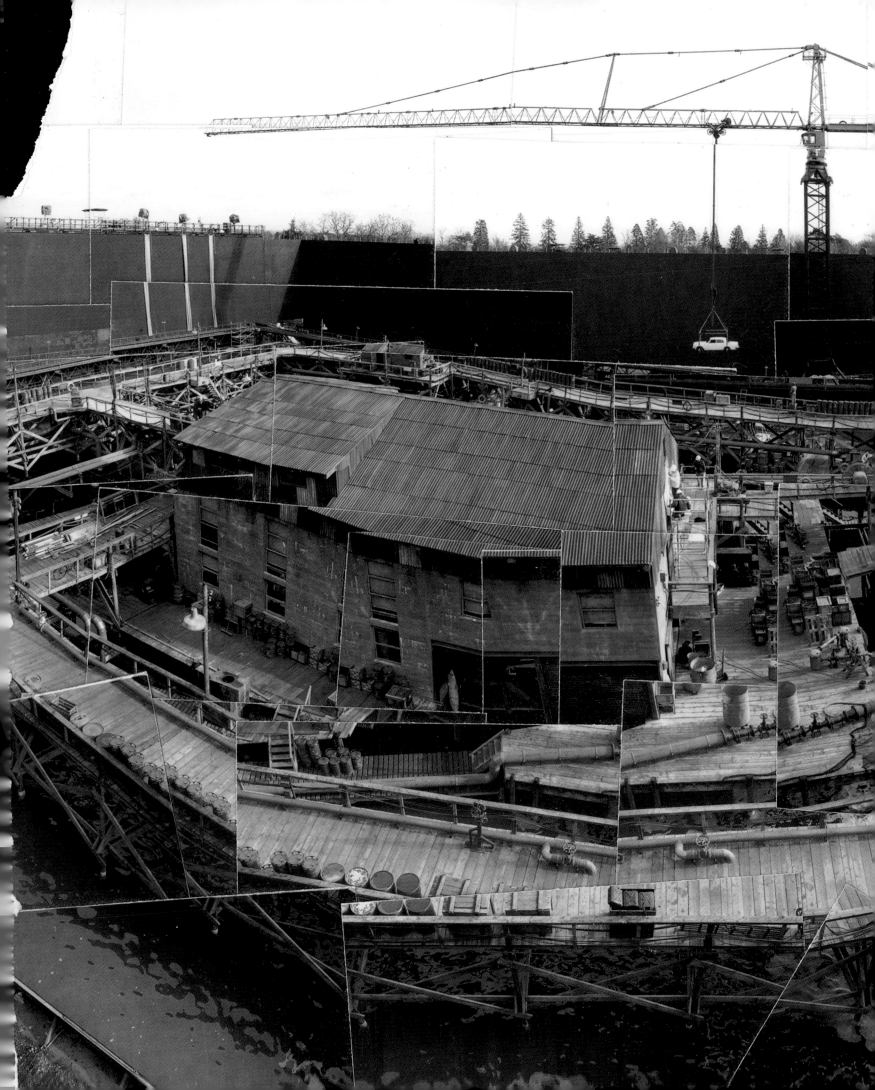

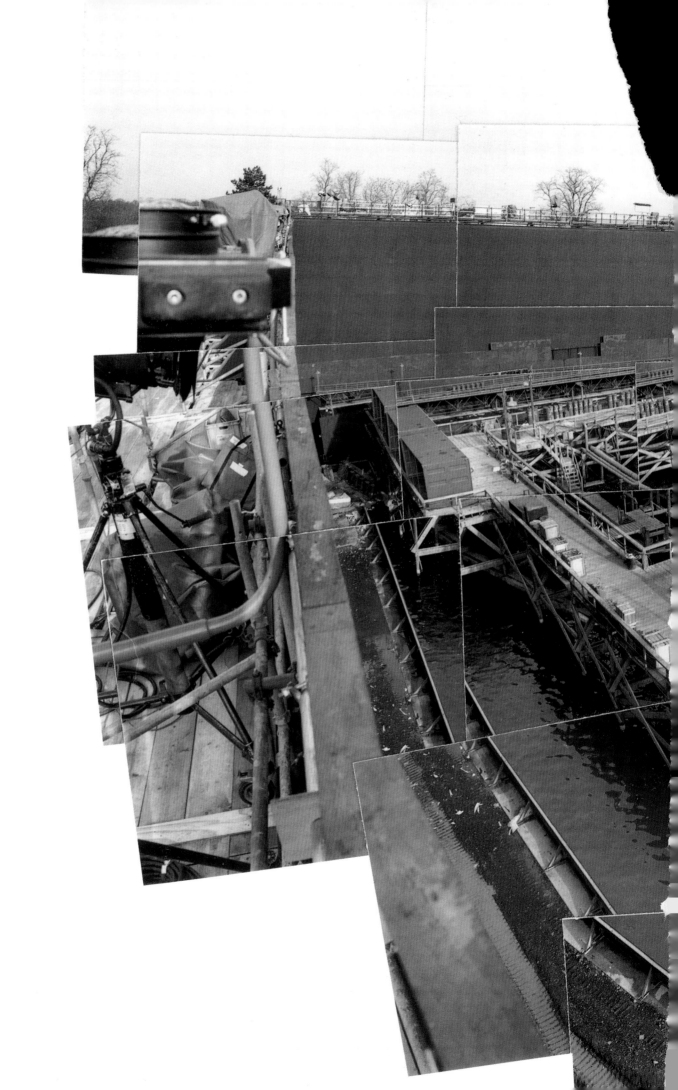

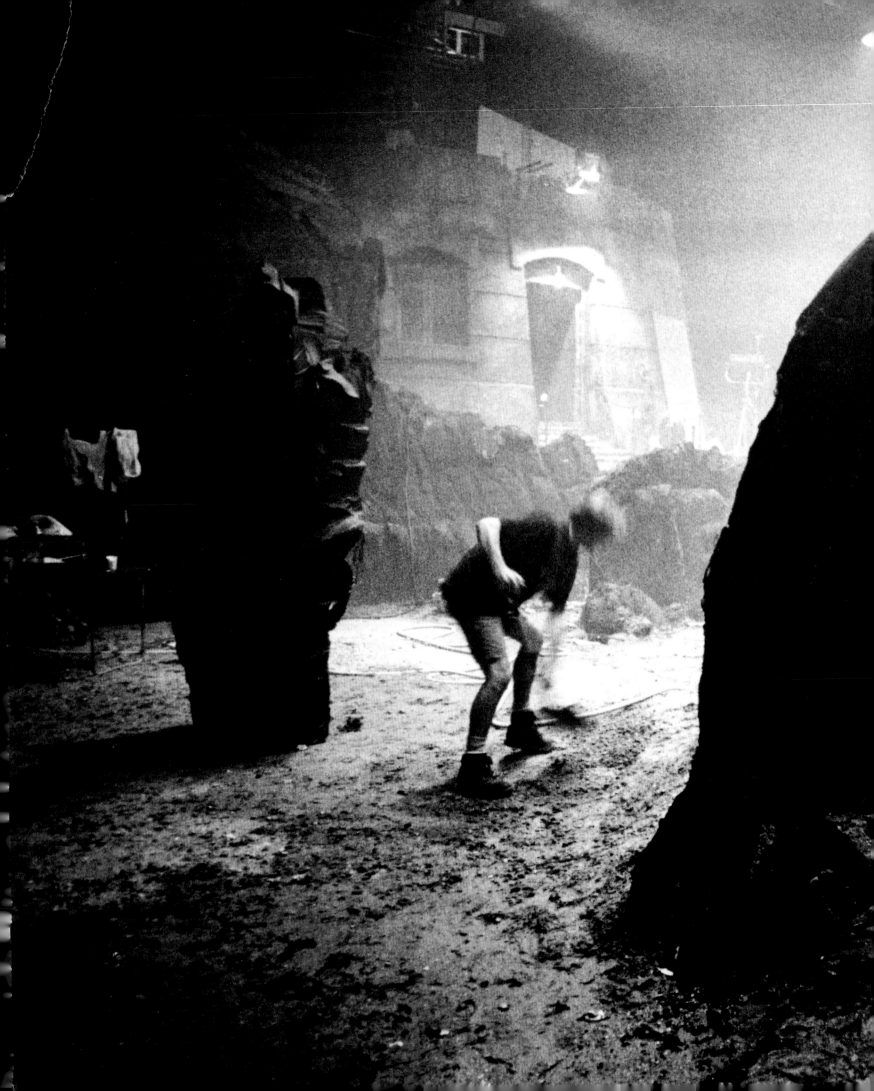

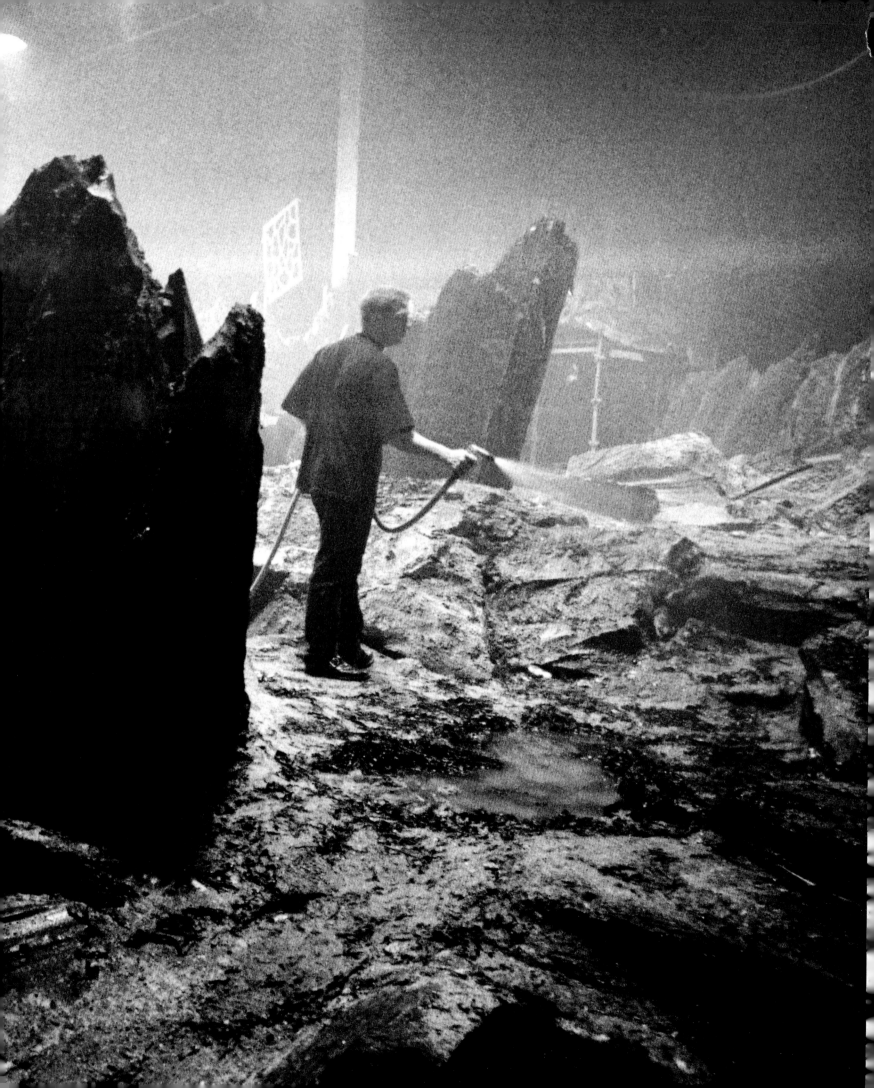

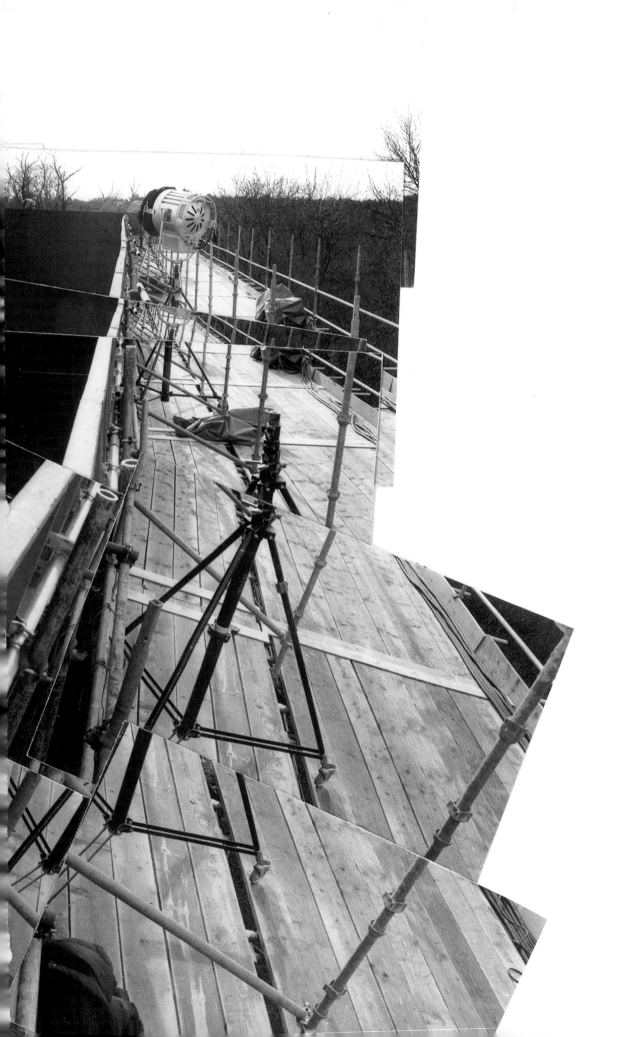

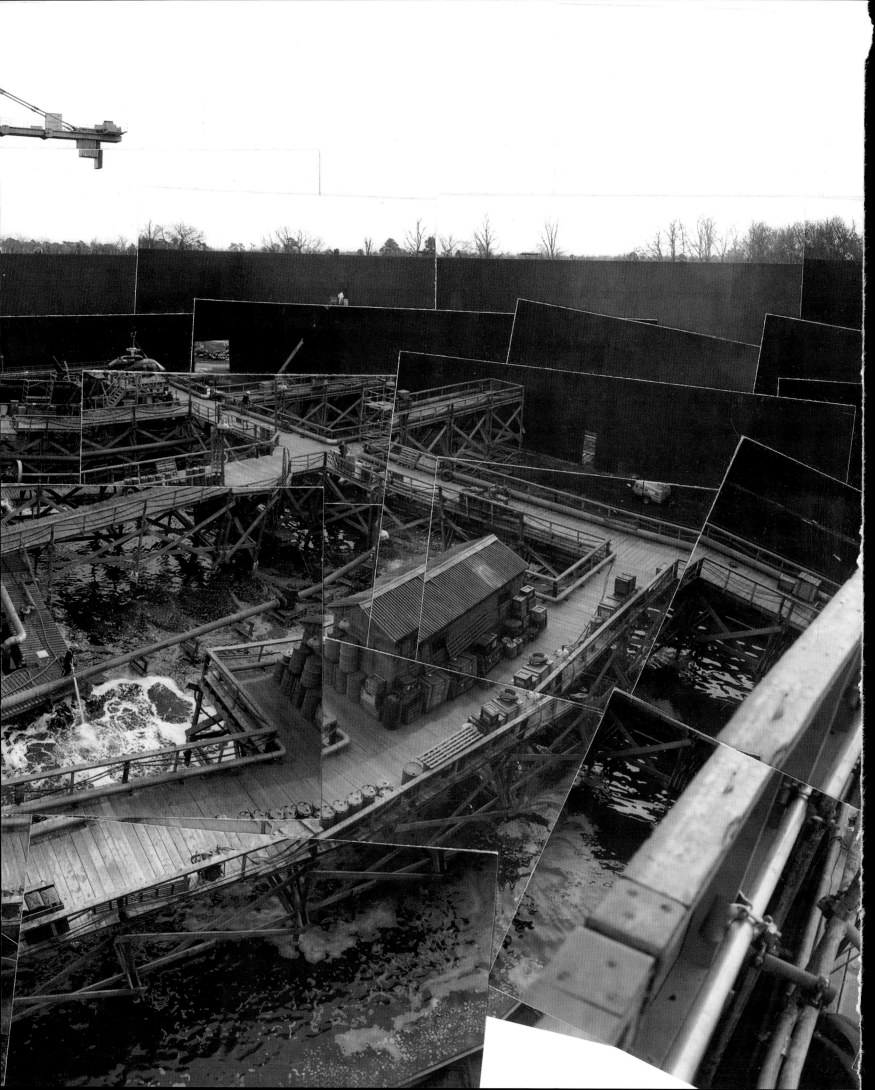

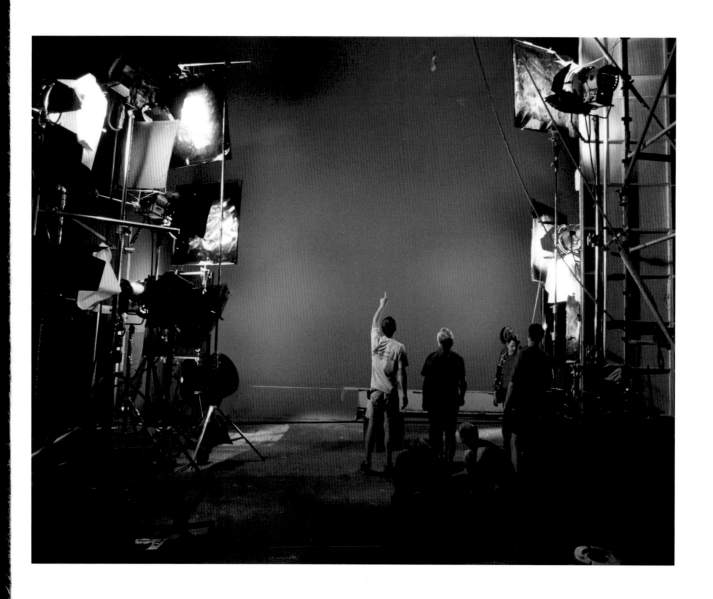

previous pages
inner gatefold:
**Bond 19 The World is
not Enough**
The largest set construction
in the UK at Pinewood
Studios

outer gatefold and above
Lighthouse
Preparing the set

Angela's Ashes
On location

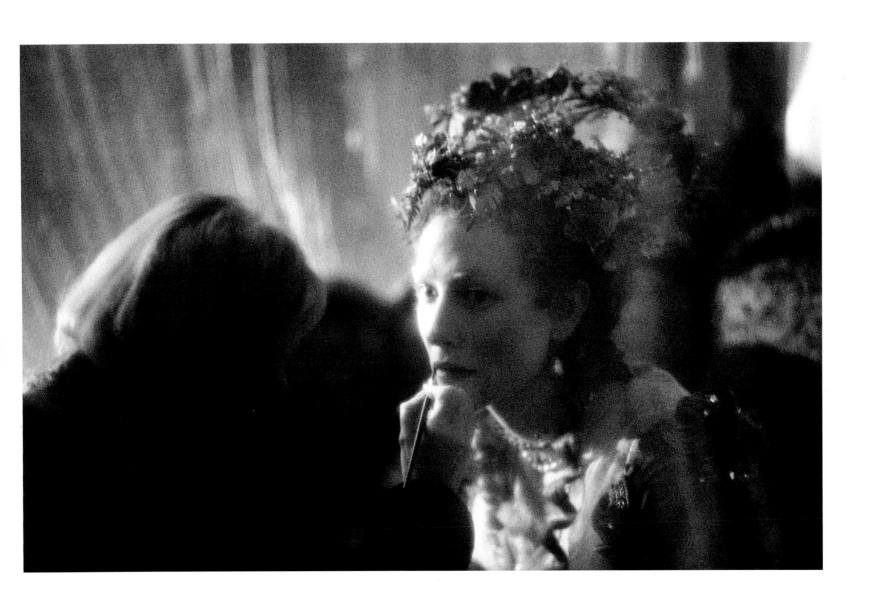

Elizabeth
Cate Blanchett

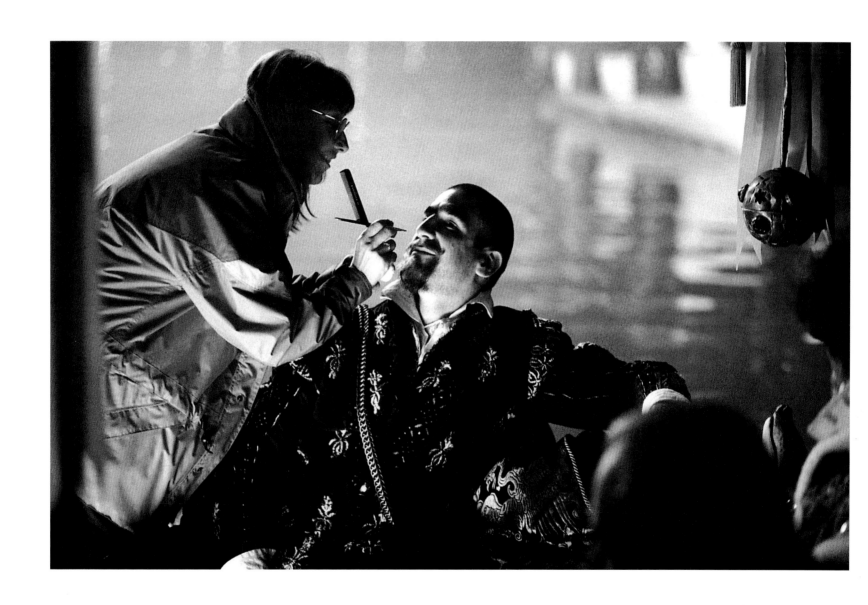

Elizabeth
Eric Cantona

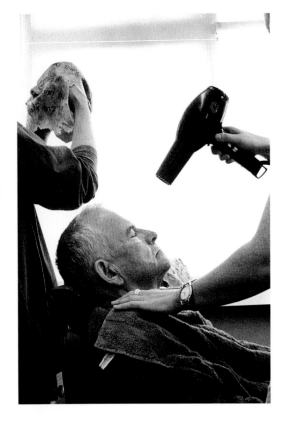
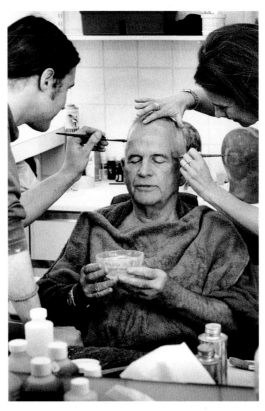
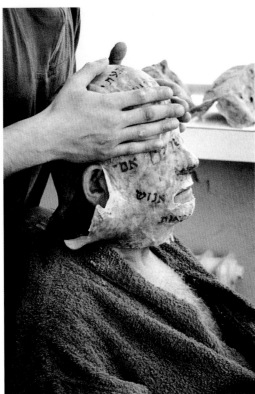
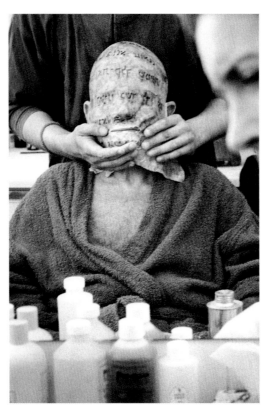

Simon Magus
Ian Holm in make-up

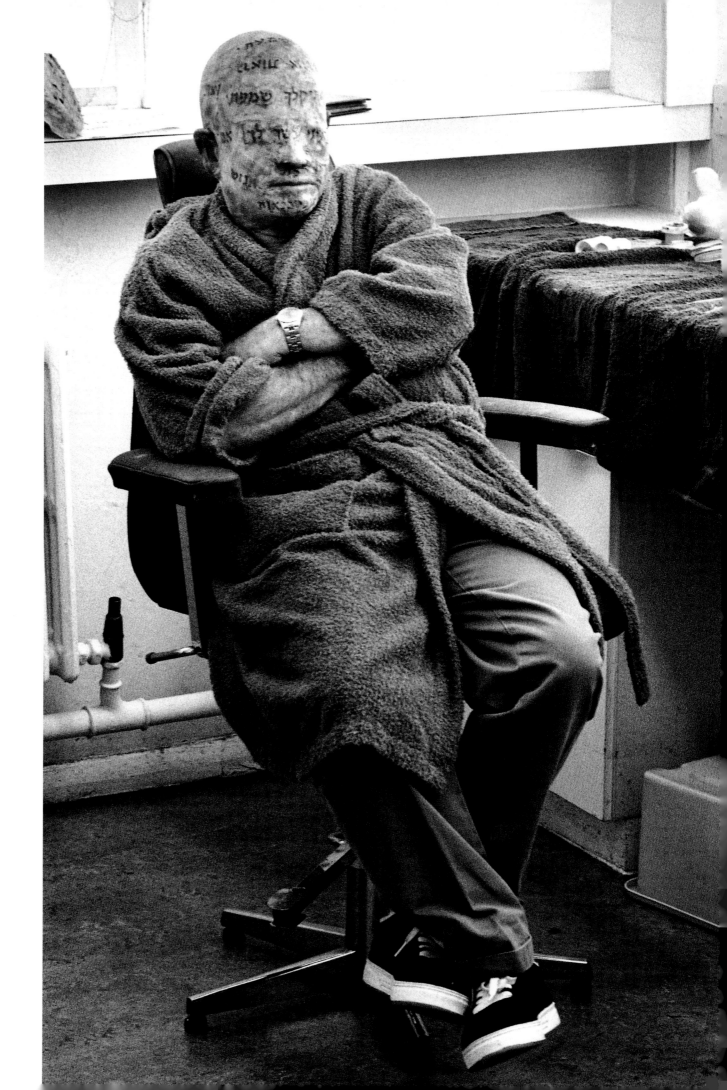

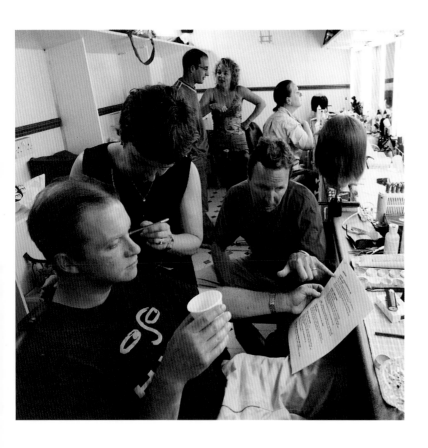

Kevin and Perry Go Large
Harry Enfield

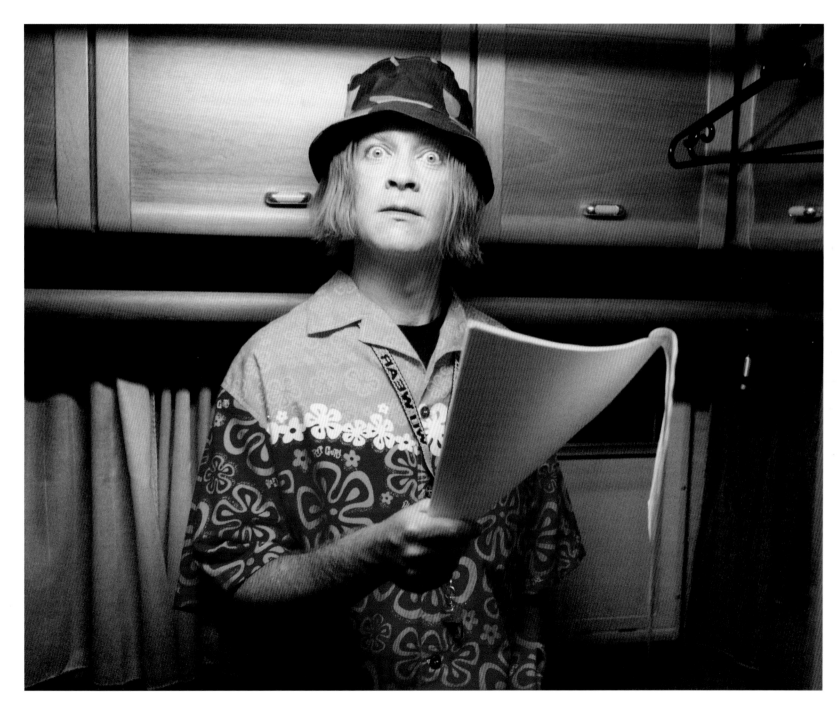

Kevin and Perry Go Large
Harry Enfield

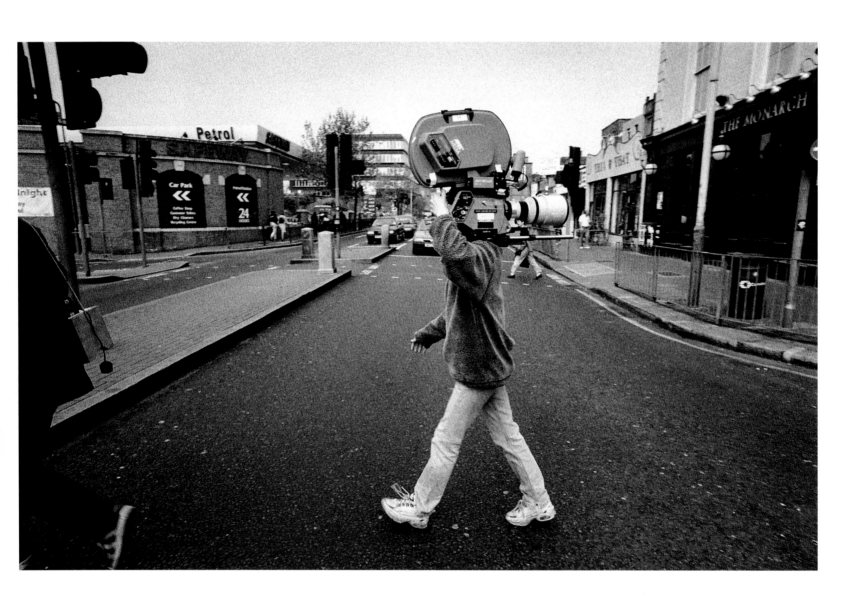

This Year's Love
Camera woman

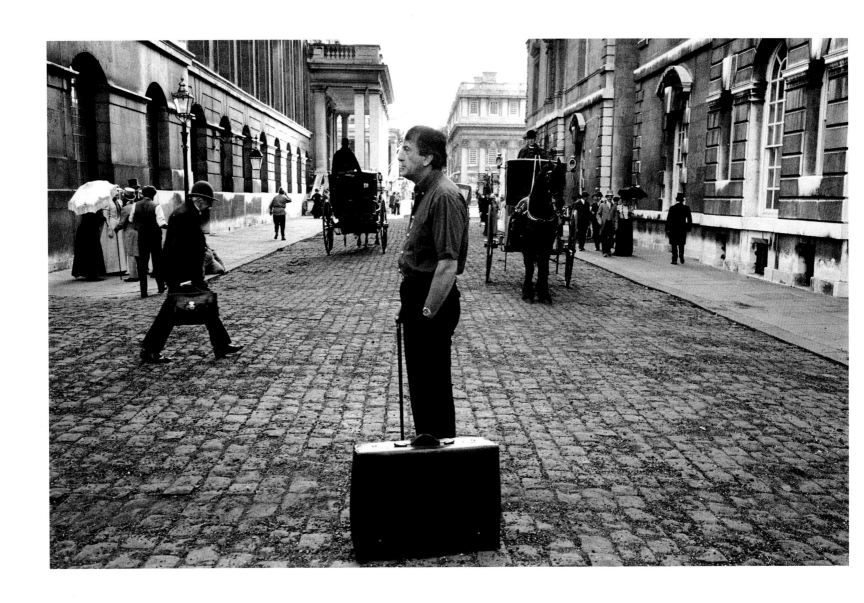

An Ideal Husband
Stand-in

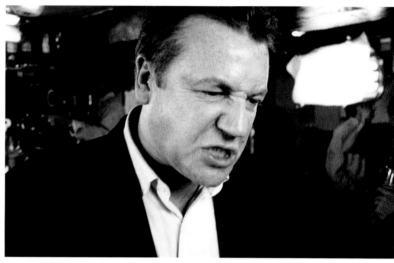

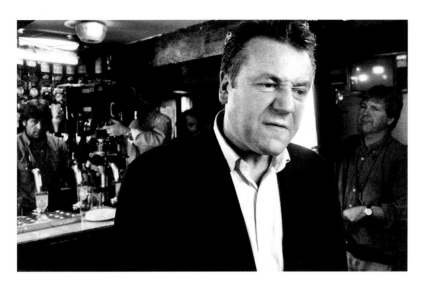 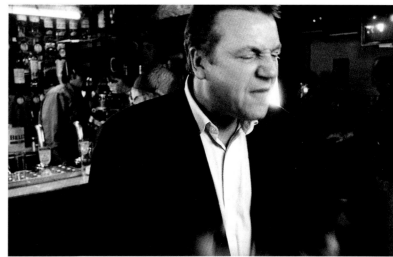

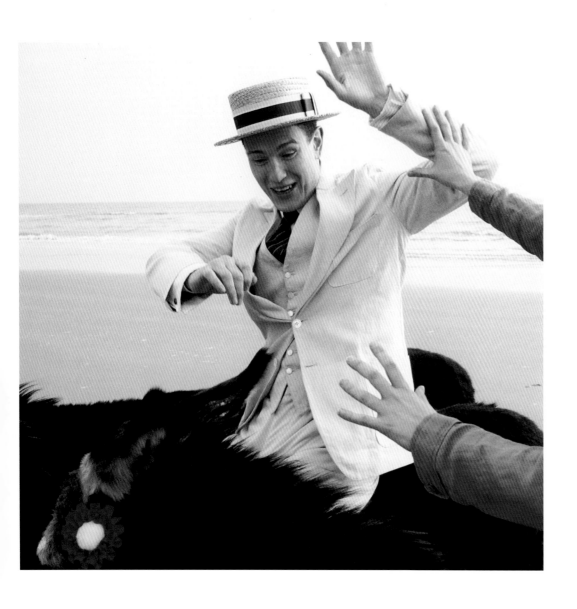

previous:
Fanny and Elvis
Ray Winstone psyching
himself up for a fight

Another Life
Nick Moran

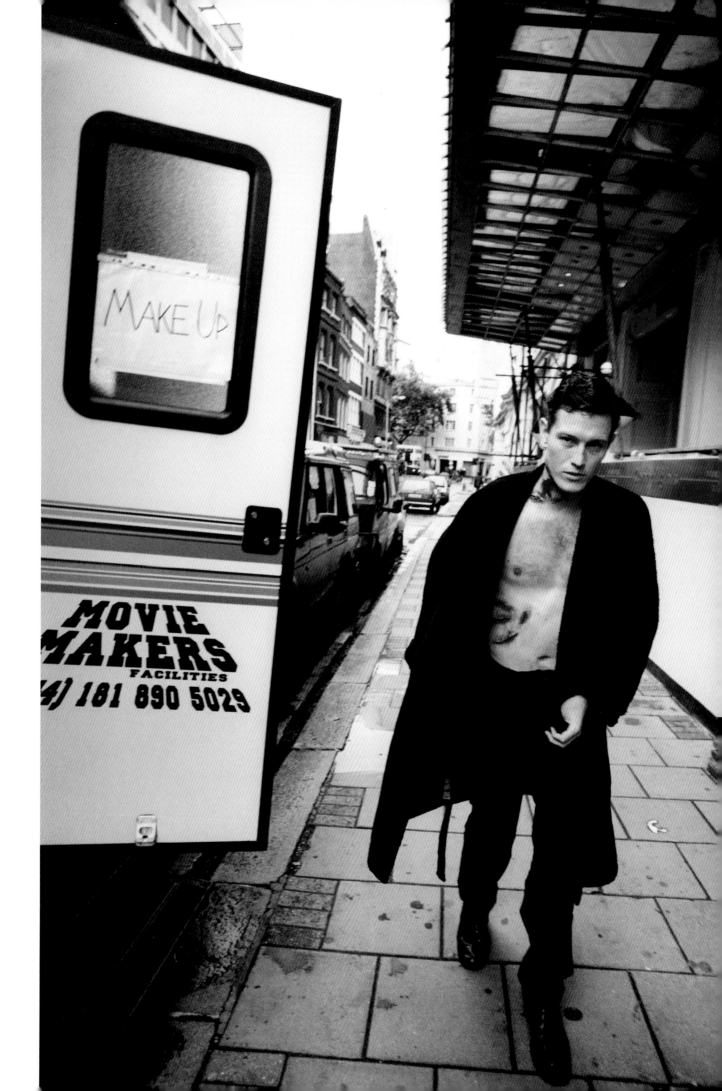

MAKE UP

MOVIE
MAKERS
FACILITIES
(4) 181 890 5029

Another Life
Nick Moran

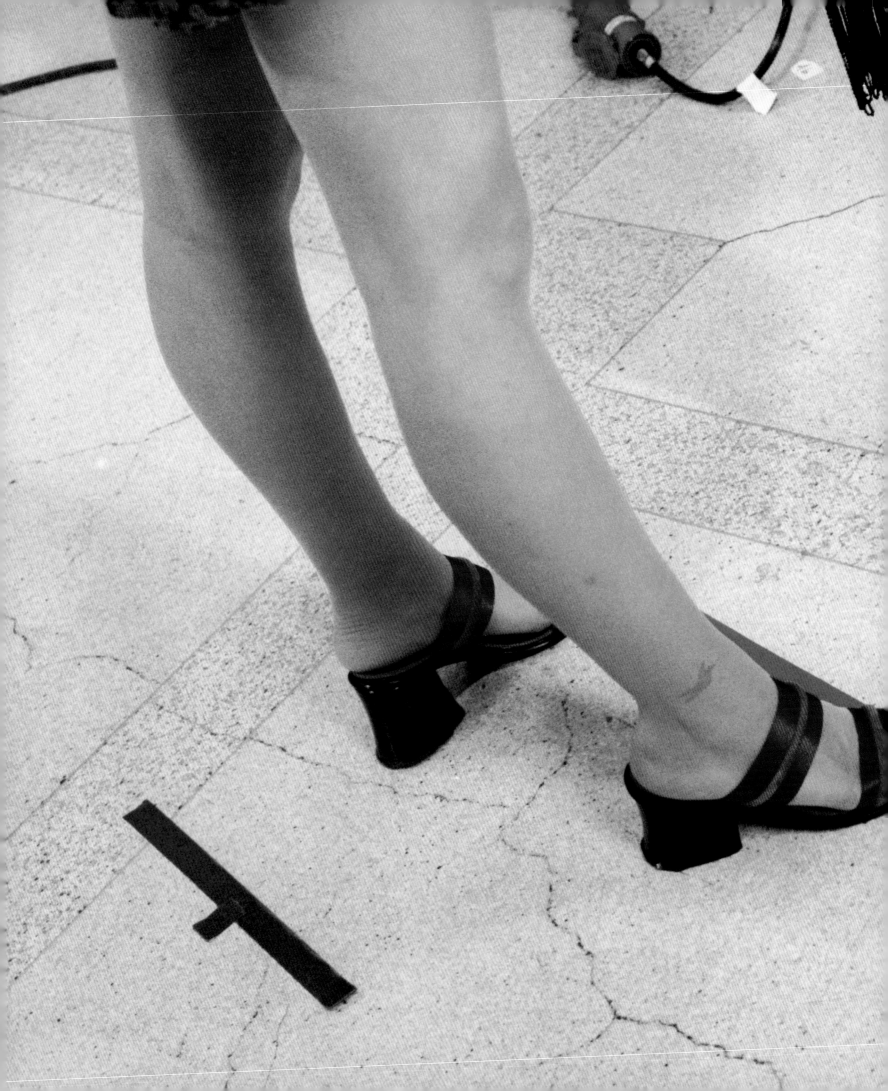

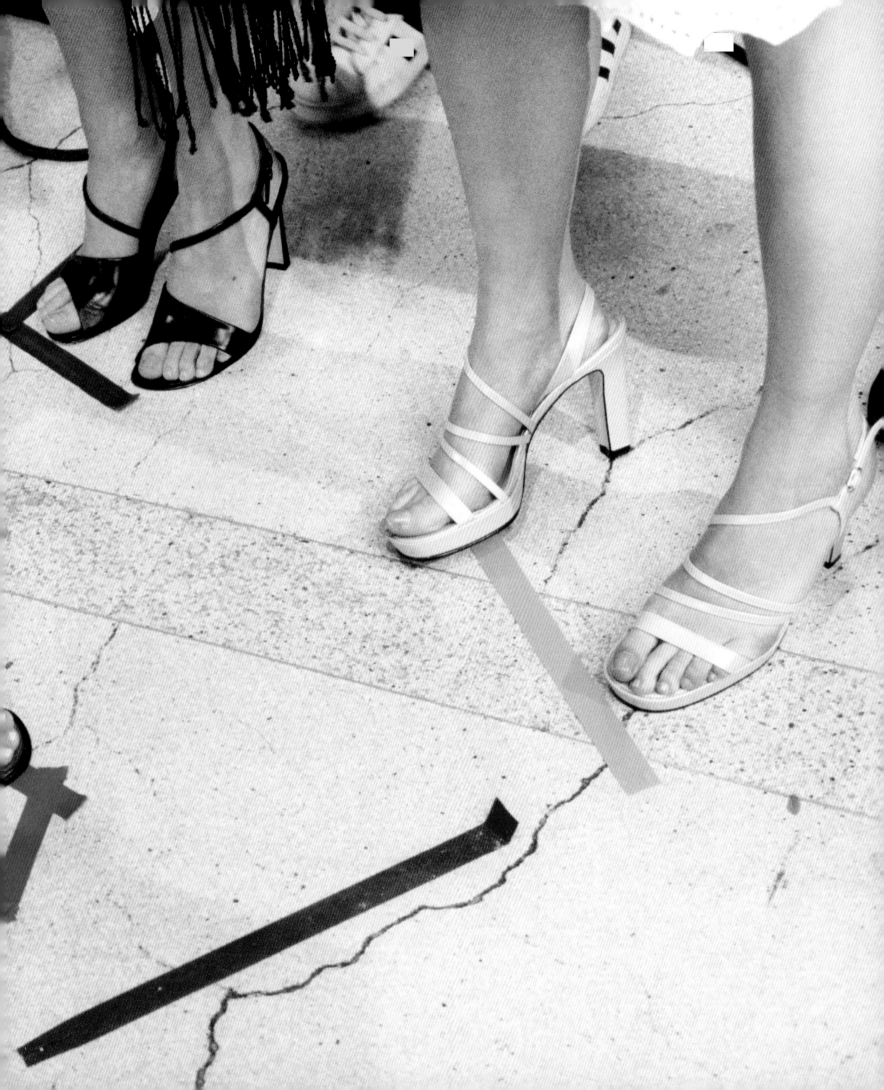

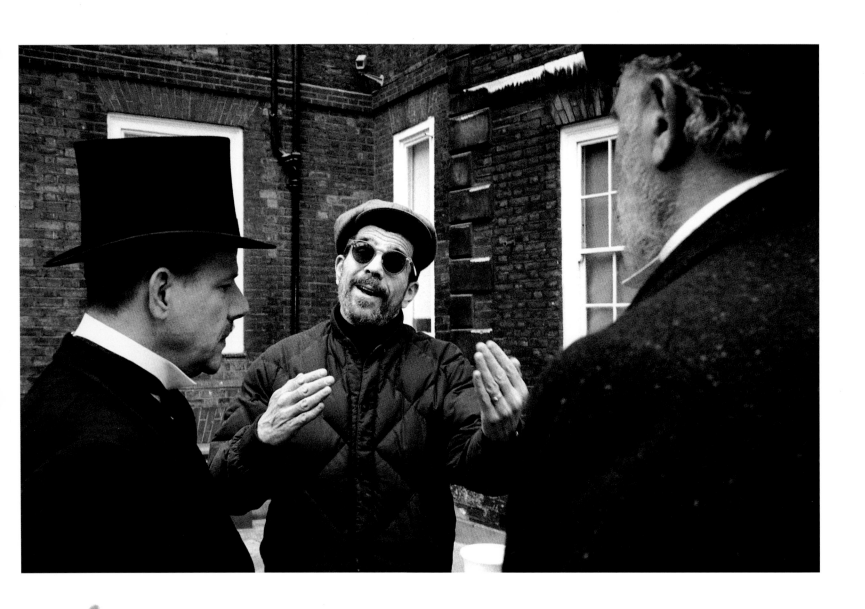

previous:
An Ideal Husband
(modern-day version)
Sadie Frost's legs

The Winslow Boy
David Mamet

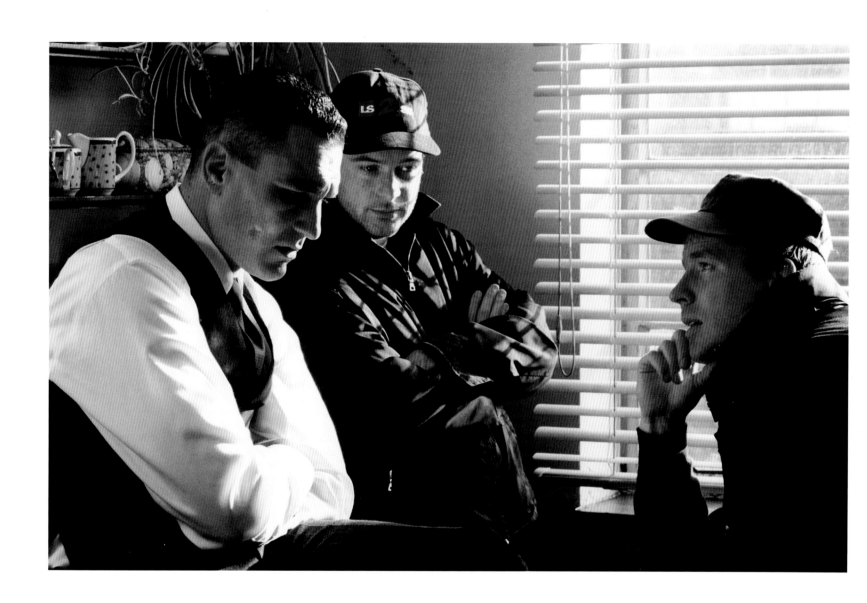

Snatch
Vinnie Jones,
Matthew Vaughn
and Guy Ritchie

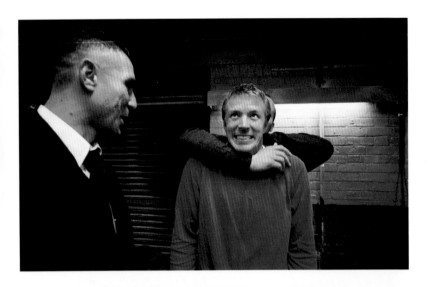

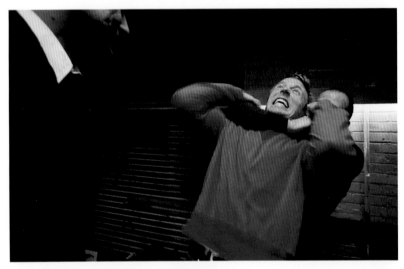

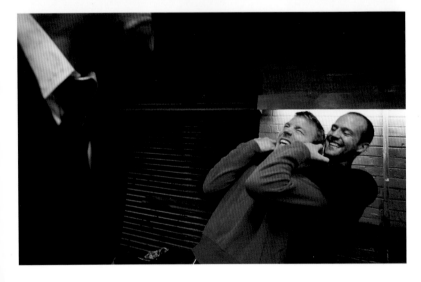

Snatch
Guy Ritchie and
Jason Statham

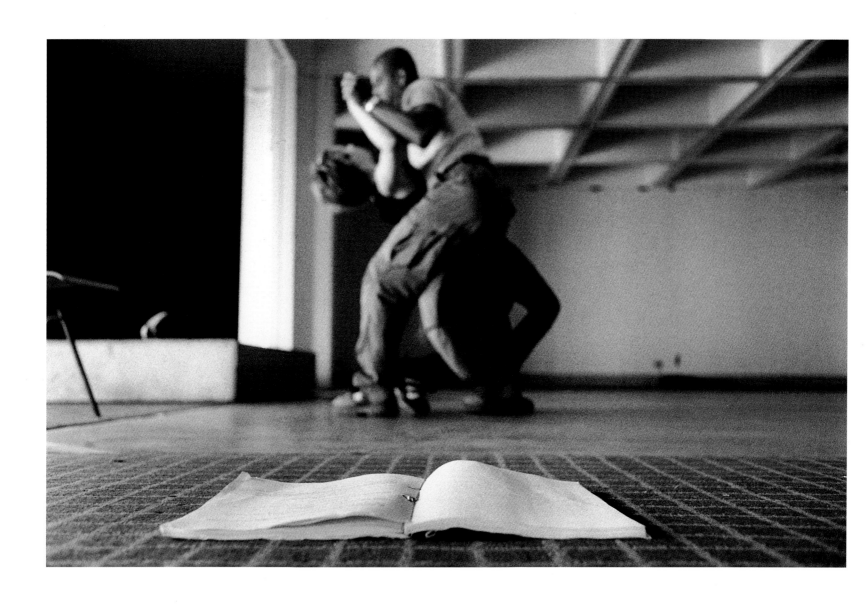

Janice Beard
Rehearsing

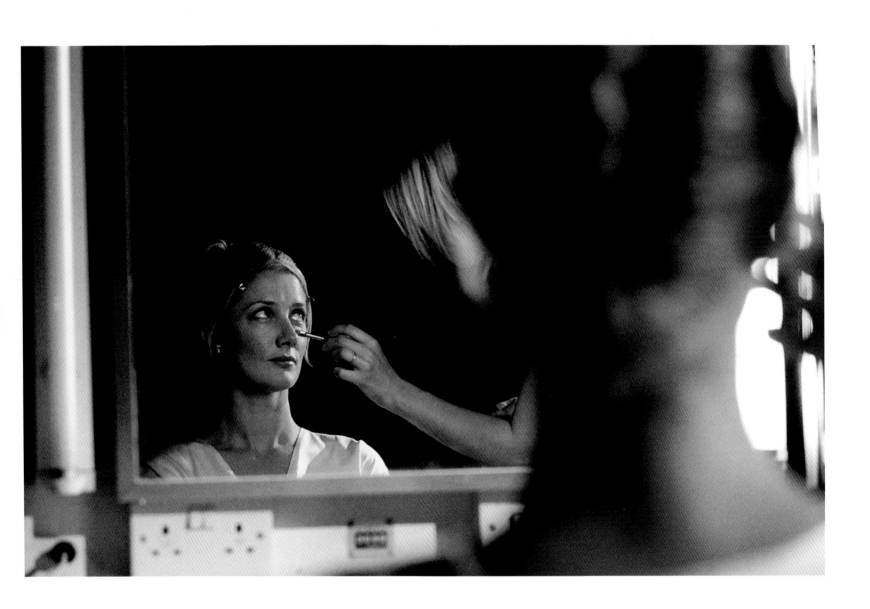

Maybe Baby
Joely Richardson

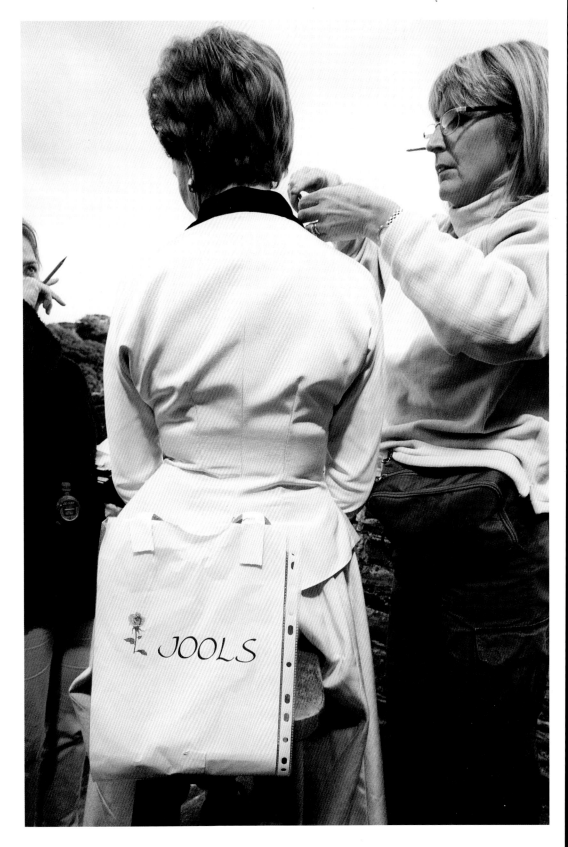

Relative Values
Julie Andrews

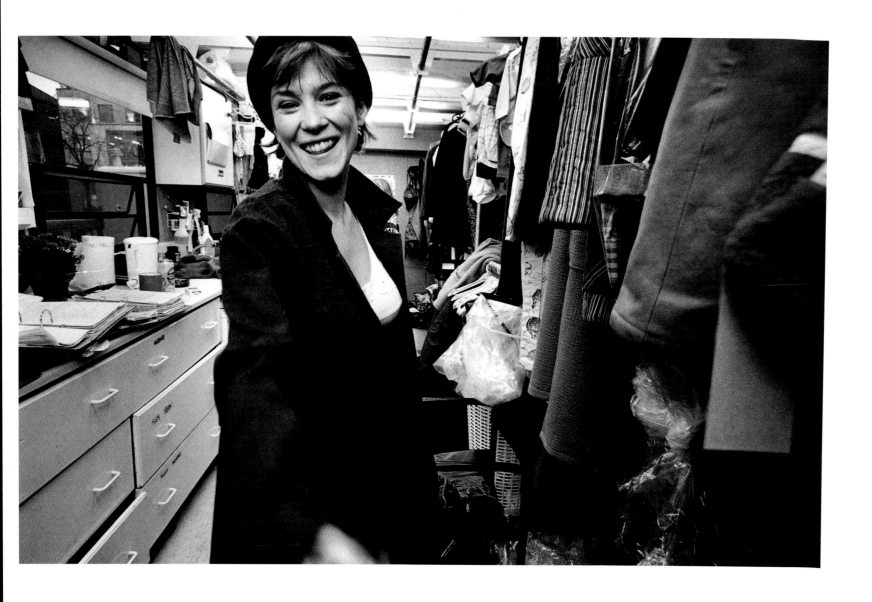

Mad Cows
Anna Friel

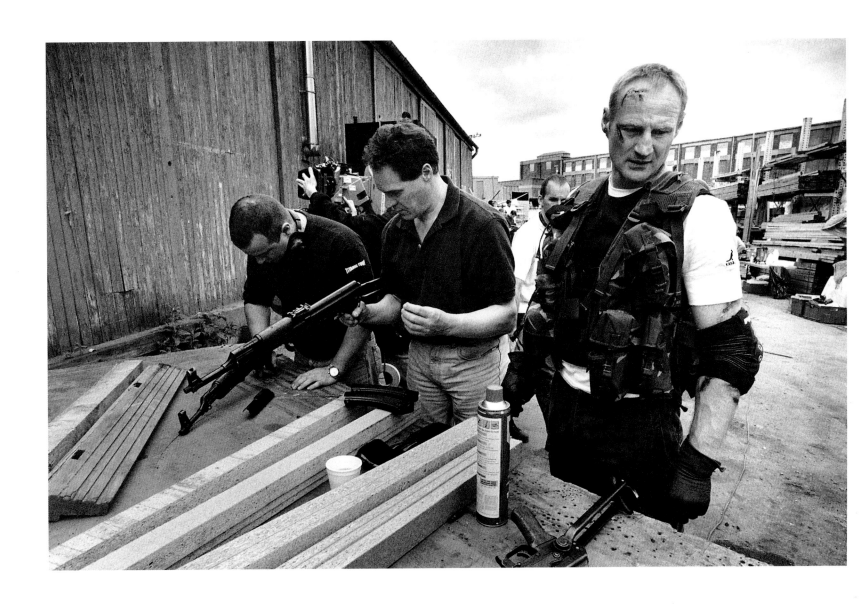

Love, Honour and Obey
William Scully QGM

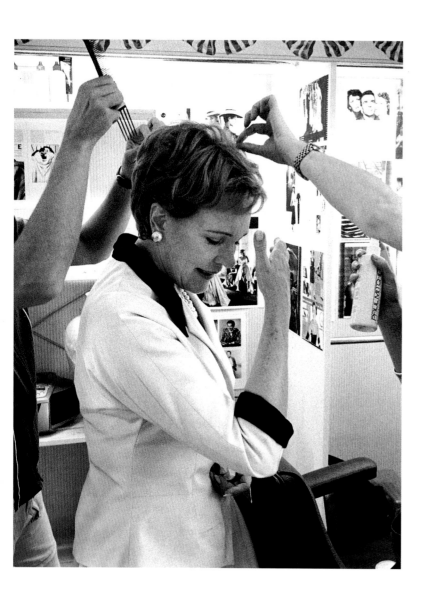

Relative Values
Julie Andrews

65

An Ideal Husband
(modern-day version)
Sadie Frost

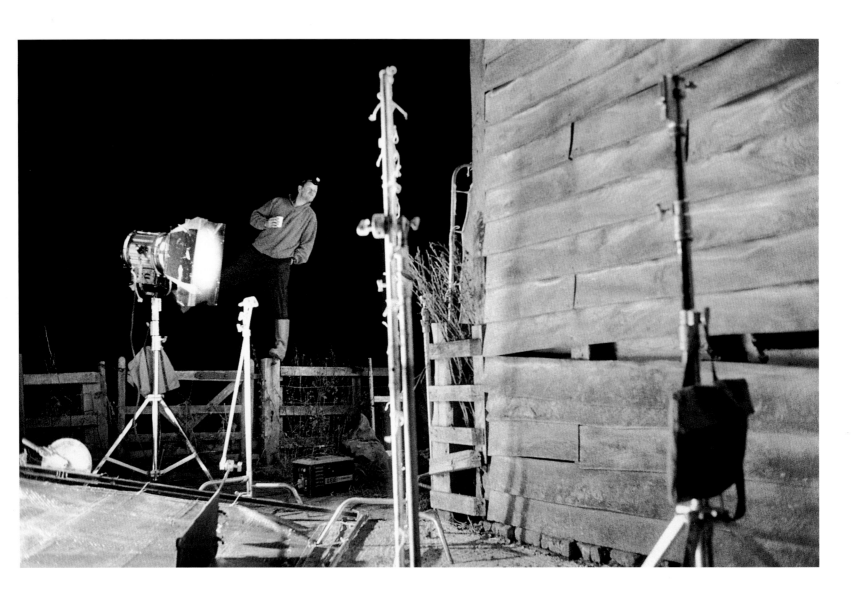

Milk
Crew member
sneaking a peek at
a closed-set sex scene

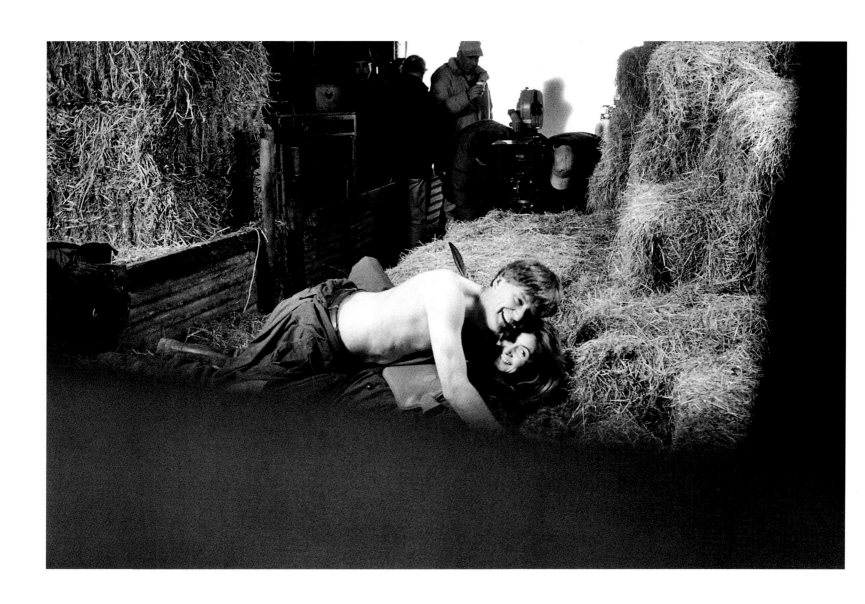

Milk
James Fleet and
Clotilde Courau

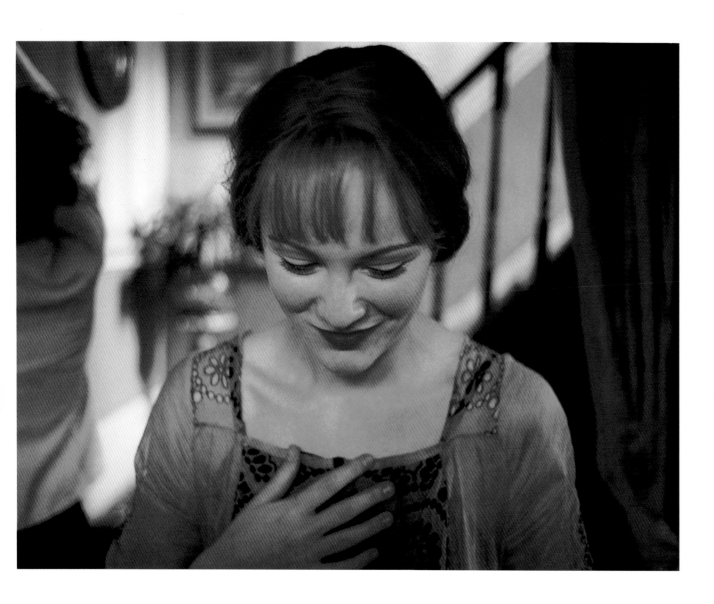

Another Life
Rachael Stirling

Each film begins as a journey with a definite destination and a clear map to guide me. In the course of the trip I invariably get tempted by siren voices down interesting side paths not on the itinerary, stop for longer than I should at distracting wayside shrines, and generally manage to get myself completely and utterly lost in the woods. Somehow, though, with the help of the crew I always reach my destination. But, by the time I arrive, it has been mysteriously altered… usually for the better.

Terry Gilliam
Director

I am most excited when we are actually shooting the film – getting up early, going to the location, meeting with the crew, planning the shots with the cameraman, rehearsing with the actors, seeing the rushes every day and then watching the editor put the scenes together as the first cut.

Ismail Merchant
Producer

THE SHOOT

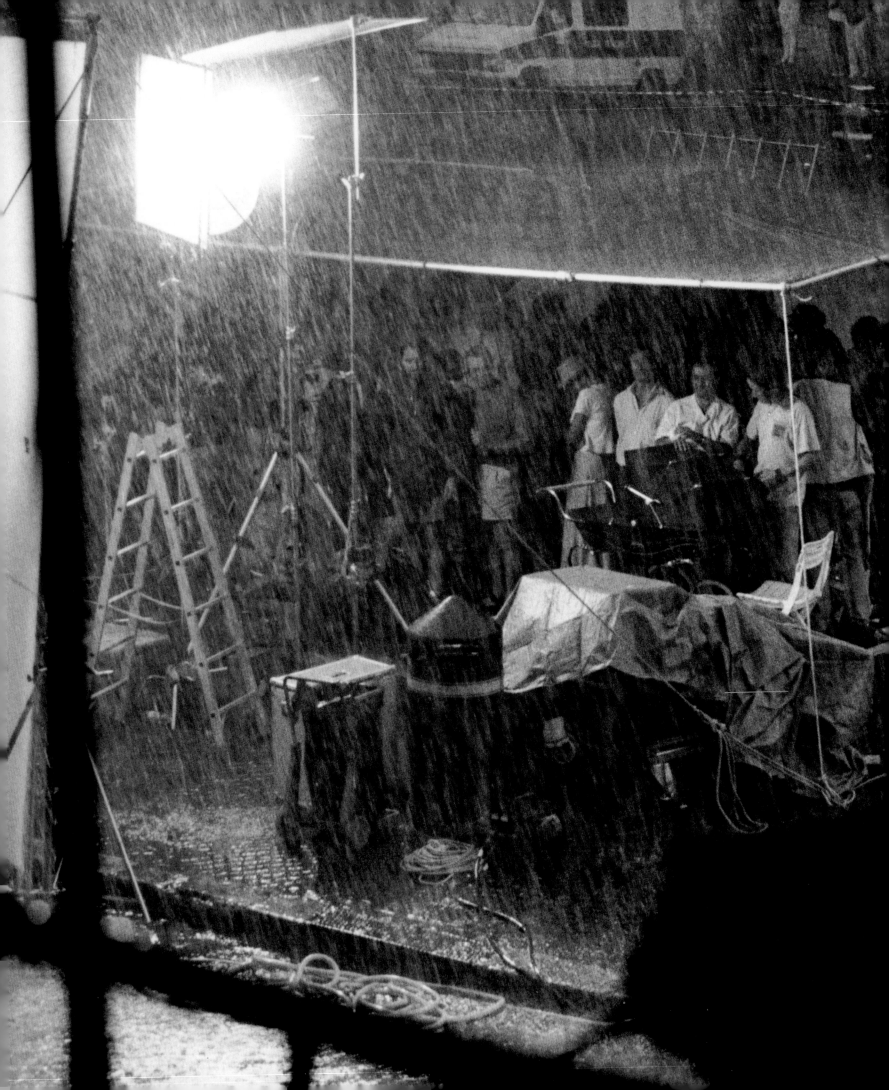

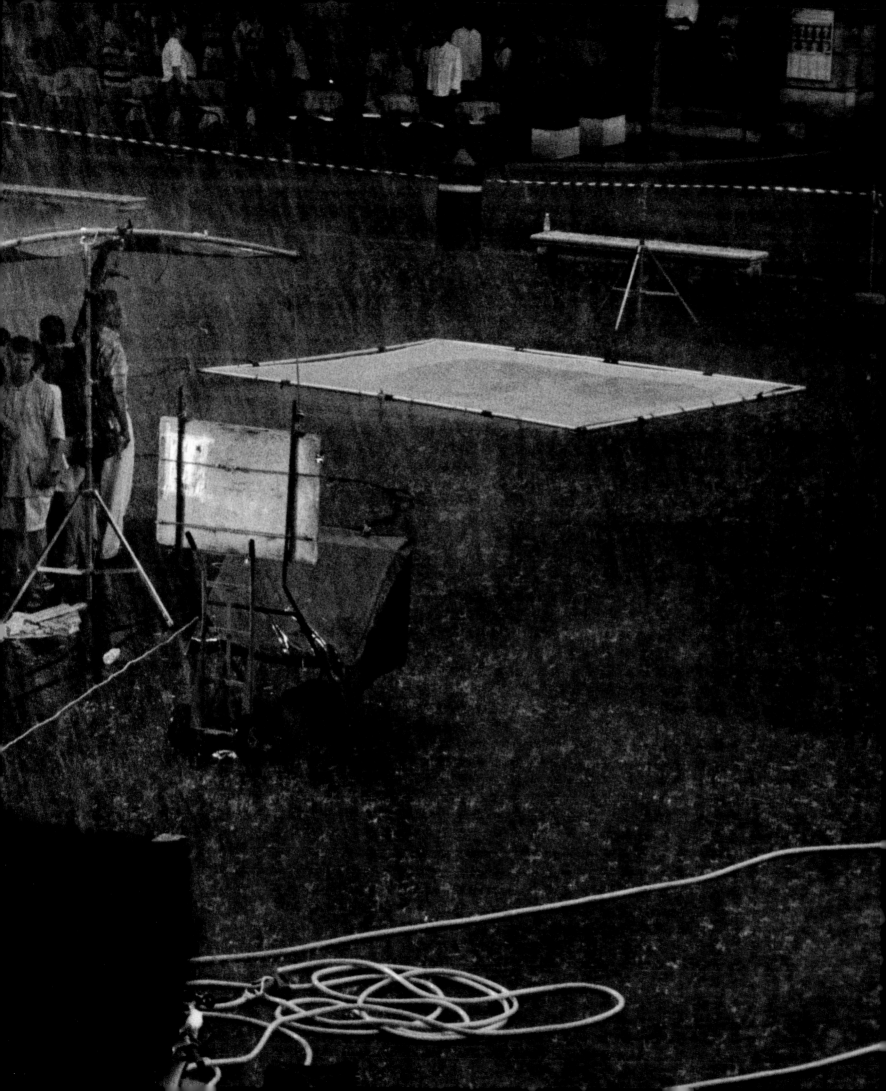

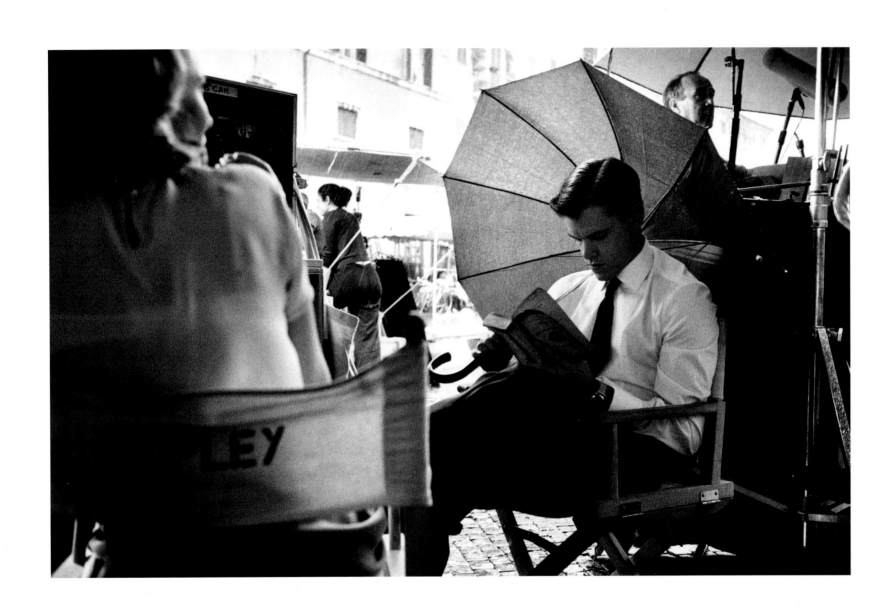

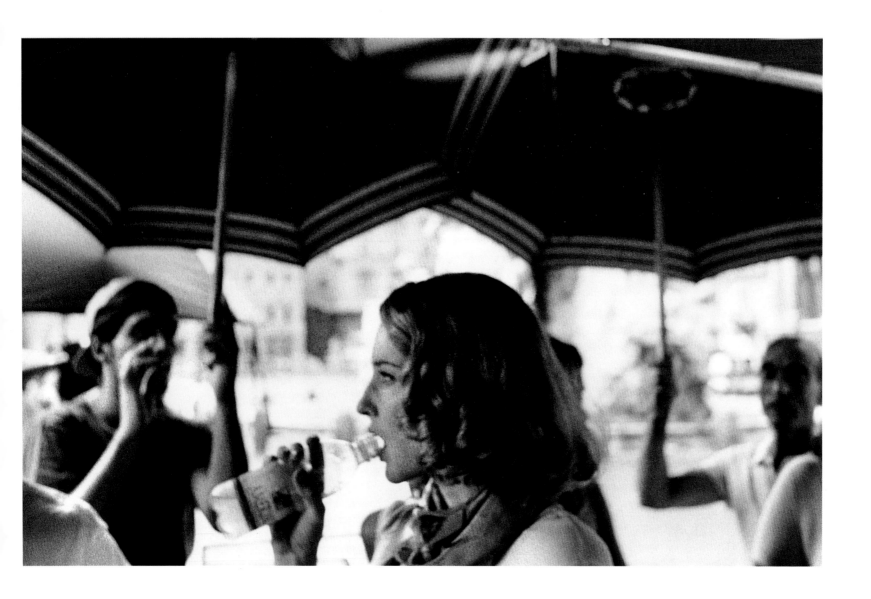

previous pages, above
and right:
The Talented Mr Ripley

Piazza Novona

Matt Damon

Cate Blanchett

Anthony Minghella

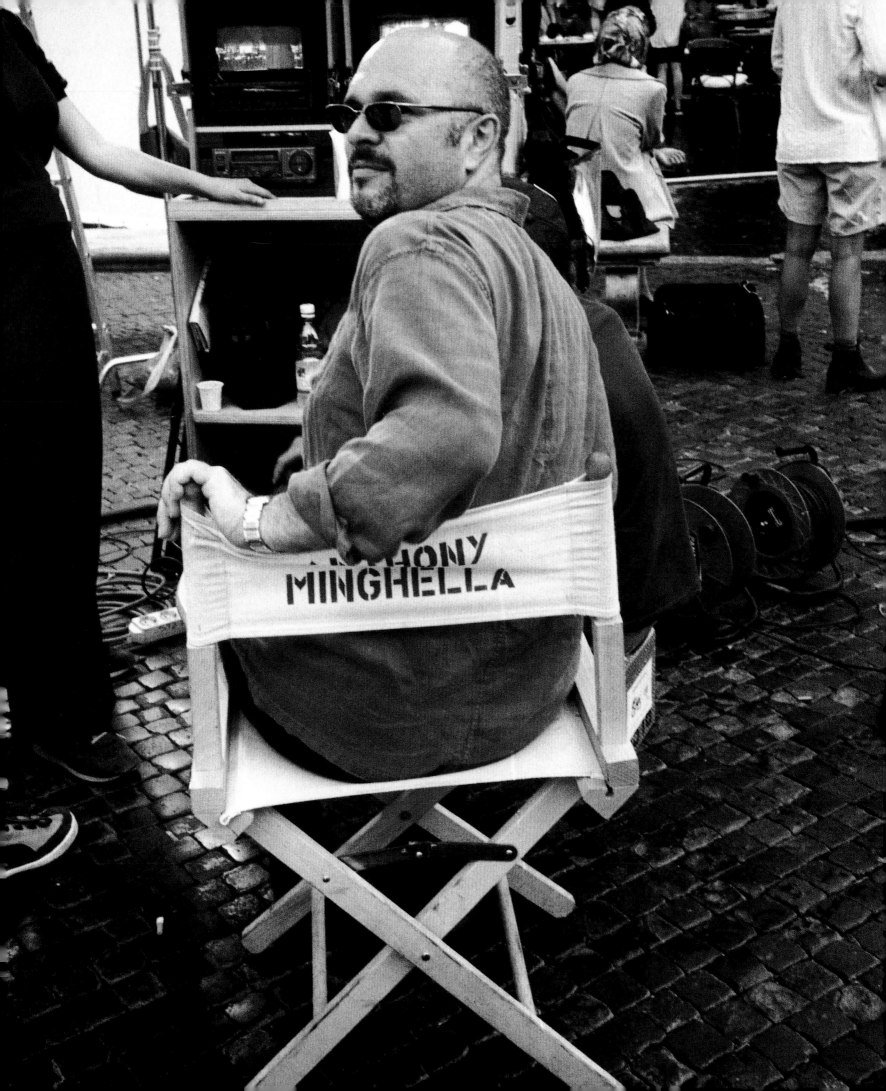

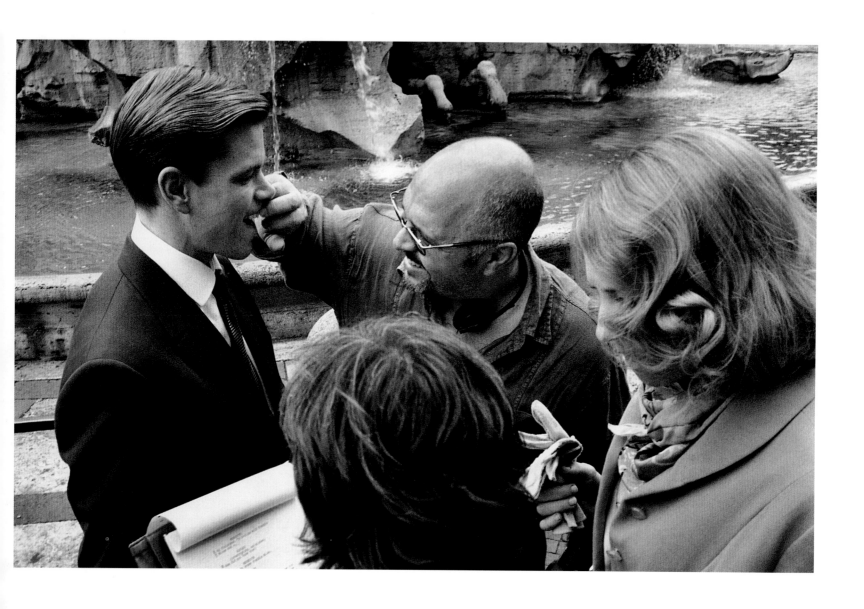

The Talented Mr Ripley
Matt Damon and
Anthony Minghella

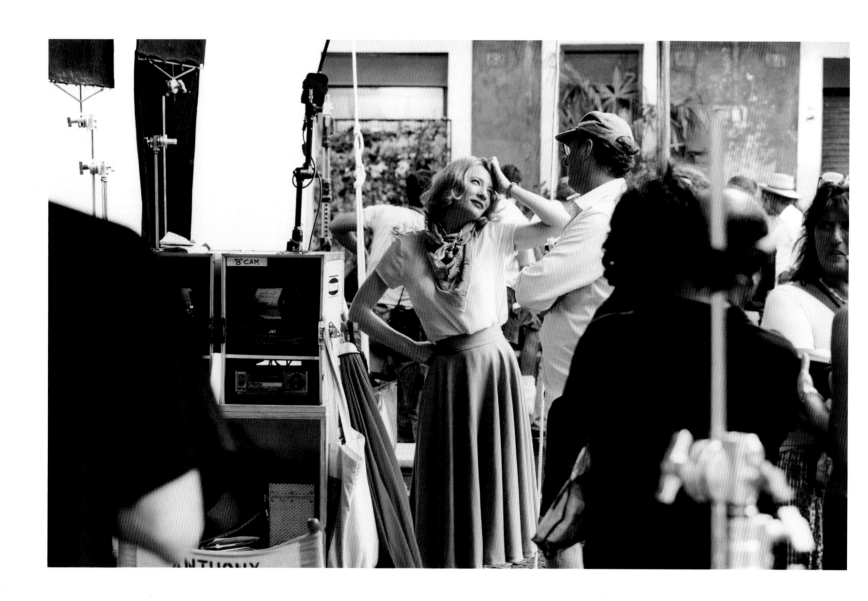

The Talented Mr Ripley
Cate Blanchett

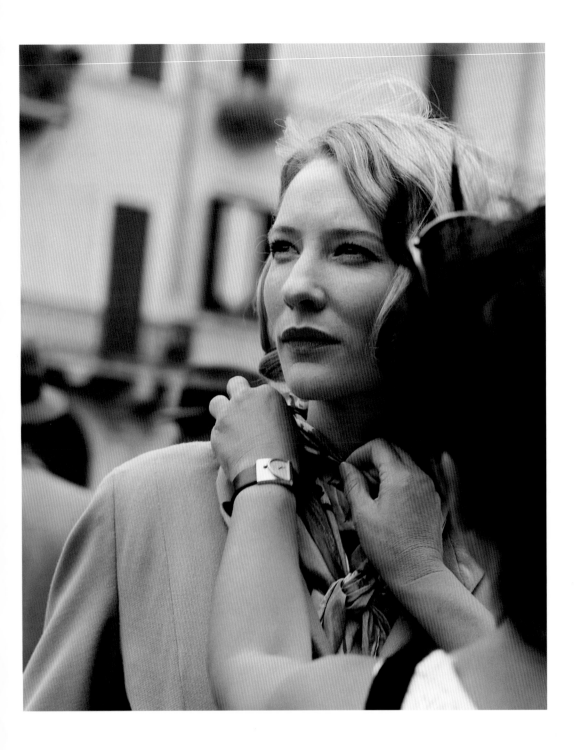

The Talented Mr Ripley
Cate Blanchett

Matt Damon

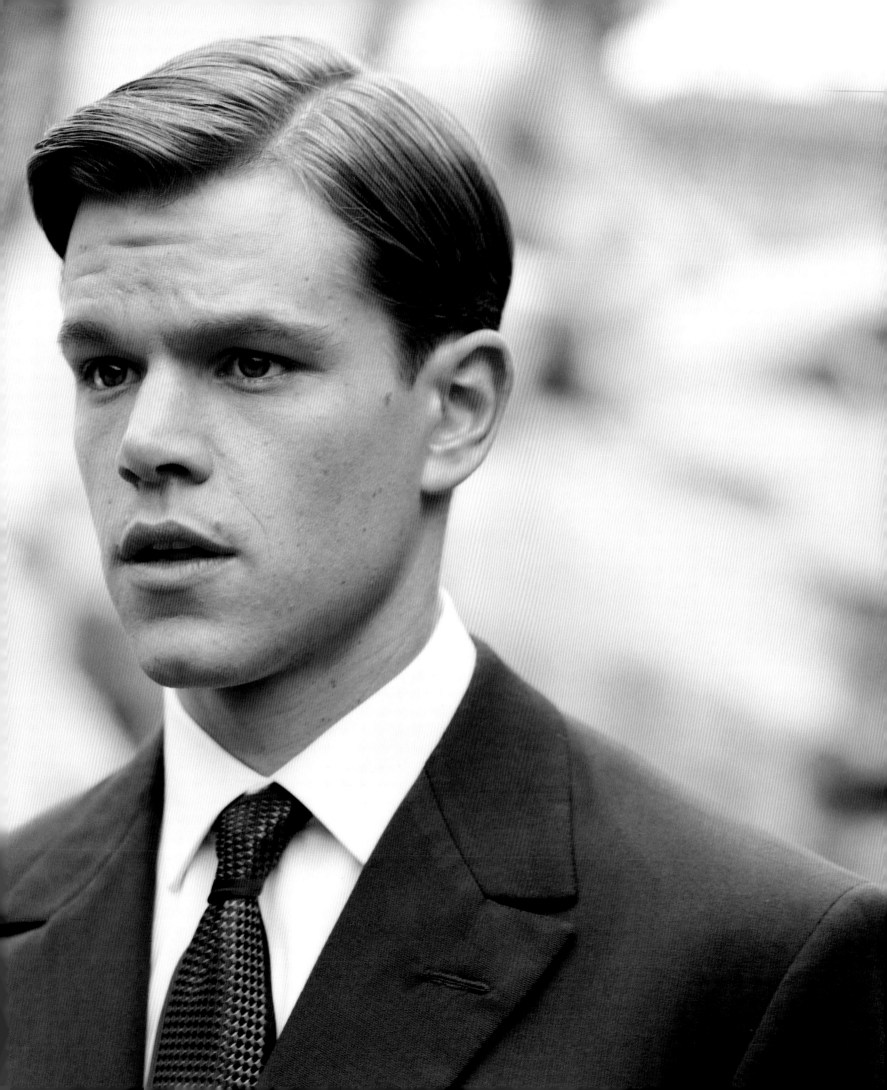

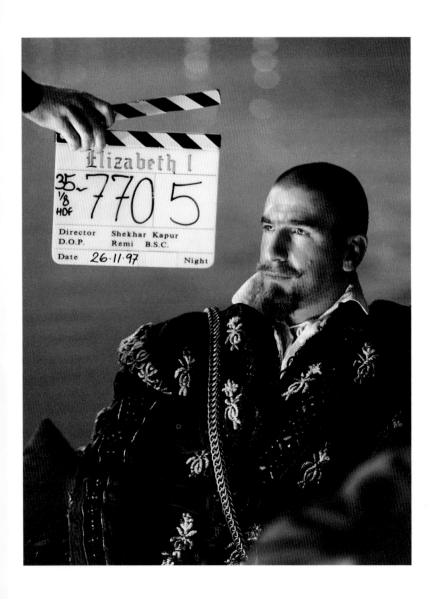

Elizabeth
Eric Cantona

Angela's Ashes
Alan Parker

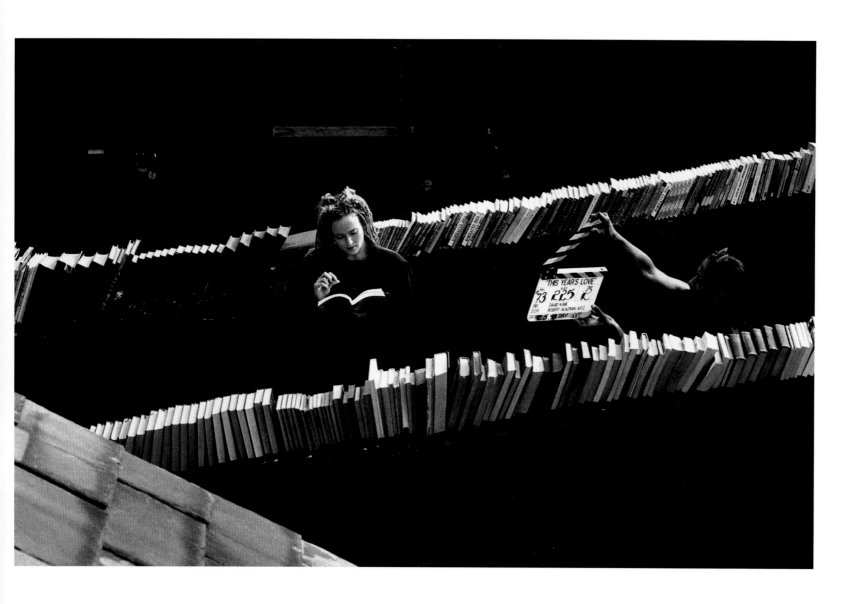

This Year's Love
Jennifer Ehle

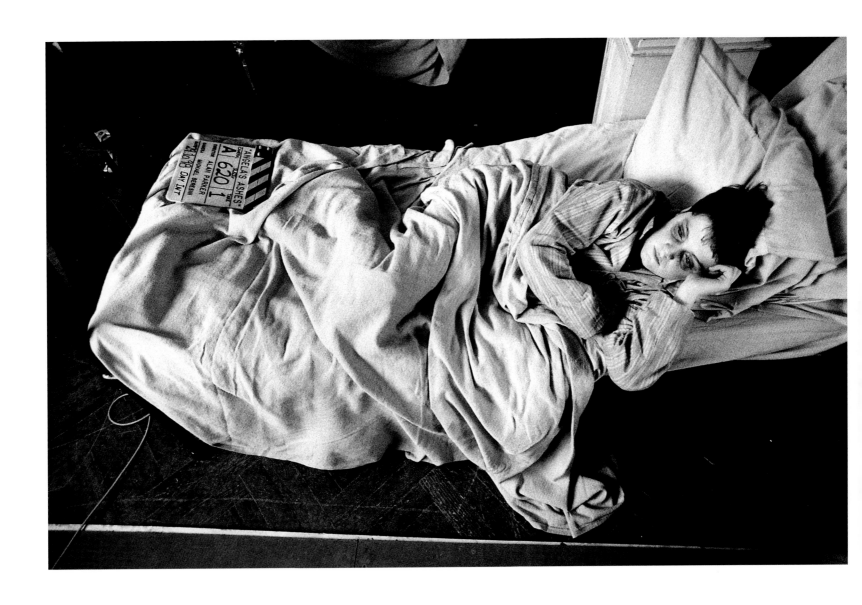

Angela's Ashes
Ciaran Owens

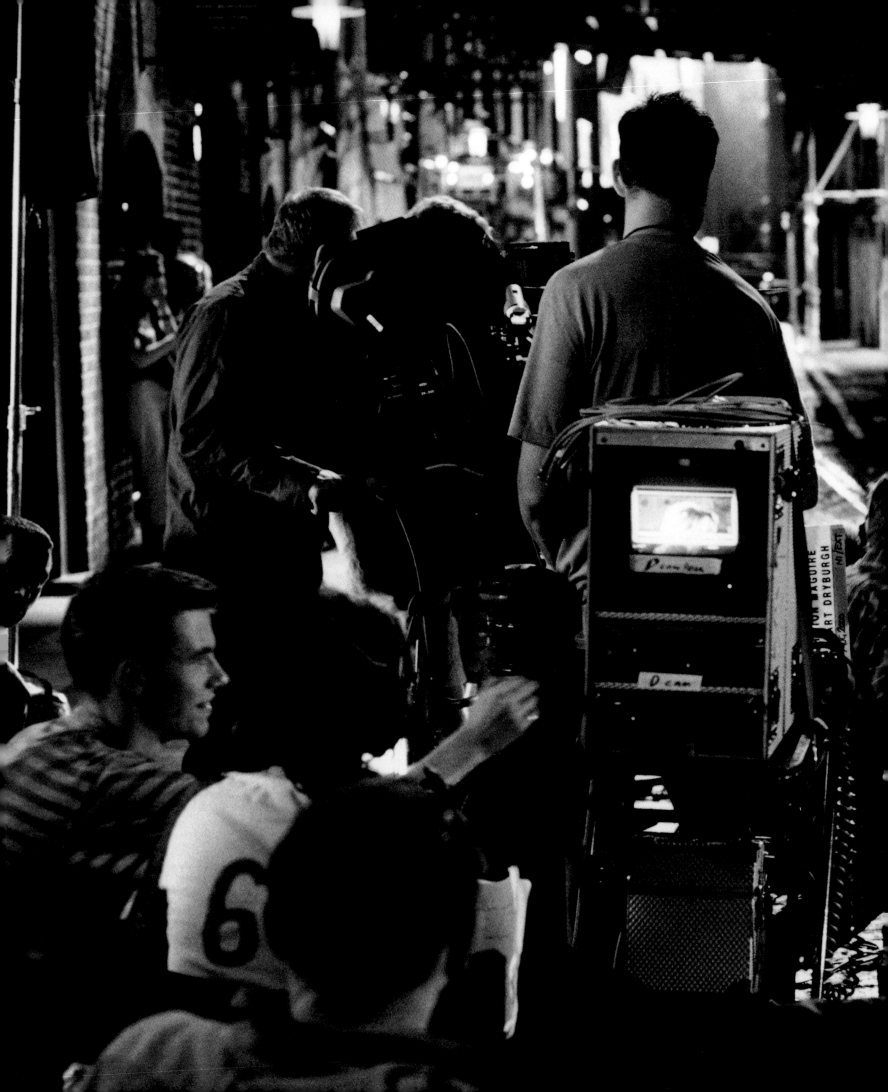

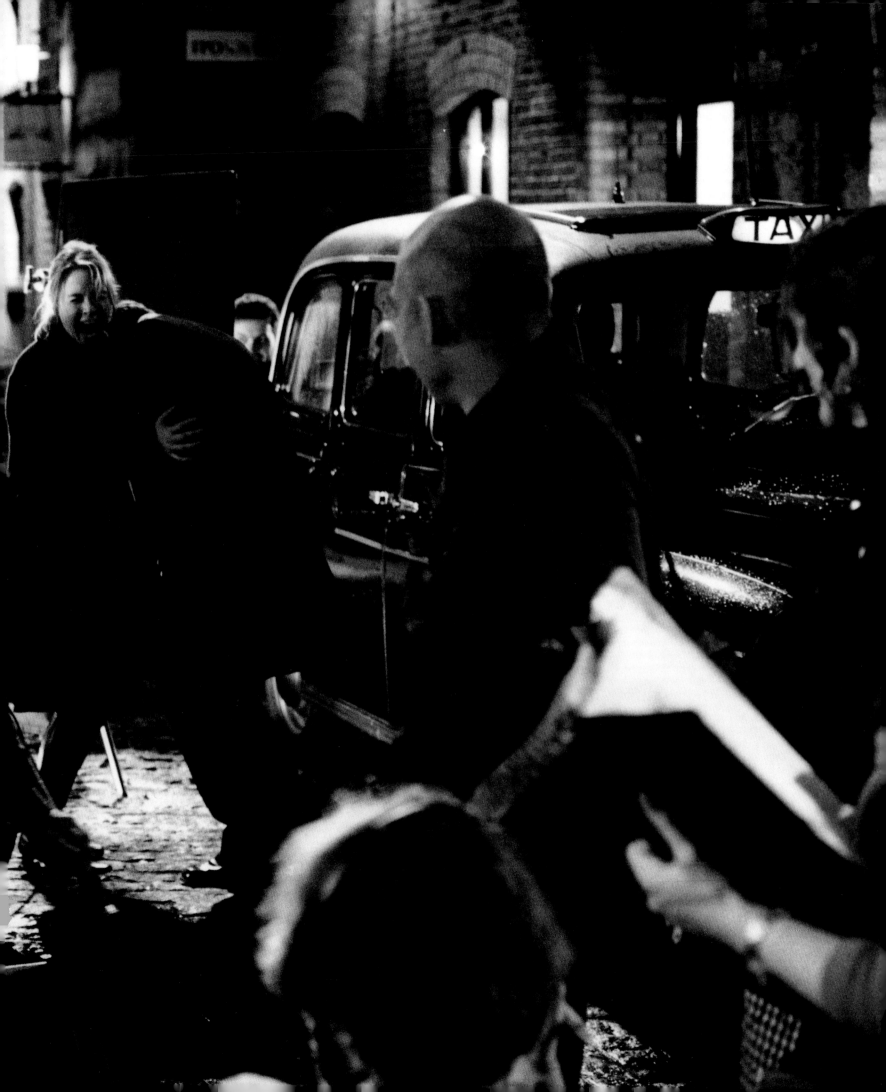

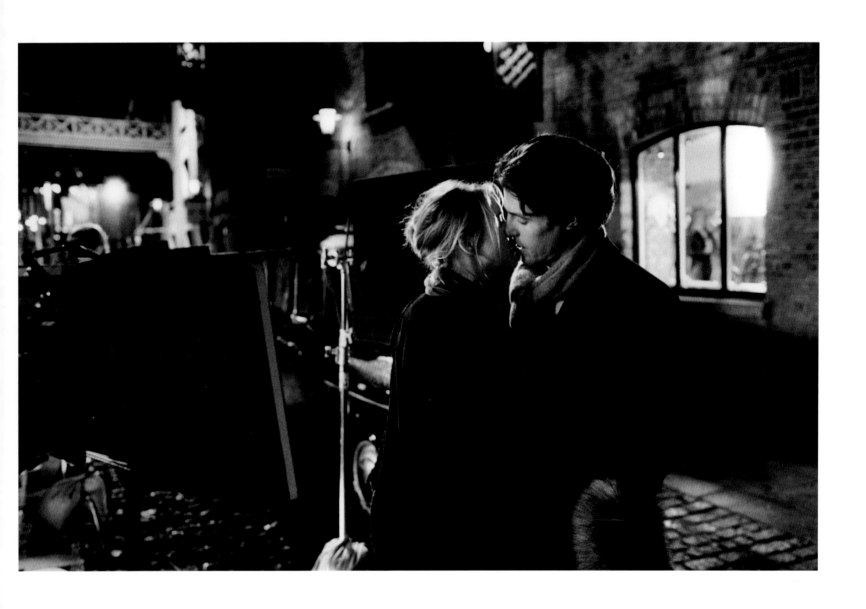

previous and above:
Bridget Jones's Diary

Renee Zellweger and
Hugh Grant

Bridget Jones's Diary
Hugh Grant and
Eric Felner

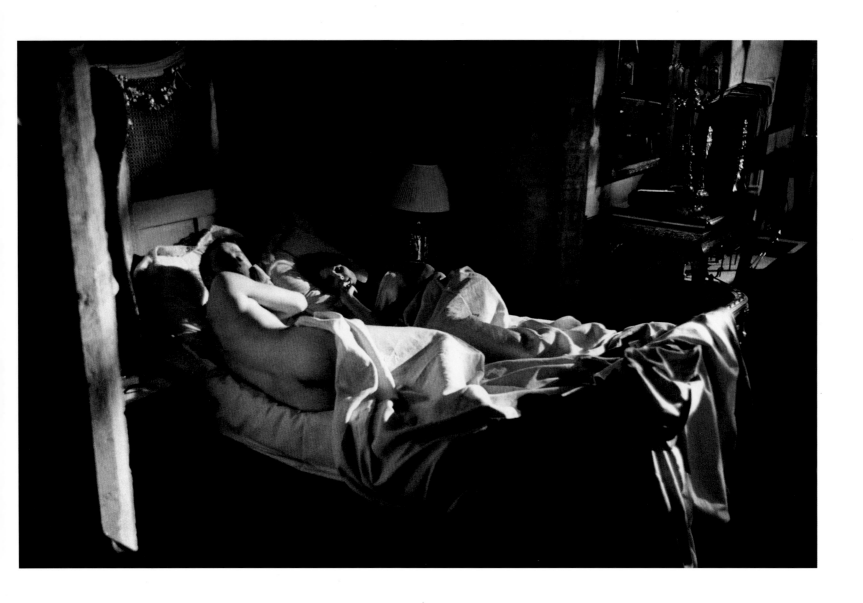

Rancid Aluminium
Rhys Ifans and Sadie Frost

An Ideal Husband
Minnie Driver

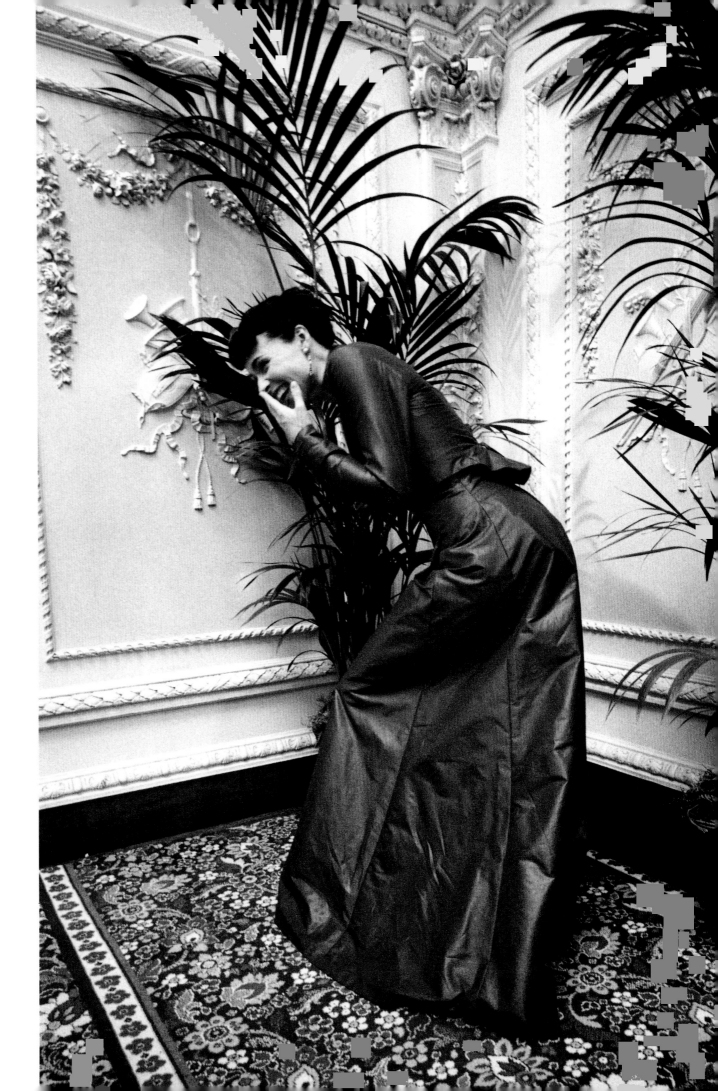

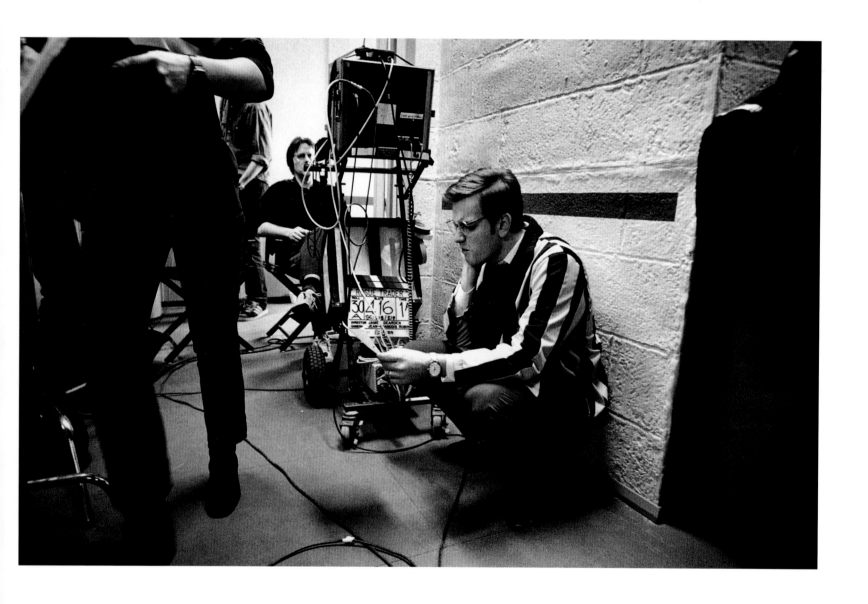

Rogue Trader
Ewan McGregor

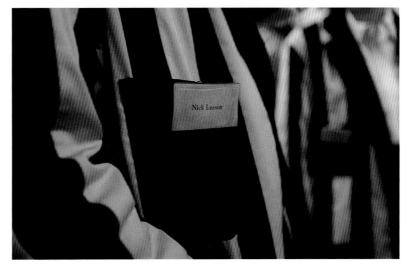

Rogue Trader
Pinewood set

Ewan McGregor

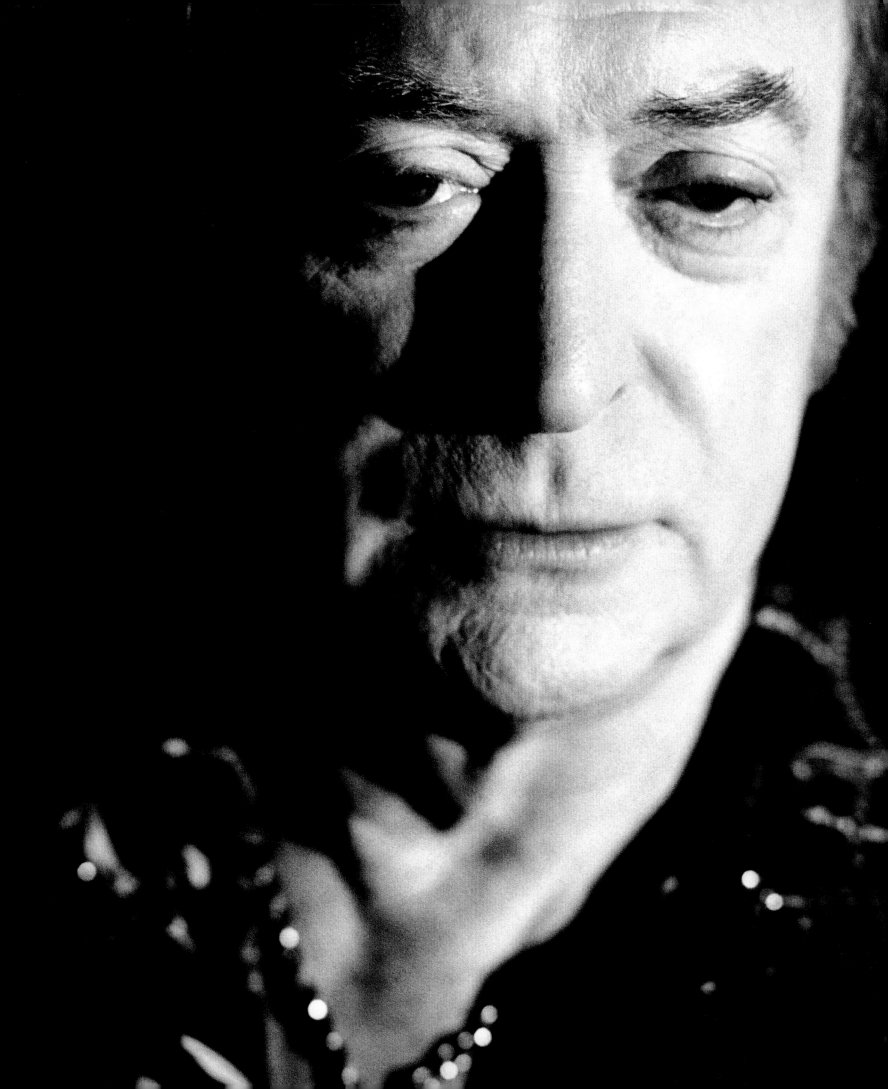

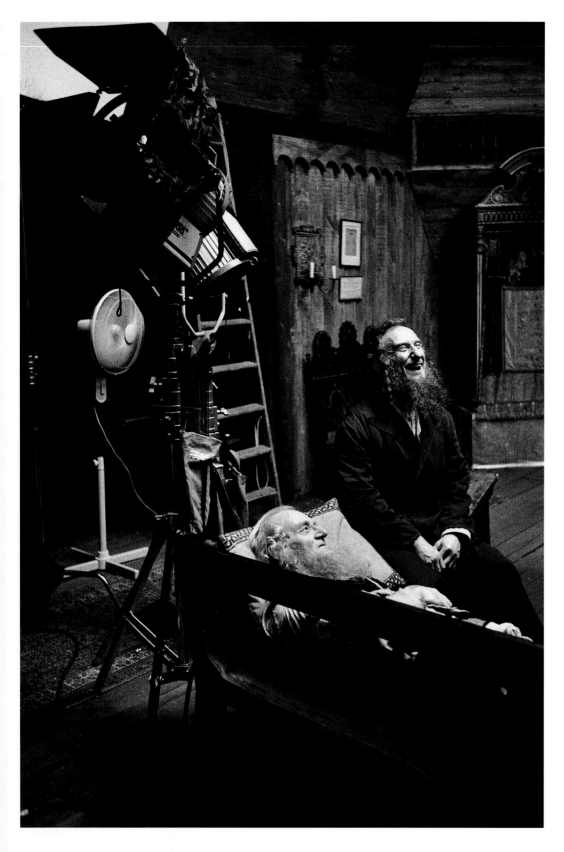

94

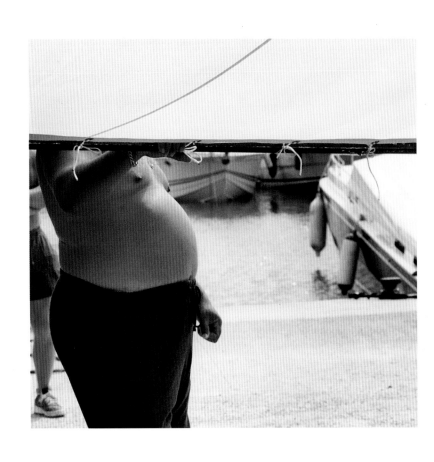

Kevin and Perry Go Large
Member of the crew

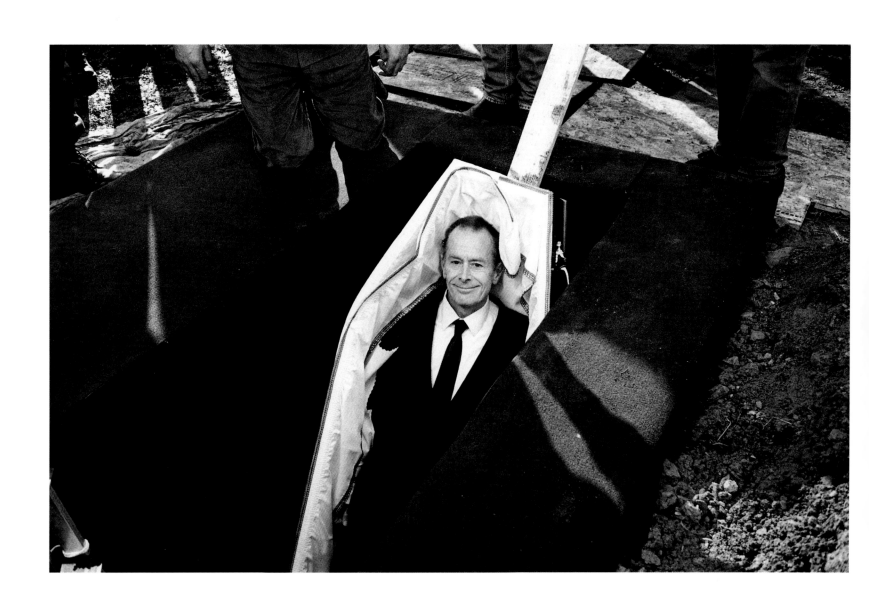

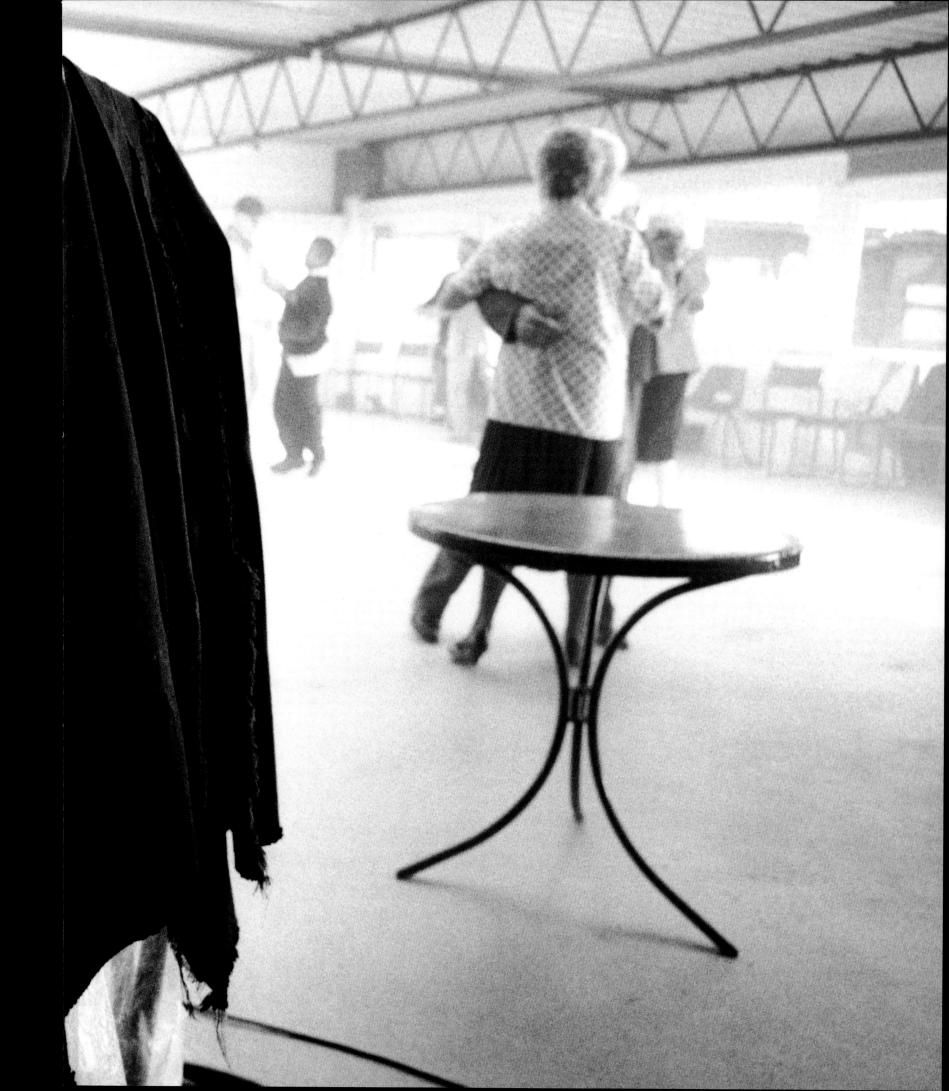

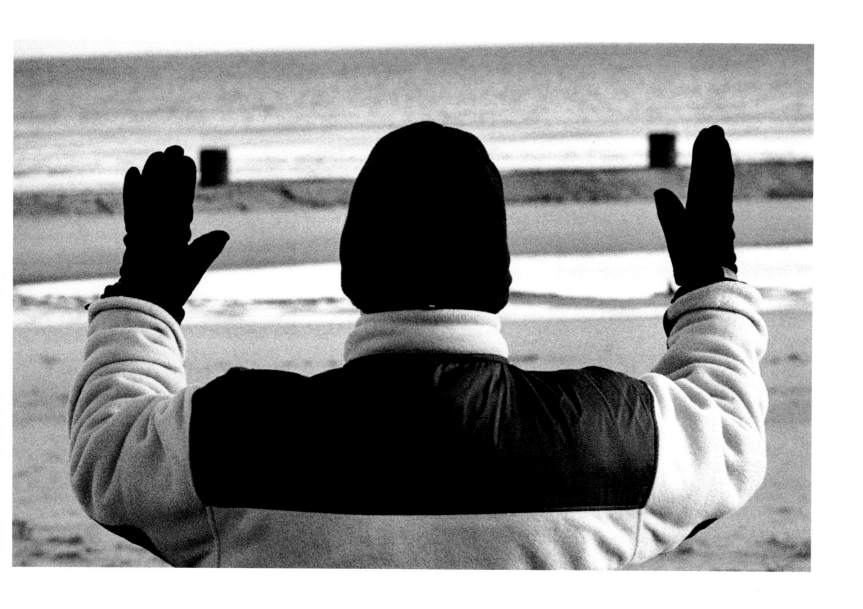

previous pages:
LA Without a Map
Andy Bradford (stuntman)

A Room for Romeo Brass
On location

above:
A Room for Romeo Brass
Shane Meadows directing

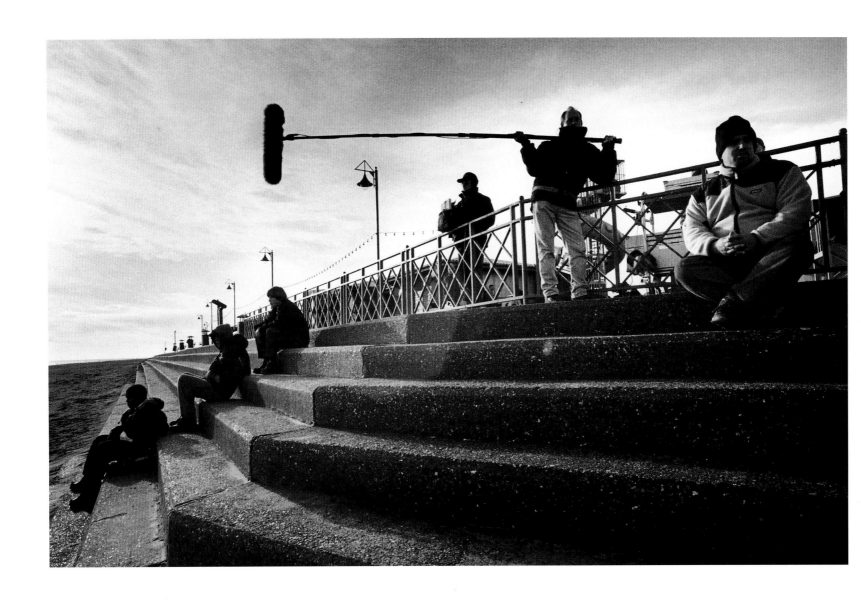

A Room for Romeo Brass
Shane Meadows and
members of the cast

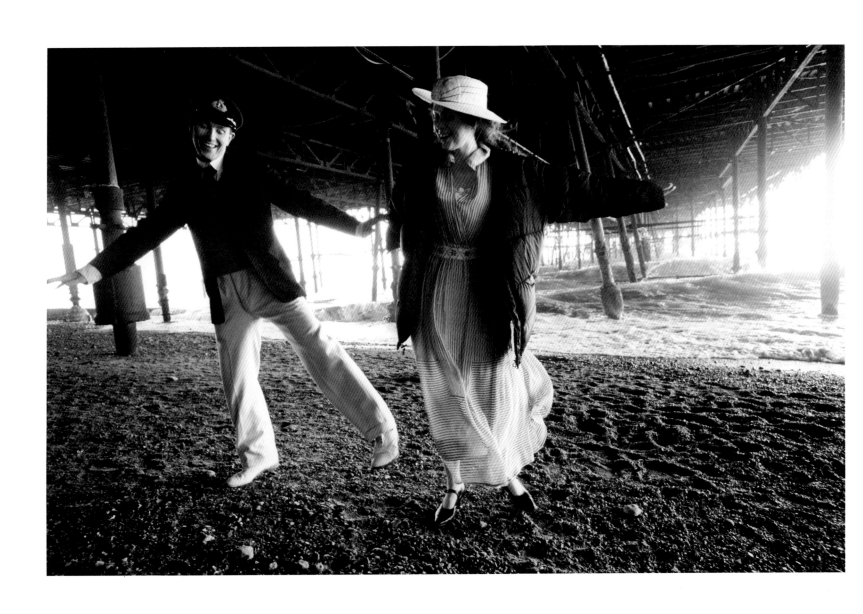

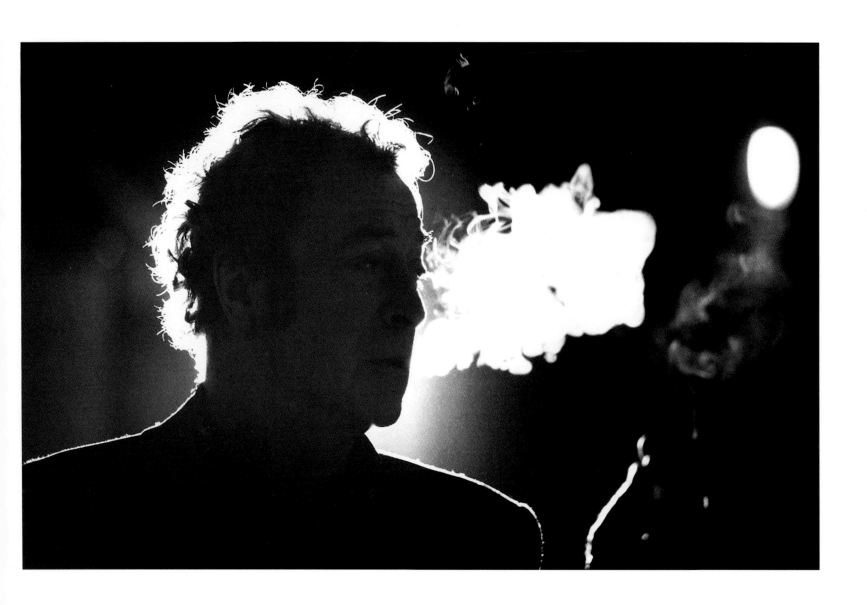

104

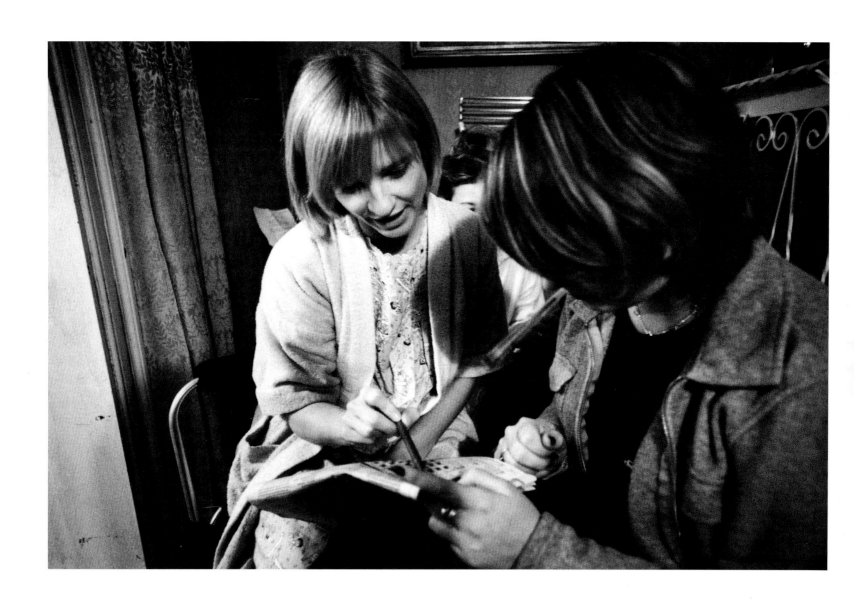

Little Voice
Jane Horrocks

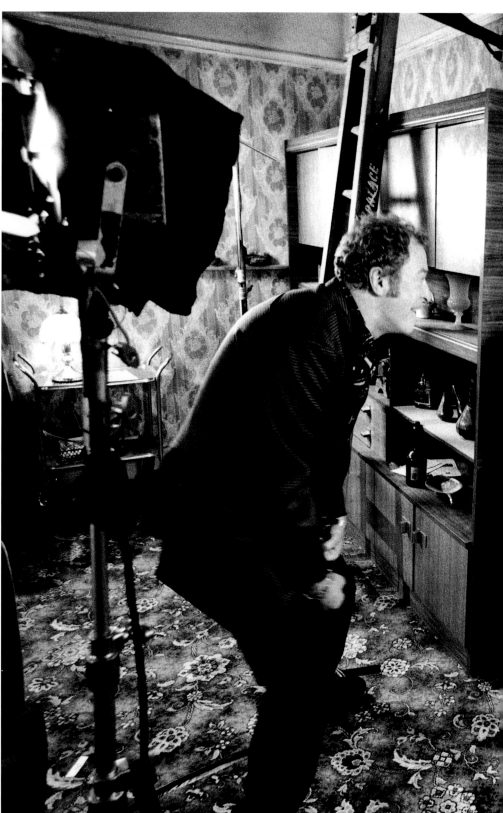

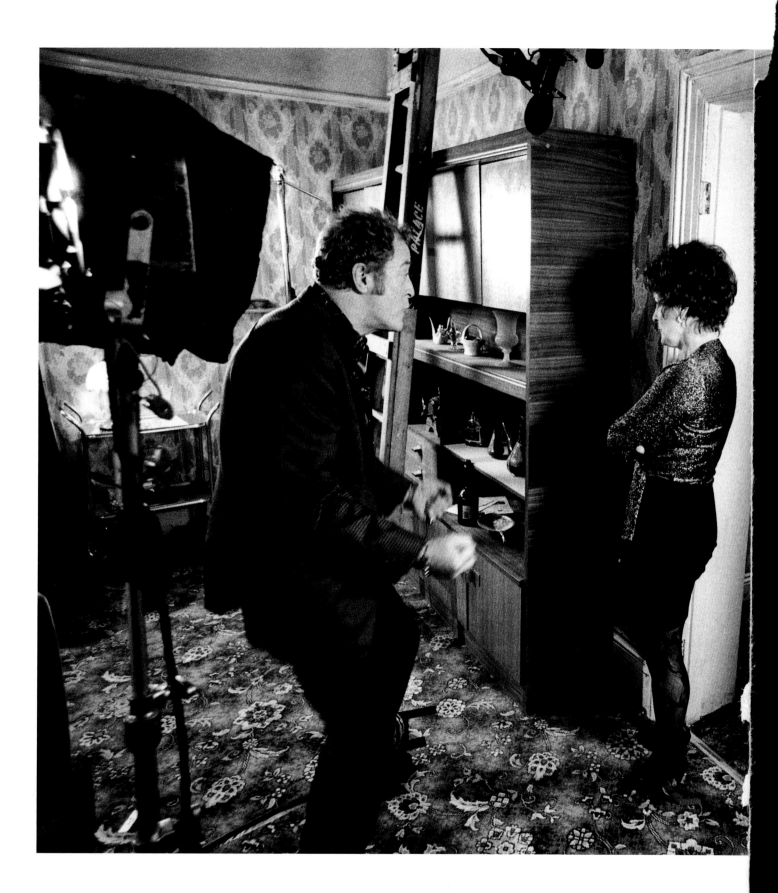

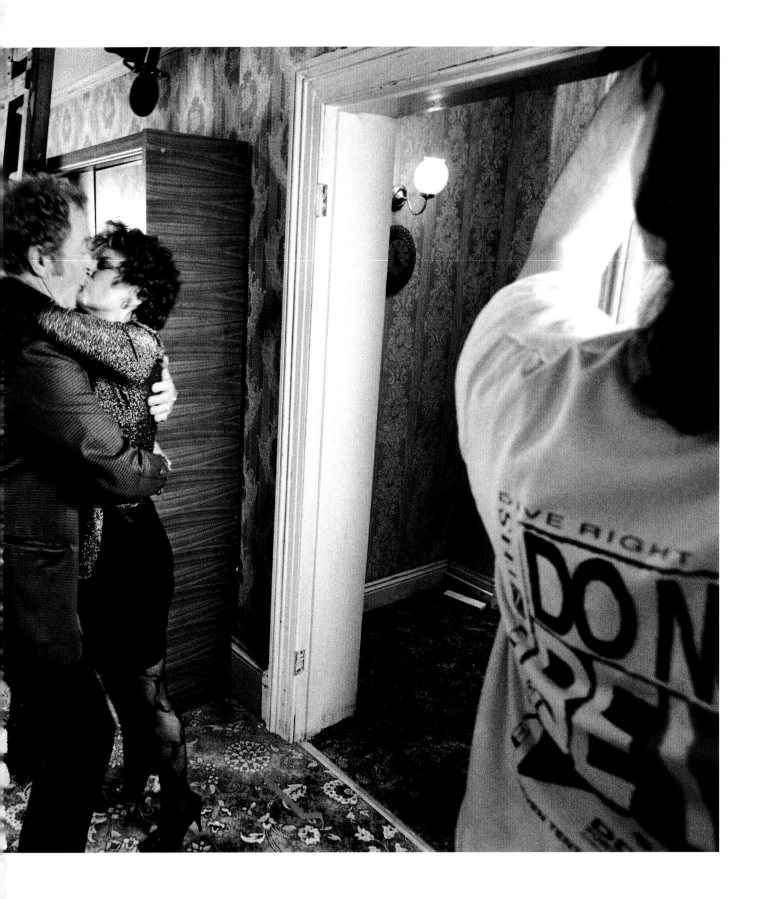

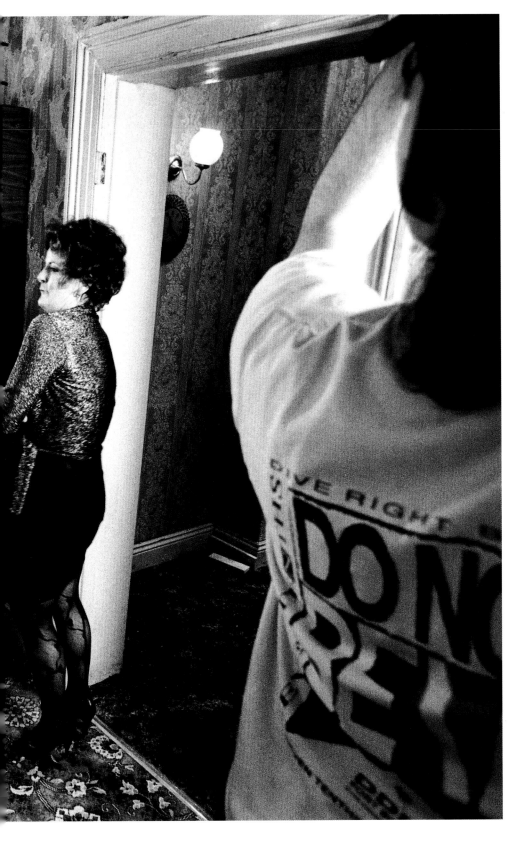

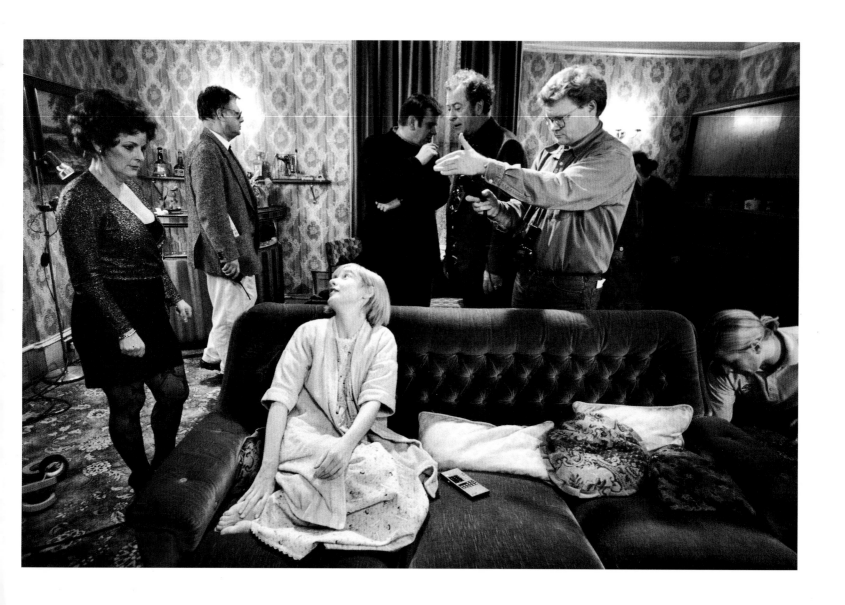

previous pages and above:
Little Voice

inner gatefold:
Michael Caine and
Brenda Blethyn

outer gatefold:
Michael Caine and
Jane Horrocks

above:
Brenda Blethyn, Jane
Horrocks and Michael Caine

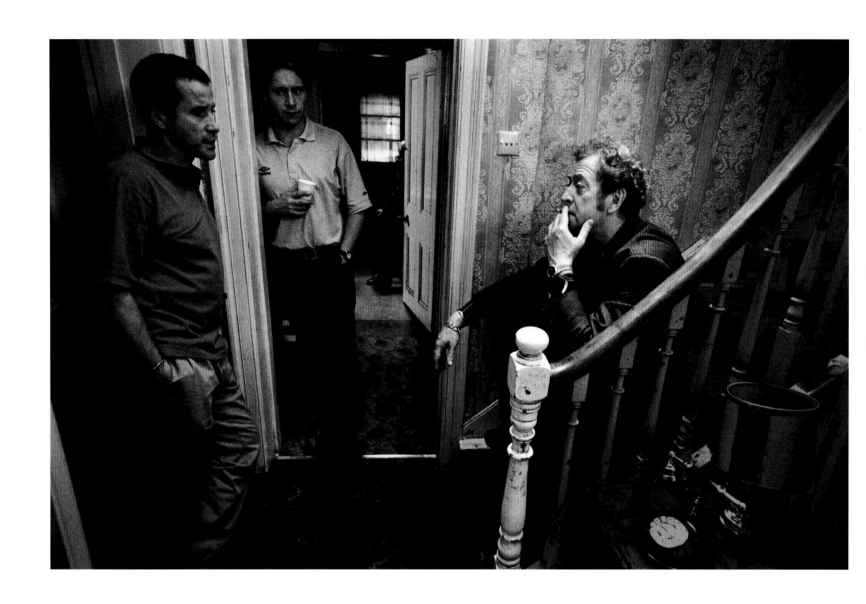

Little Voice
Michael Caine and crew

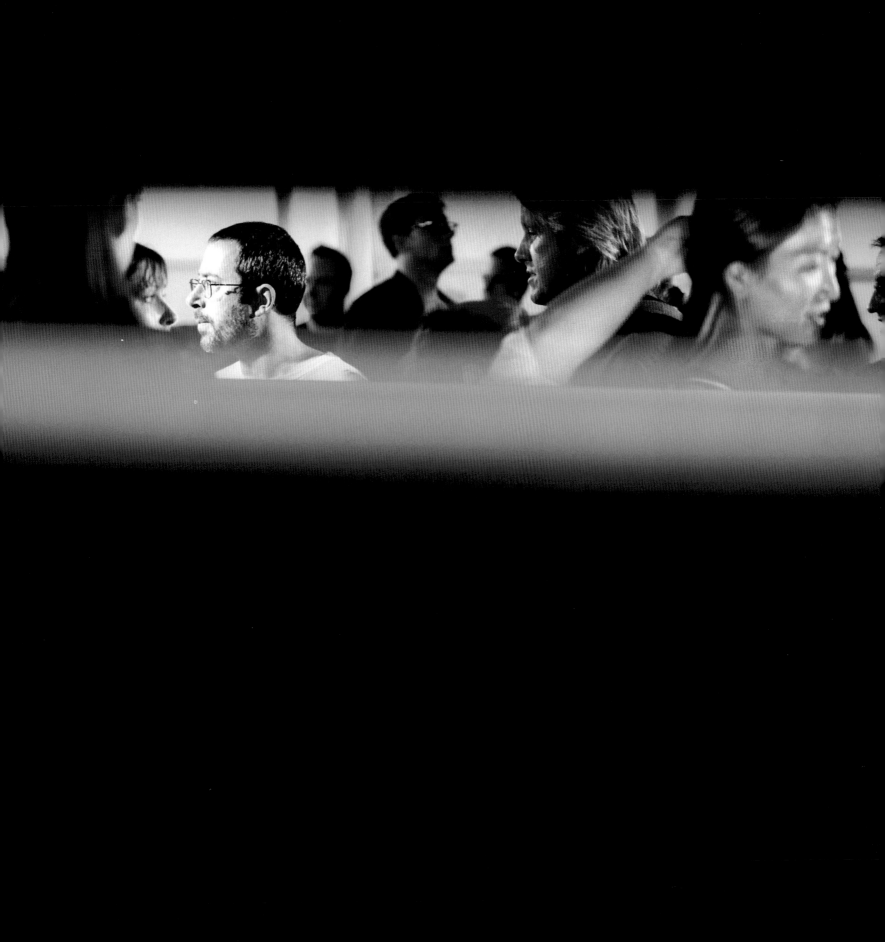

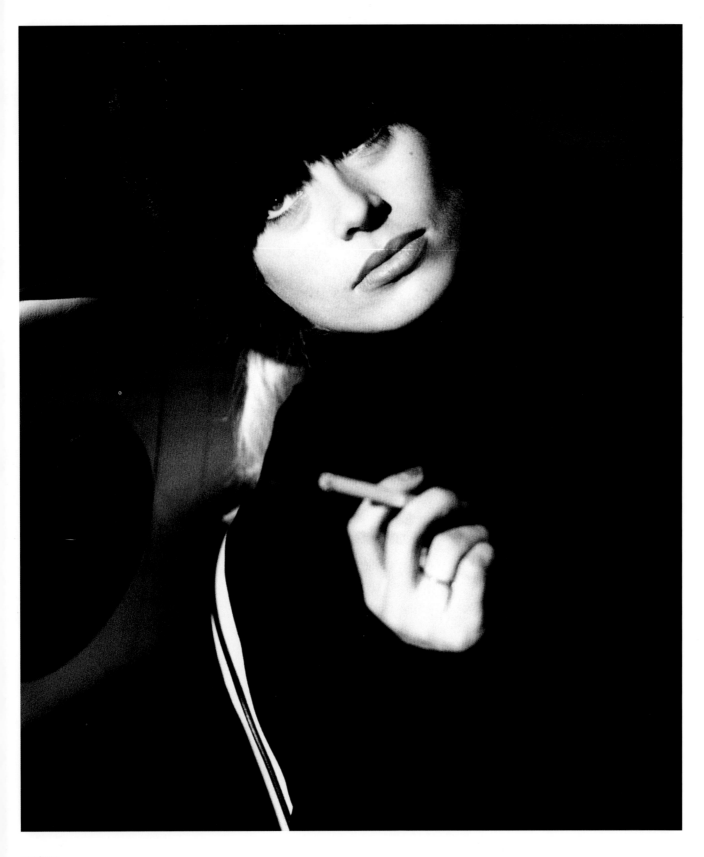

previous:
Maybe Baby
Ben Elton

**Lock, Stock and Two
Smoking Barrels**
Laura Bailey

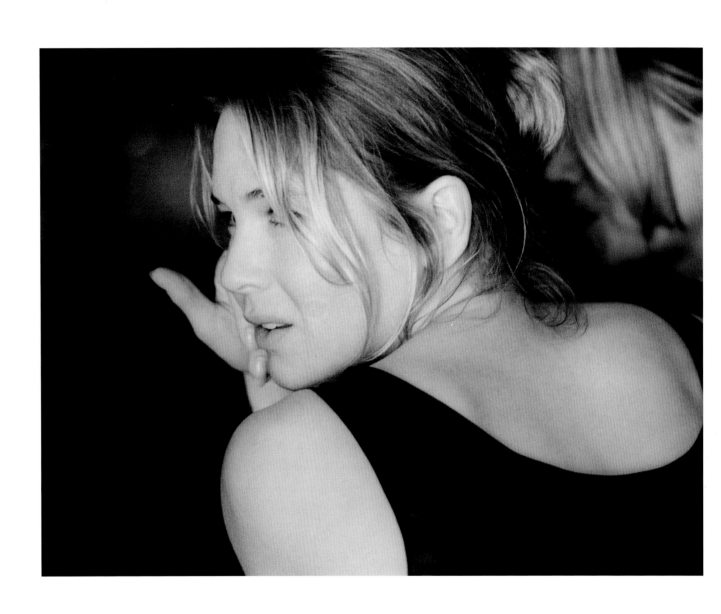

Bridget Jones's Diary
Renee Zellweger

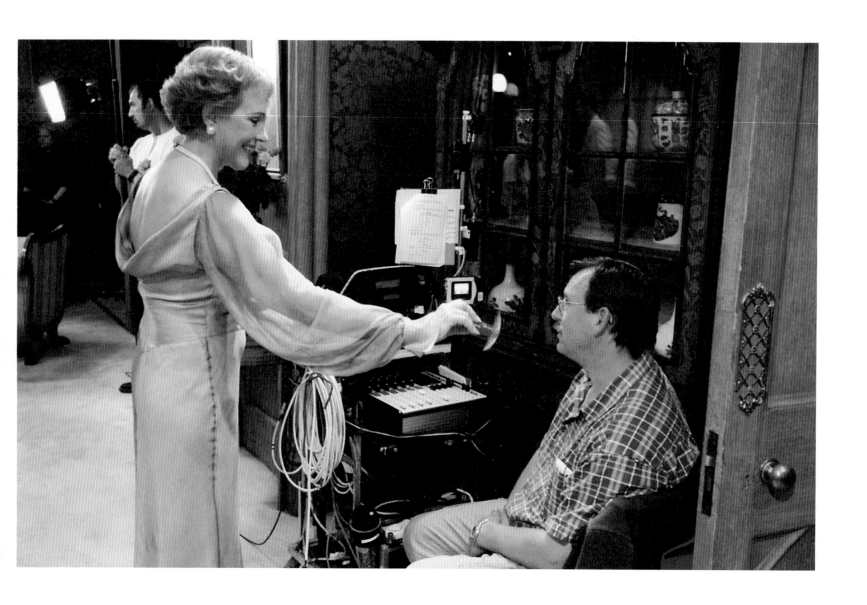

Relative Values
Julie Andrews

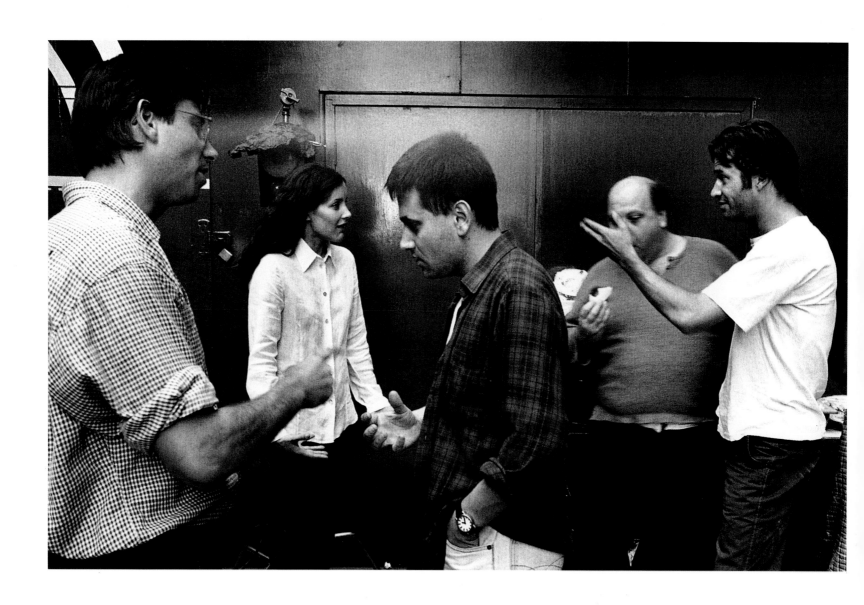

Lighthouse
Members of the cast
and crew

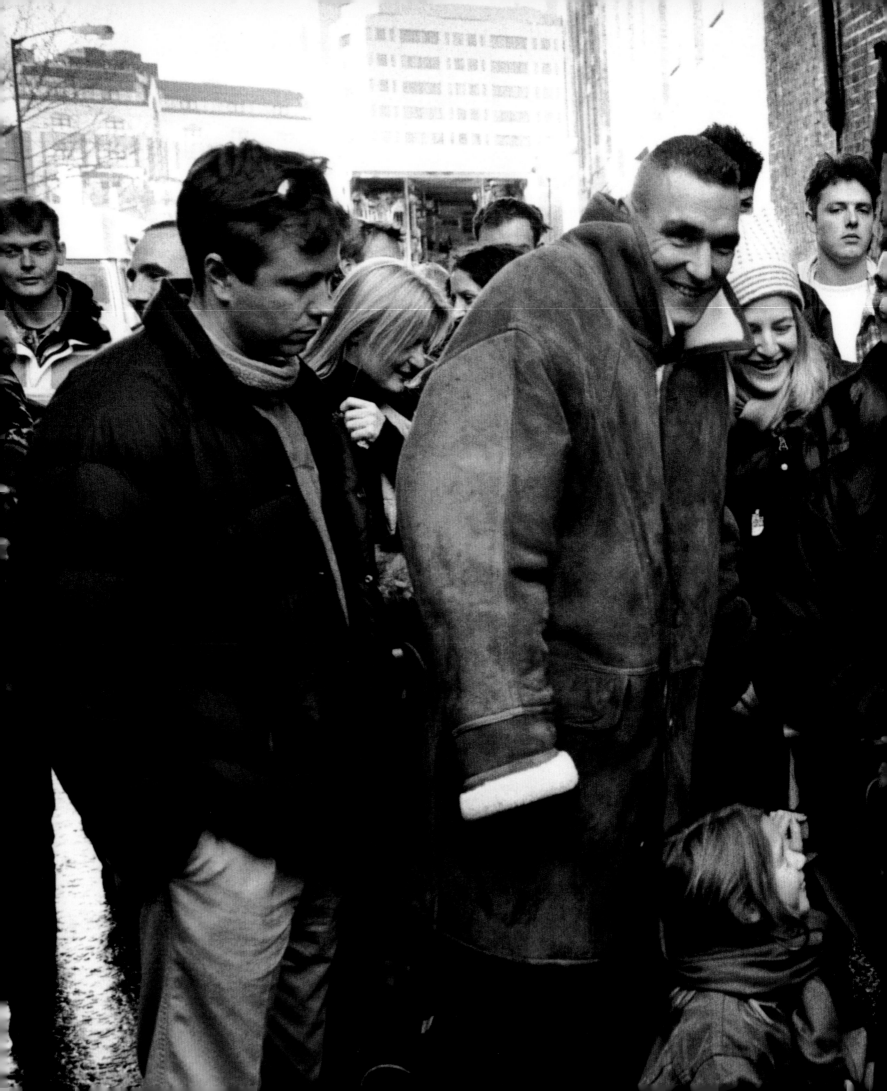

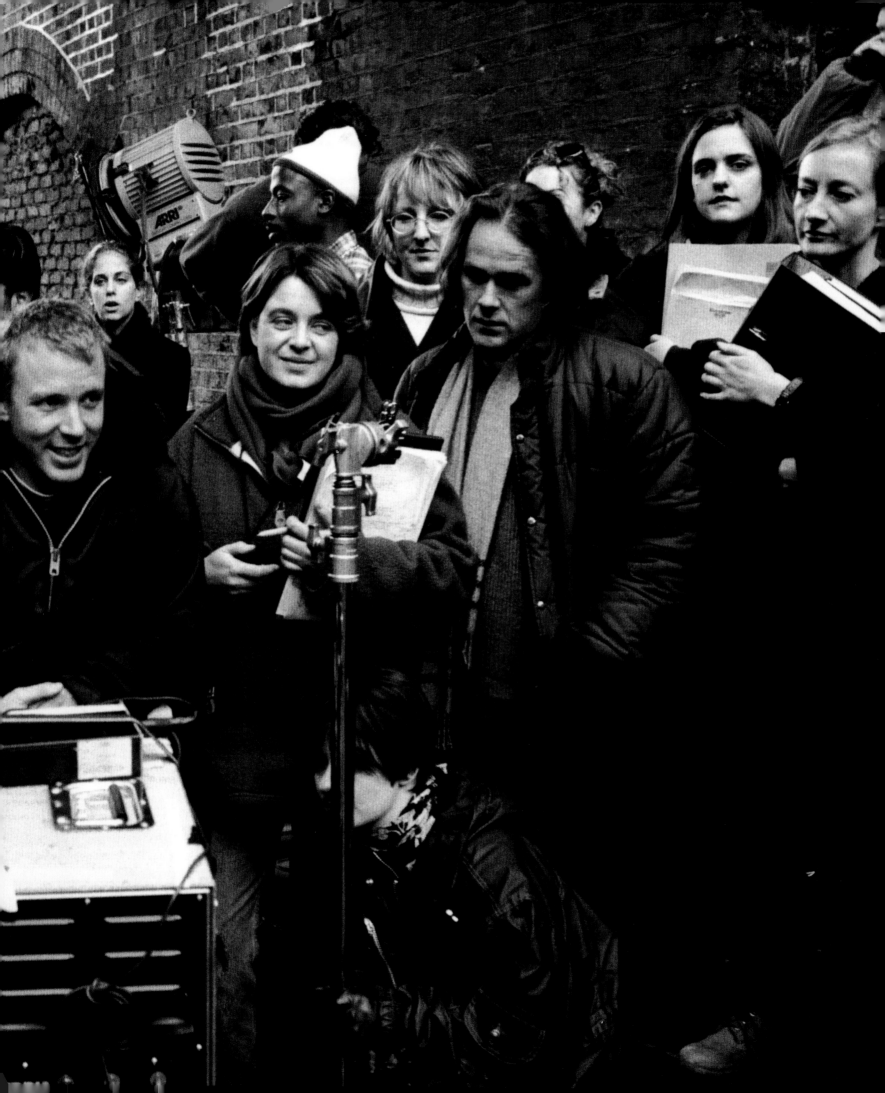

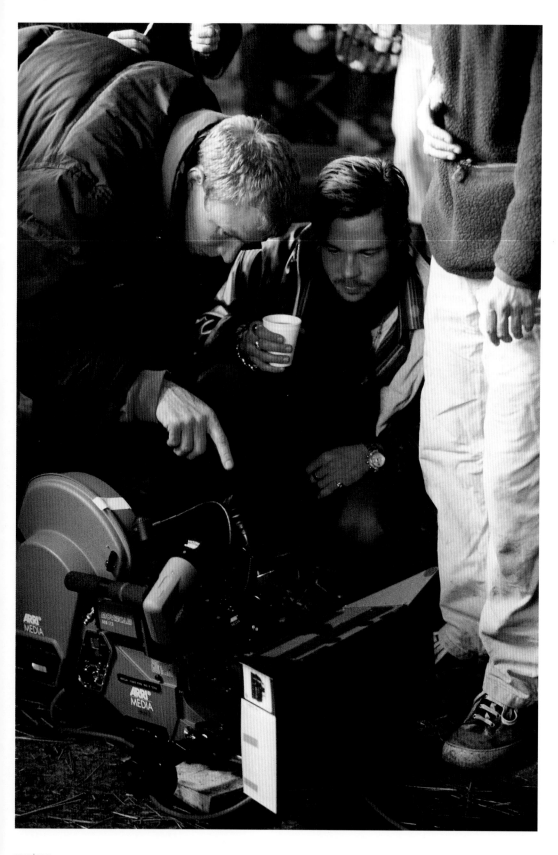

previous:
**Lock, Stock and Two
Smoking Barrels**

Snatch
Guy Ritchie and Brad Pitt

Snatch
Vinnie Jones

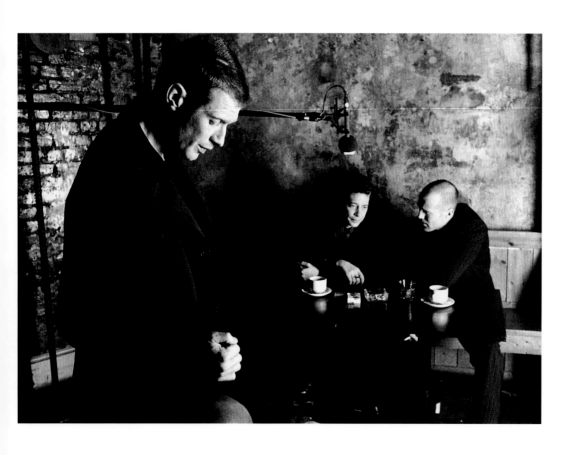

**Lock, Stock and Two
Smoking Barrels**
Jason Flemyng,
Dexter Fletcher and
Jason Statham

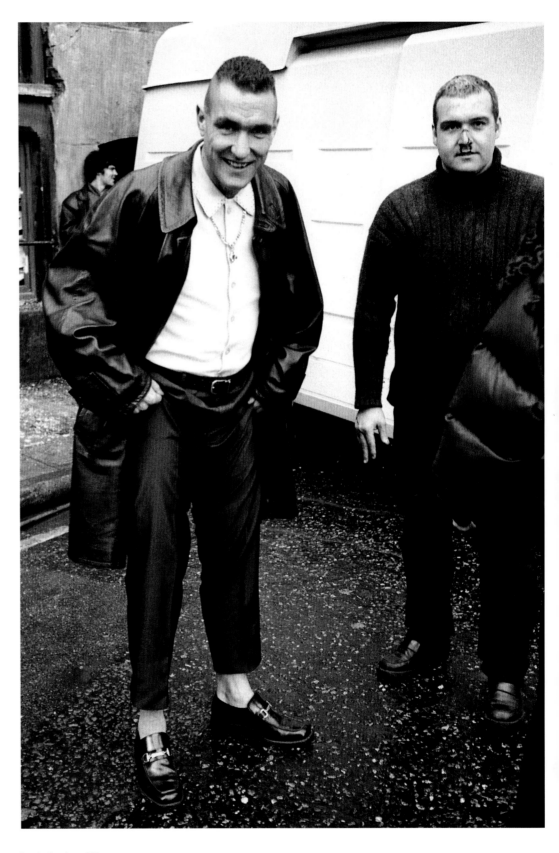

Lock, Stock and Two
Smoking Barrels
Vinnie Jones and
Frank Harper

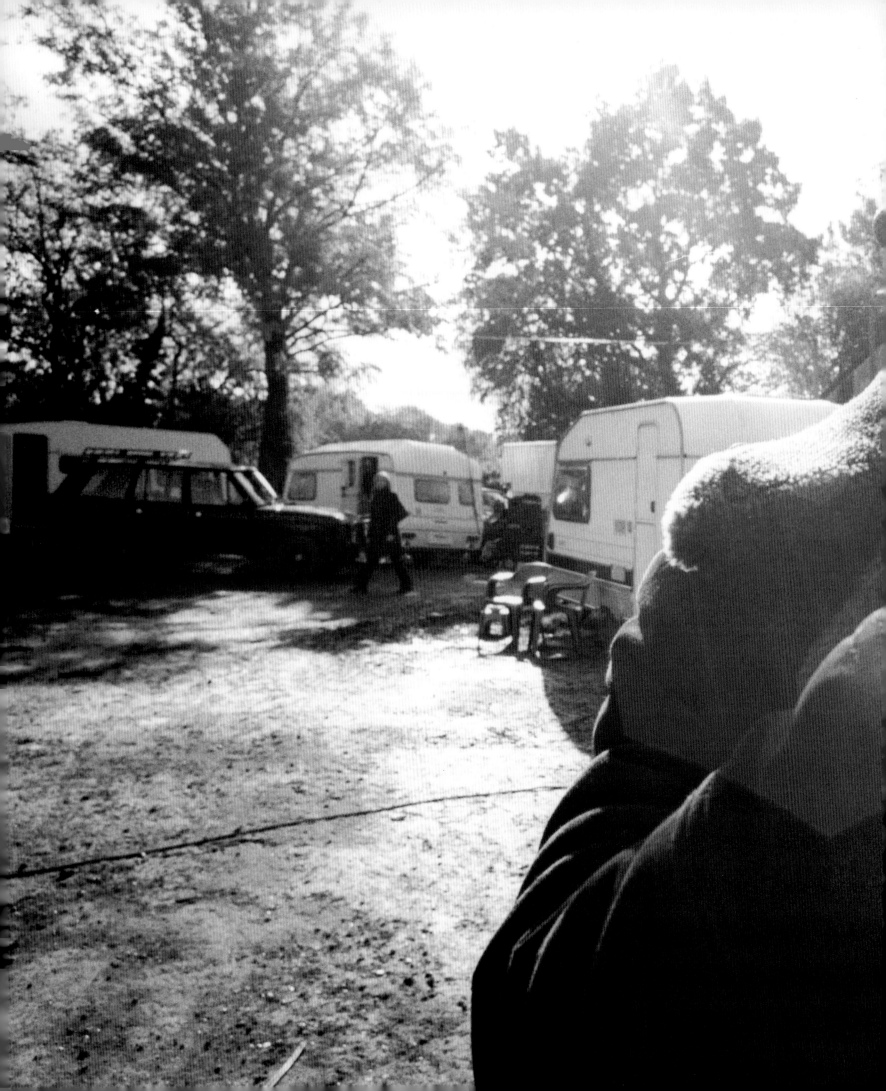

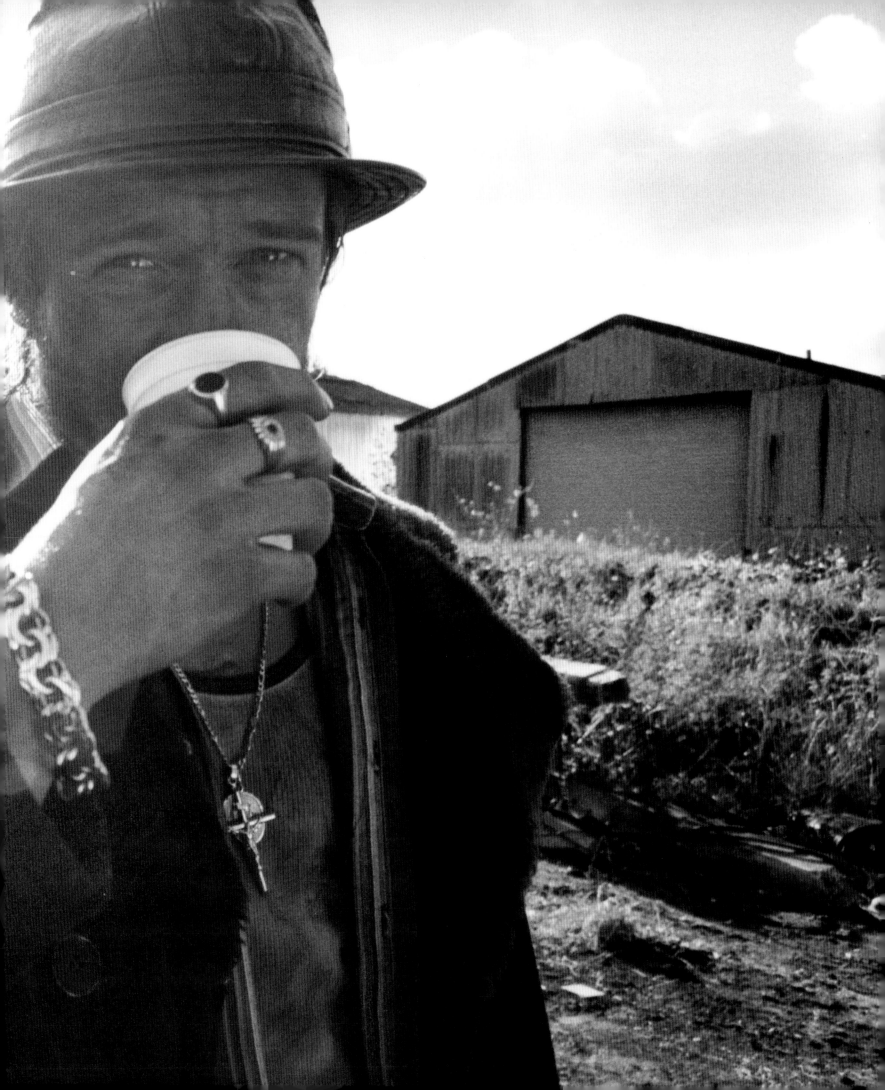

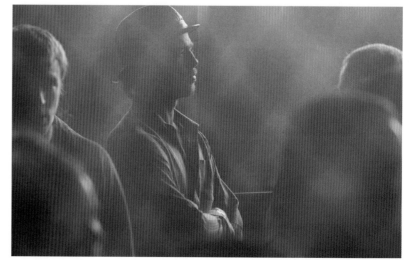

previous and above:
Snatch
Brad Pitt

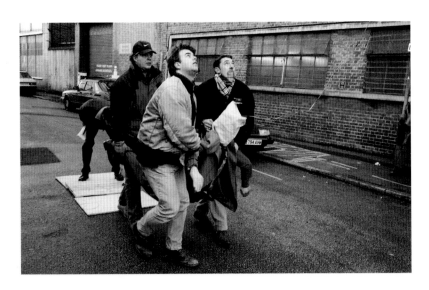
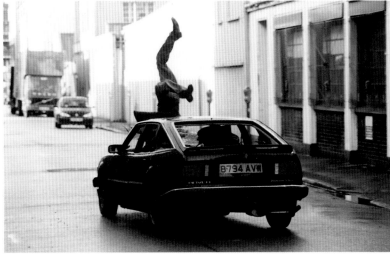
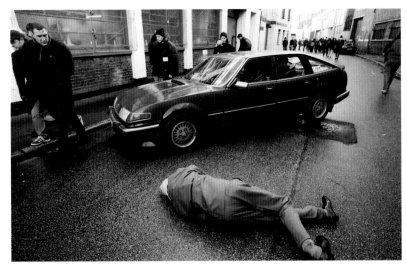
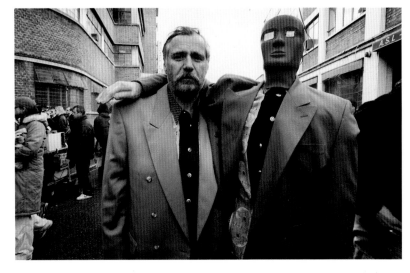

Snatch
Stunt scene

Rade Serbedzija

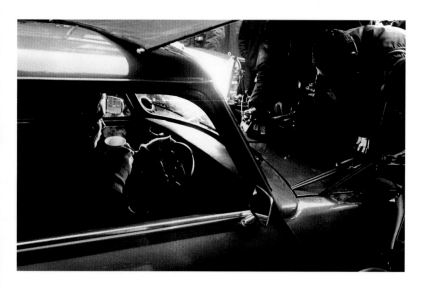

Lock, Stock and Two
Smoking Barrels
Laura Bailey

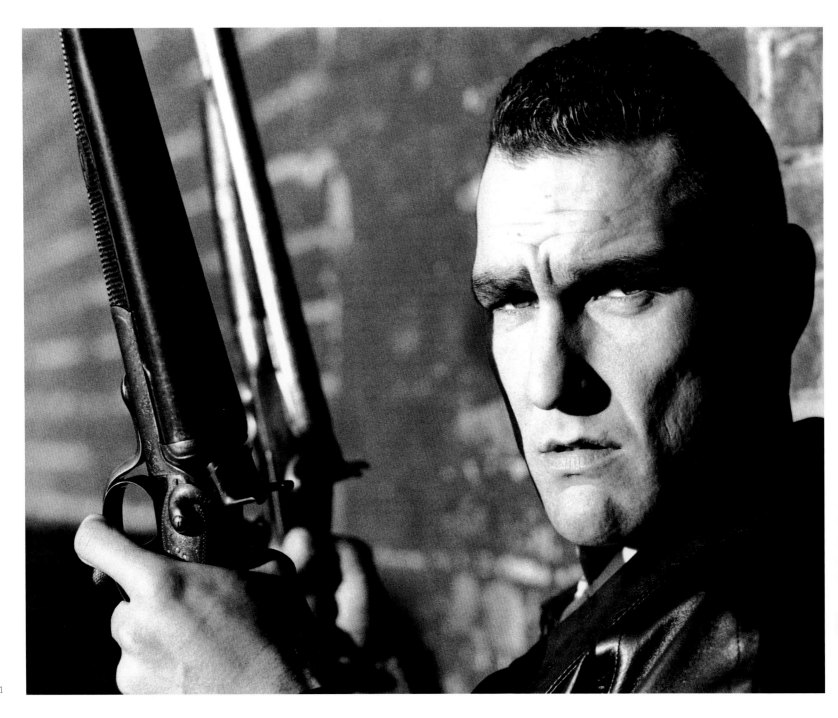

Lock, Stock and Two
Smoking Barrels
Vinnie Jones

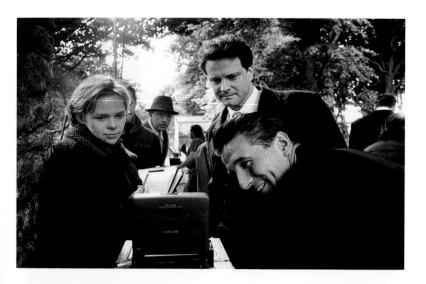

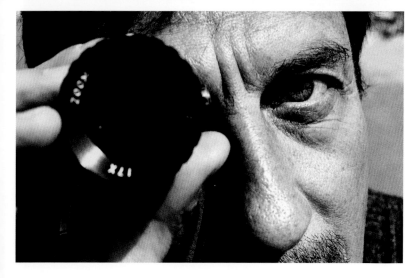

Relative Values
Colin Firth and
William Baldwin

Roland Joffé in Cannes

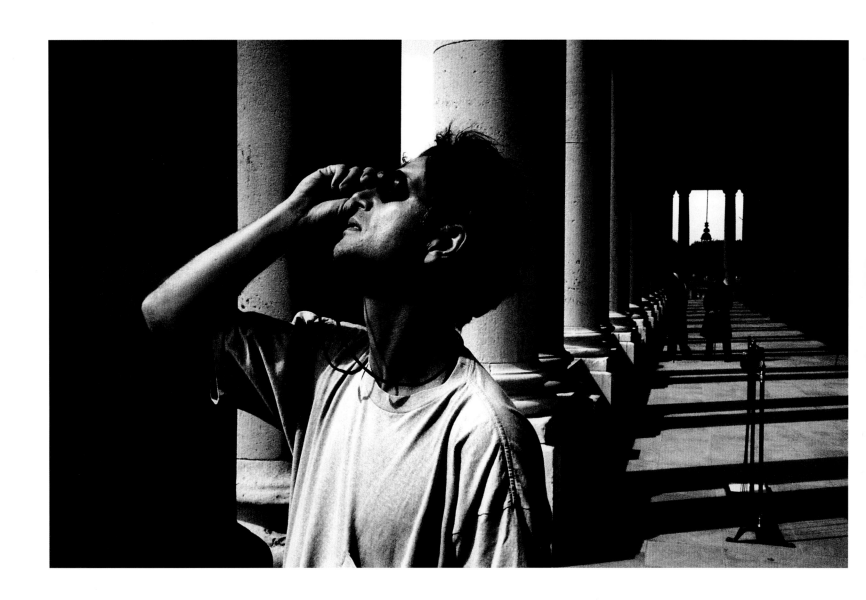

An Ideal Husband
Director of Photography
David Johnson

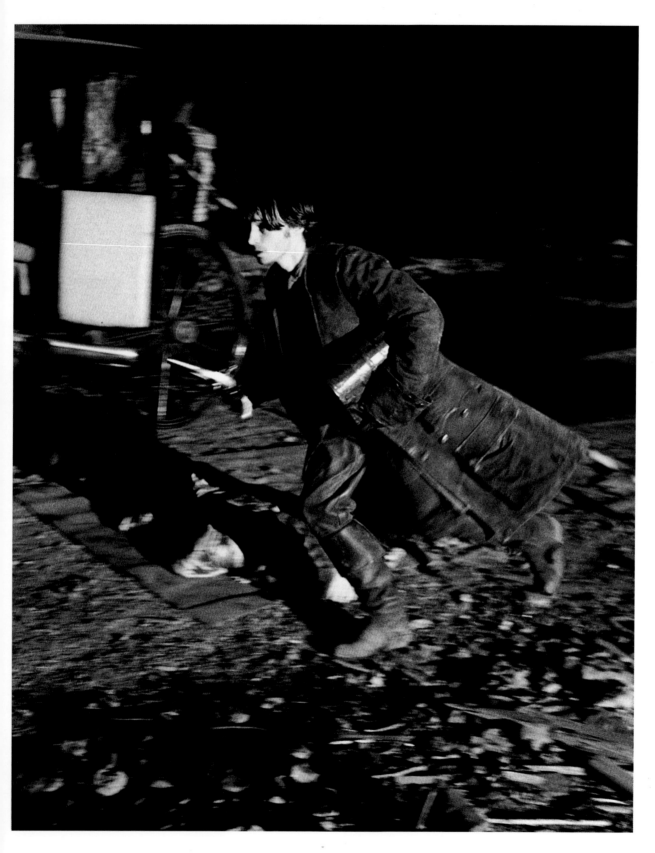

previous and above:
Plunkett and Macleane

Robert Carlyle

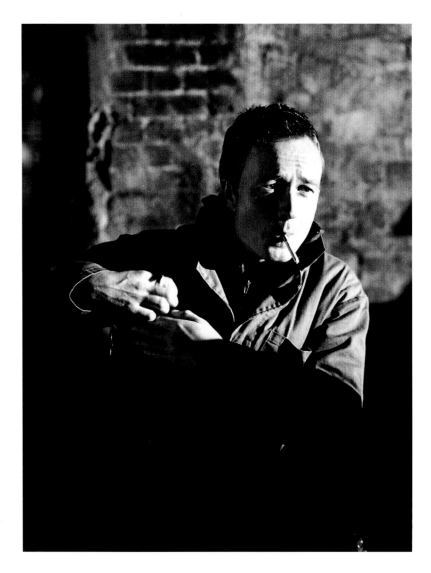

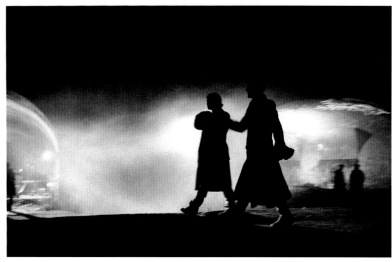

Plunkett and Macleane

top left:
Jake Scott, director

others:
On set

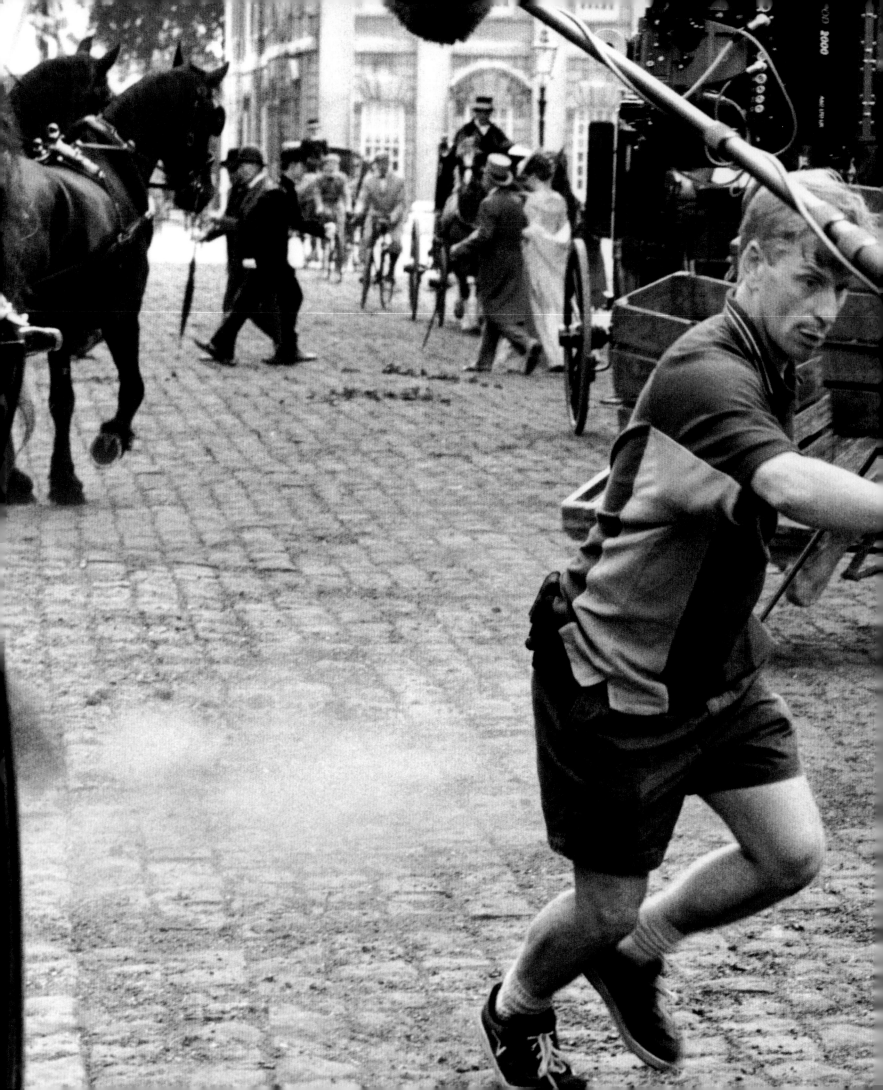

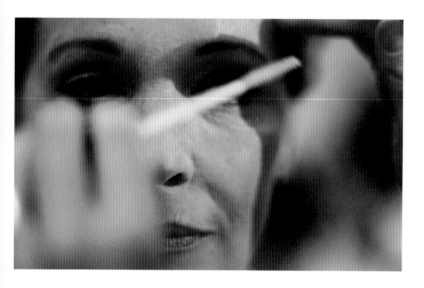

previous:
An Ideal Husband
Action

Relative Values
Julie Andrews

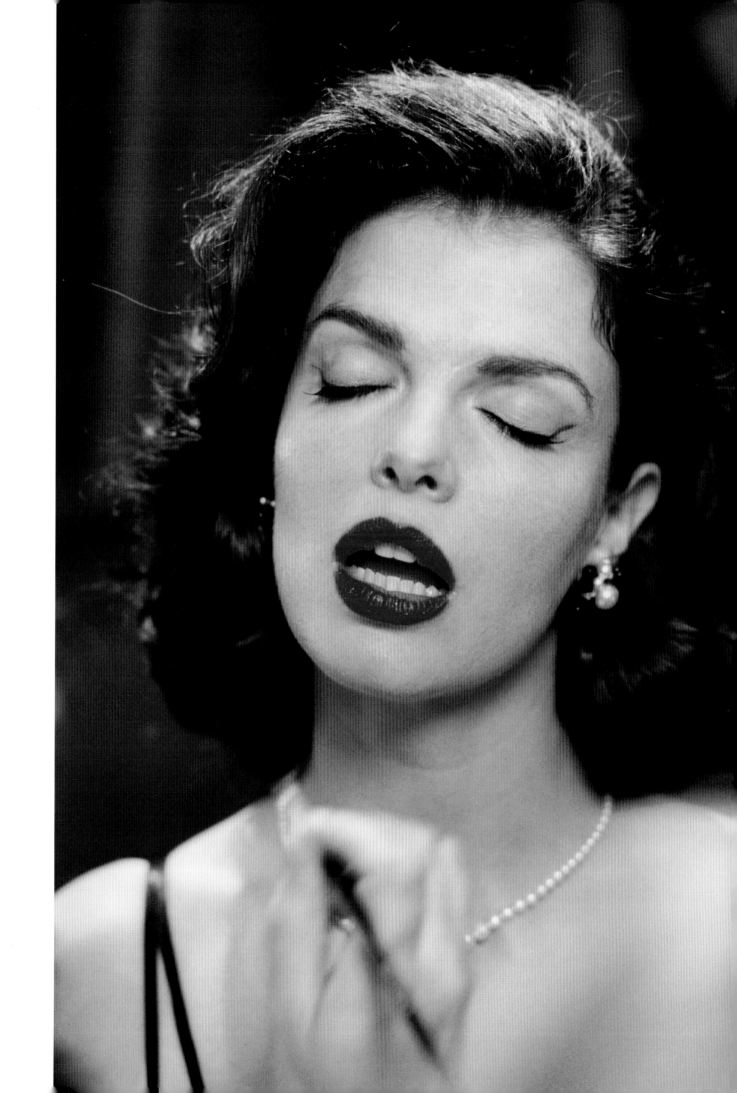

141

Relative Values
Jeanne Tripplehorn

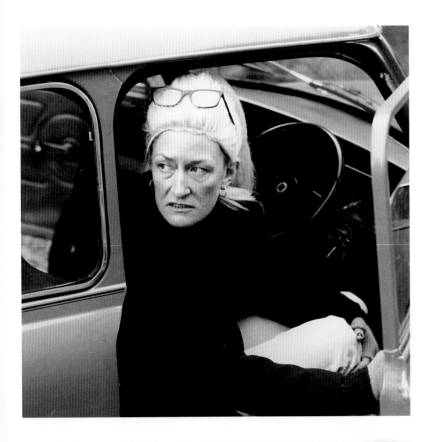

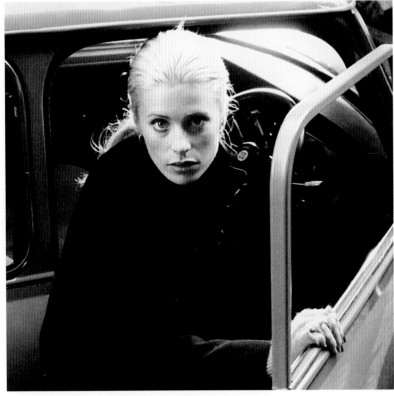

**Lock, Stock and Two
Smoking Barrels**
Stuntwoman

Laura Bailey

Kevin and Perry Go Large
Rhys Ifans

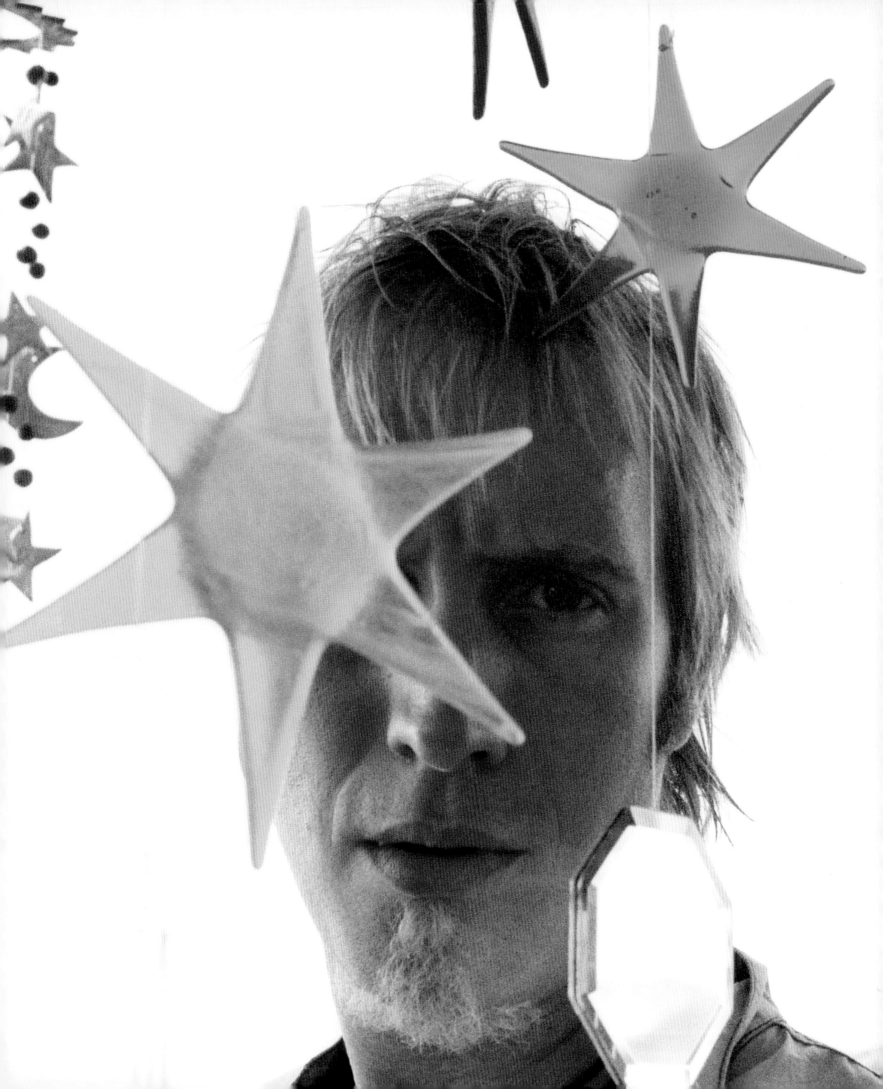

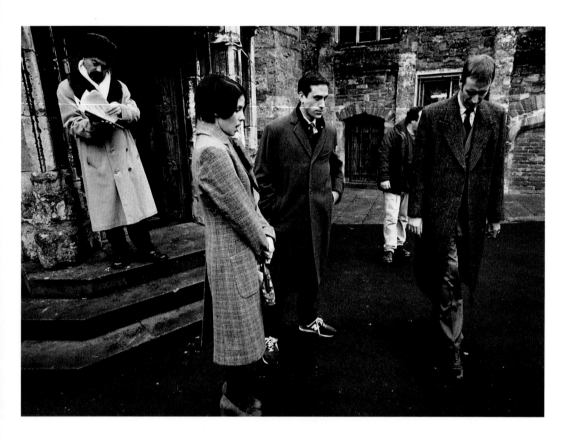

Rancid Aluminium
Keith Allen, Sadie Frost,
Joseph Fiennes and
Rhys Ifans

Sadie Frost

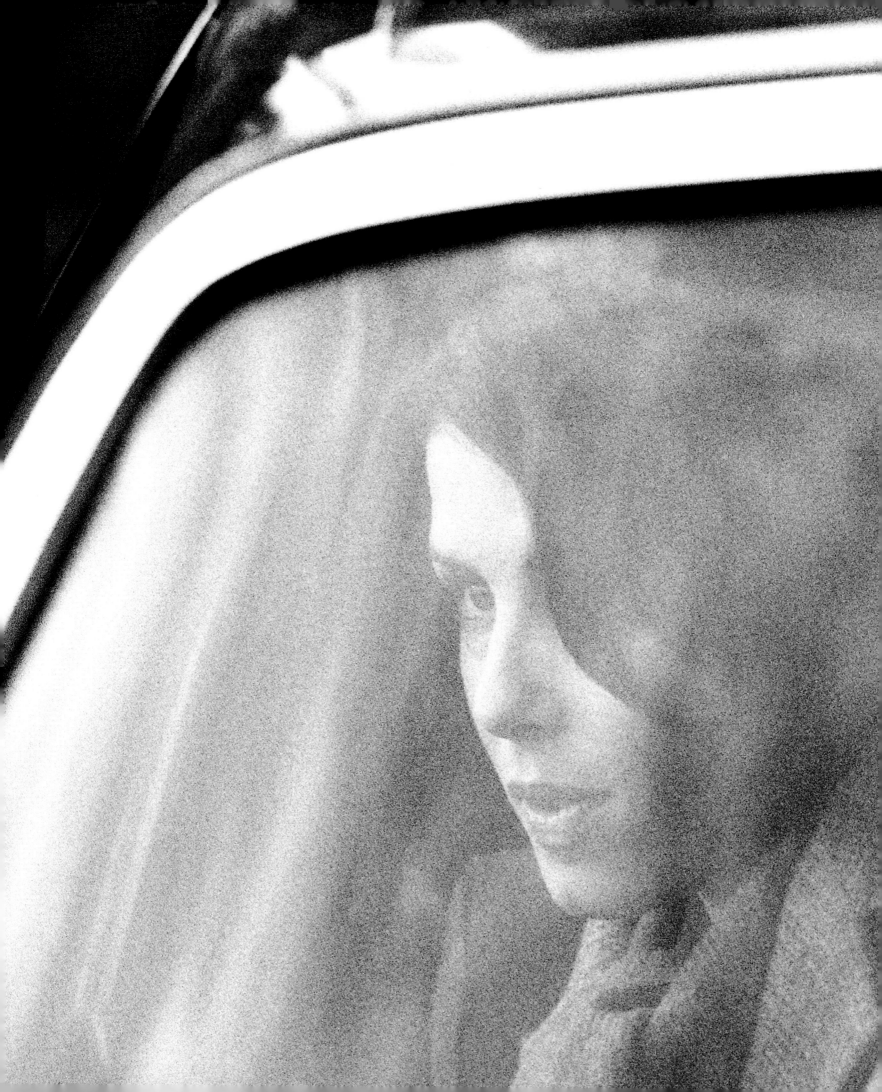

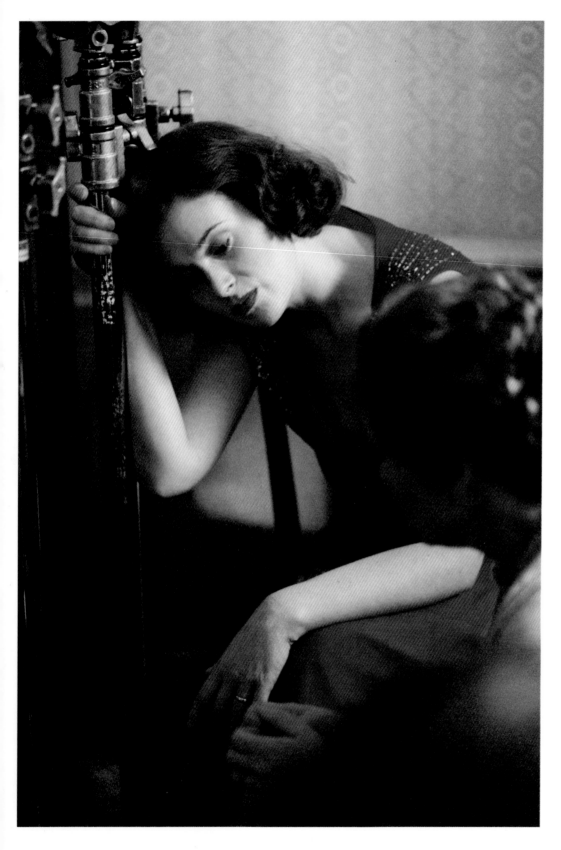

Another Life
Natasha Little

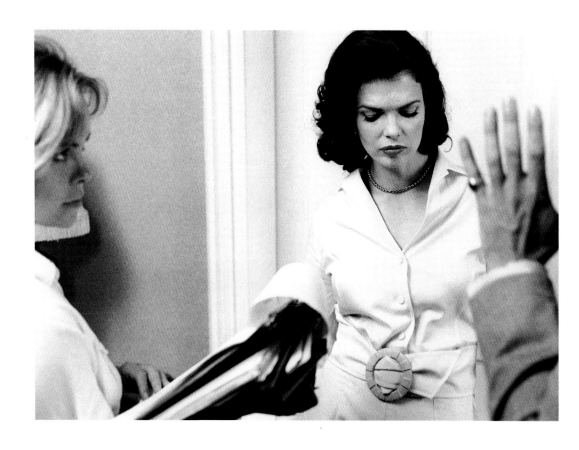

Relative Values
Jeanne Tripplehorn

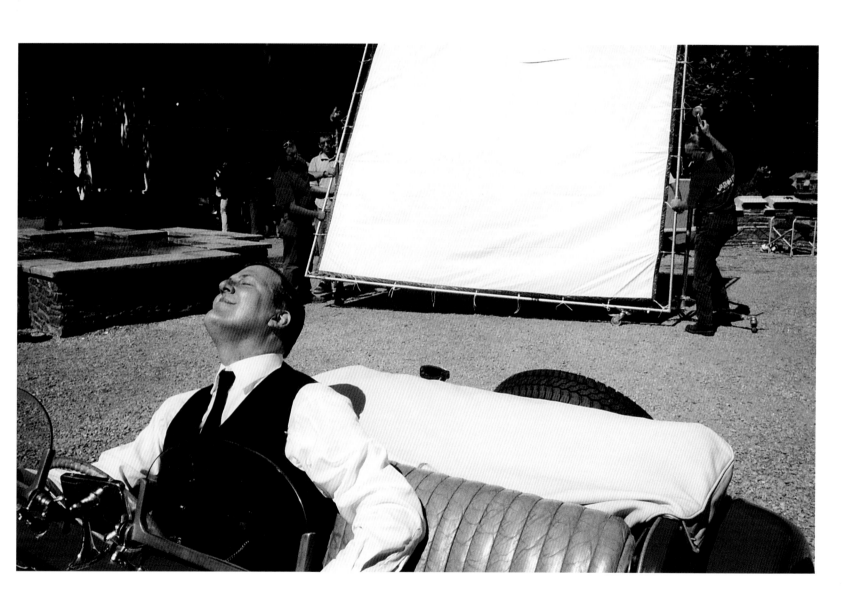

Relative Values
Stephen Fry

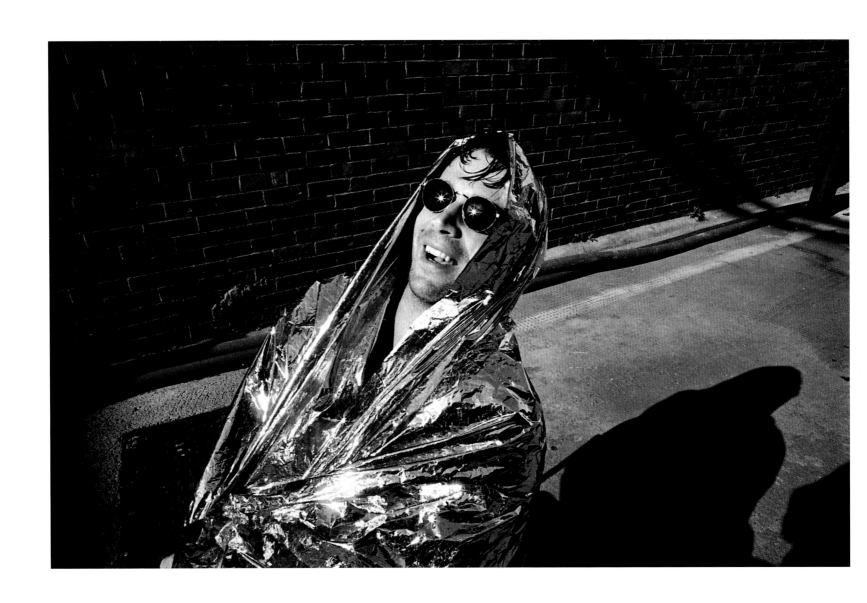

Lighthouse
James Purefoy

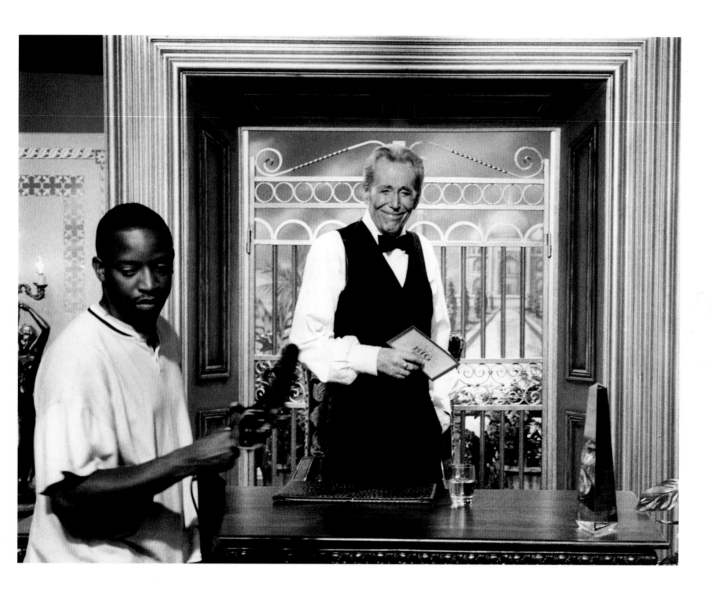

The Final Curtain
Peter O'Toole

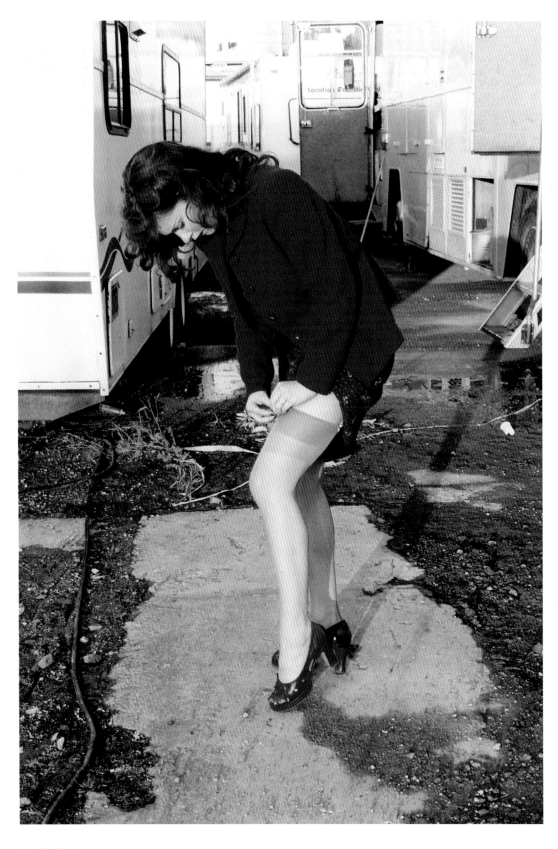

The War Bride
Anna Friel

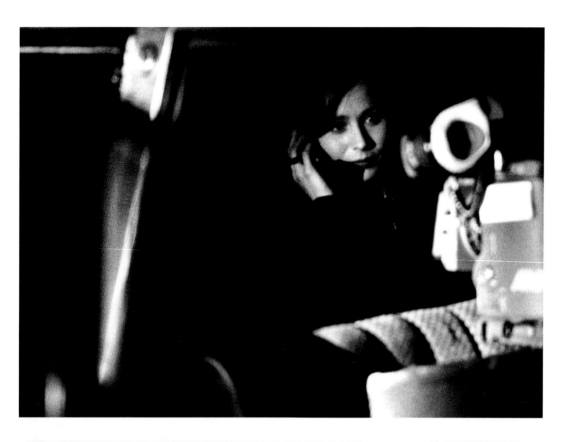

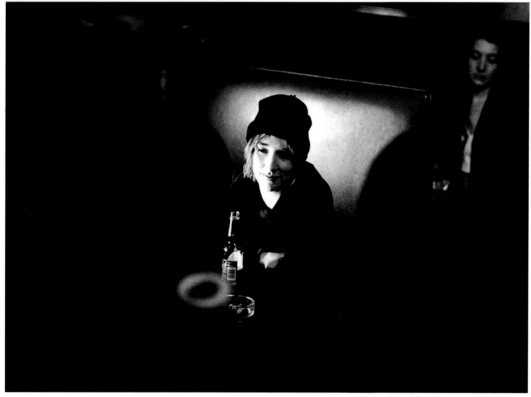

Rancid Aluminium
Tara Fitzgerald

This Year's Love
Emily Woof

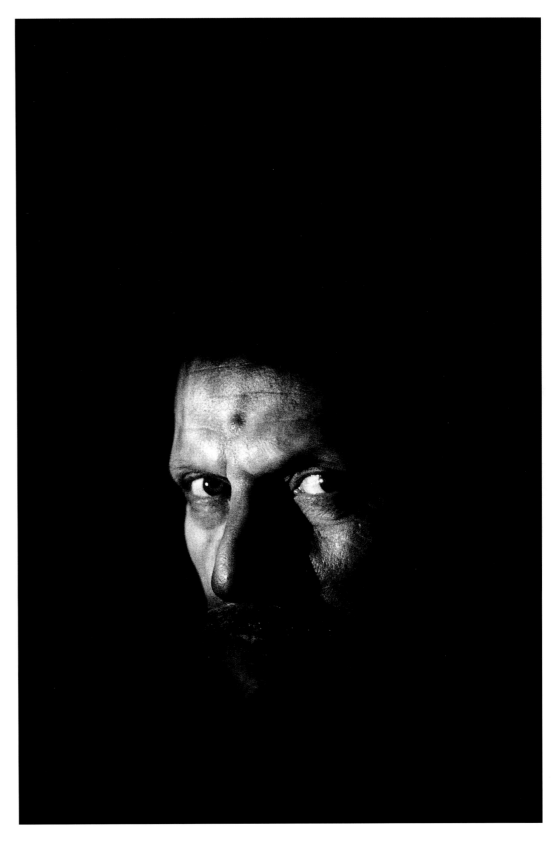

Rancid Aluminium
Steven Berkoff

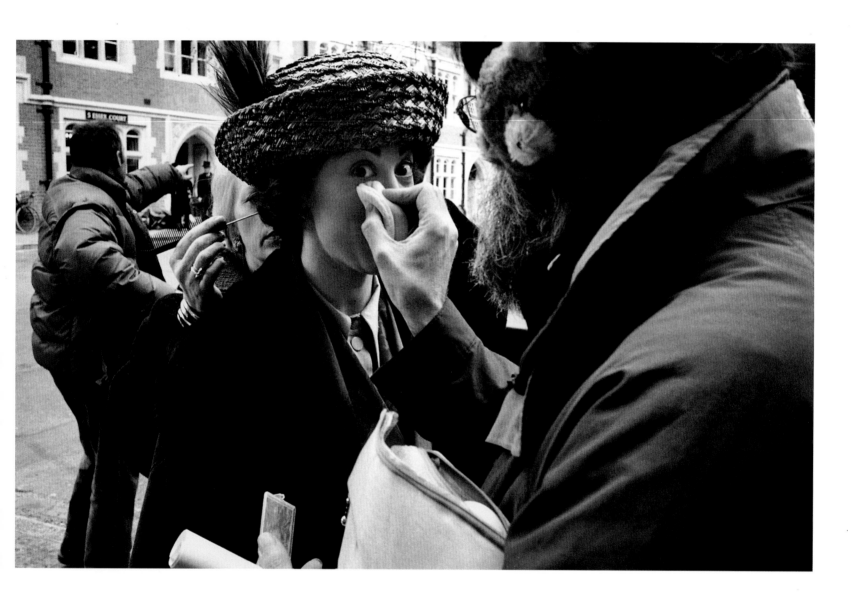

The Winslow Boy
Rebecca Pidgeon

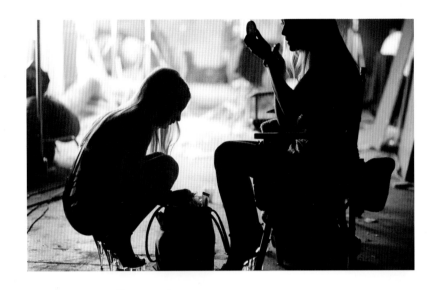

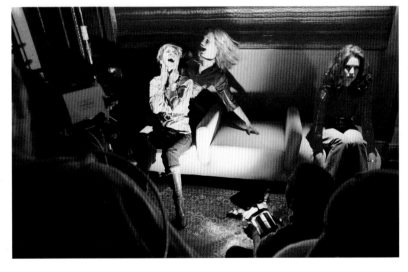

Kevin and Perry Go Large
Twins

Dead Babies
Members of the cast

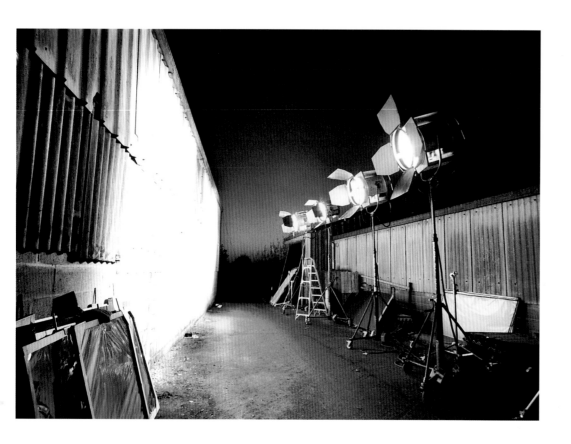

Snatch
Off set

I got my nickname, Nobby, off Griff Rhys Jones. Julie Christie called me 'The Sandwich Man', but then I was pleased to be called anything by Julie Christie.

The true actors are the ones who are just as real, just as vibrant once the cameras are off, once their lunch is ready or the day's done and the beers come out. Eddie Izzard was into everything, he wanted to learn every last technical detail that he could. Gerard Depardieu would just wander into the kitchen and help himself, nosing around the fridge, stirring the sauce. Bruce Willis forked out to keep the set in doughnuts and buns, and Kristin Scott Thomas went paint-balling and laser-questing with the crew. I've loved her ever since. Bob Hoskins holds court, everyone has to stop and listen, whilst Guy Ritchie buys the rounds (you'd be surprised how many don't). He says, 'Look, I'm not being funny, but I earn more than you.'

On set there's usually a fantastic atmosphere, but the different groups don't merge together that much. Stuntmen, many of whose fathers were stuntmen too, are true gentlemen and concentrate on the carbohydrates. There's the riggers, the meat-and-two-veg boys, and then the camera crew. Then of course, at the top – the set is a great place for hierarchy – are the actors. At that level, whatever they want to eat they get, whether it's the Hay Diet or carbohydrate-, dairy-, gluten- or fat-free food.

A set is a military operation, and soldiers march on their stomachs. Some of the sets take your breath away. Gladiator had thousands of extras, being shipped about in great armies of people carriers. They had to install traffic lights in this forest and barracks of shower units for the crew.

Nobby Foley
Fayre Do's film catering

BREAKS

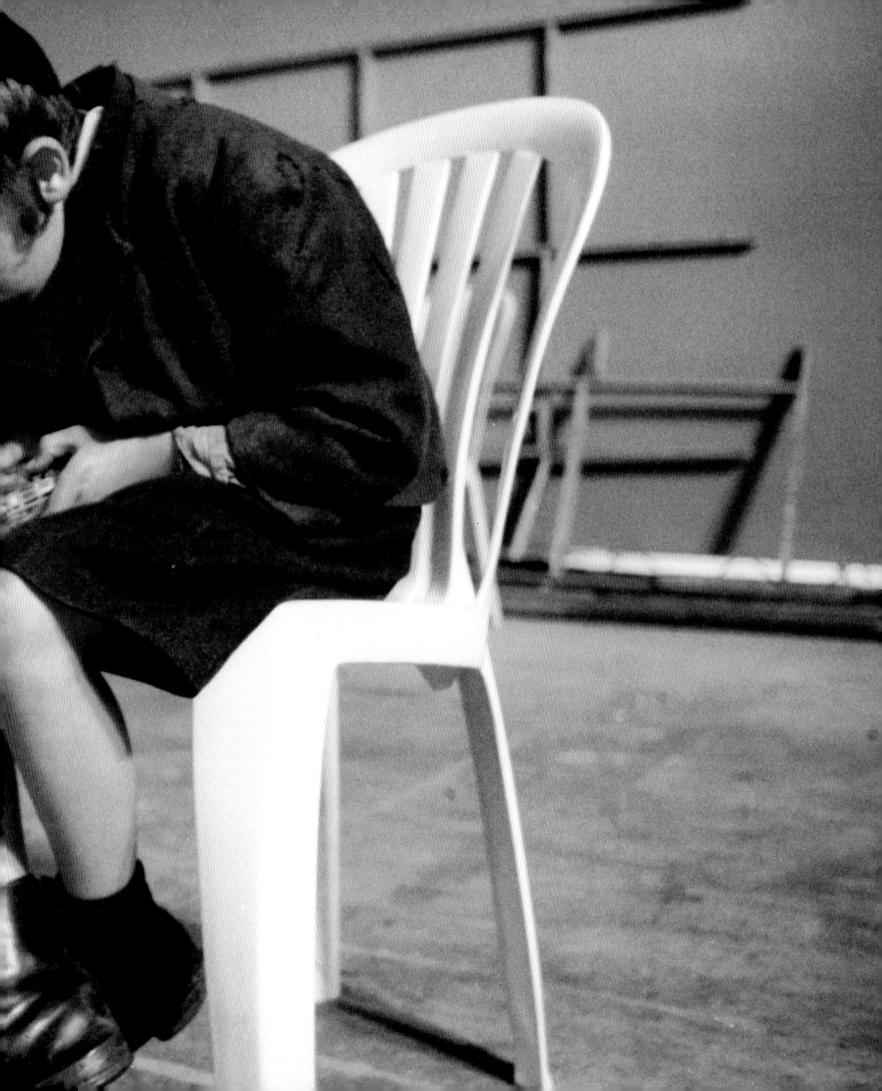

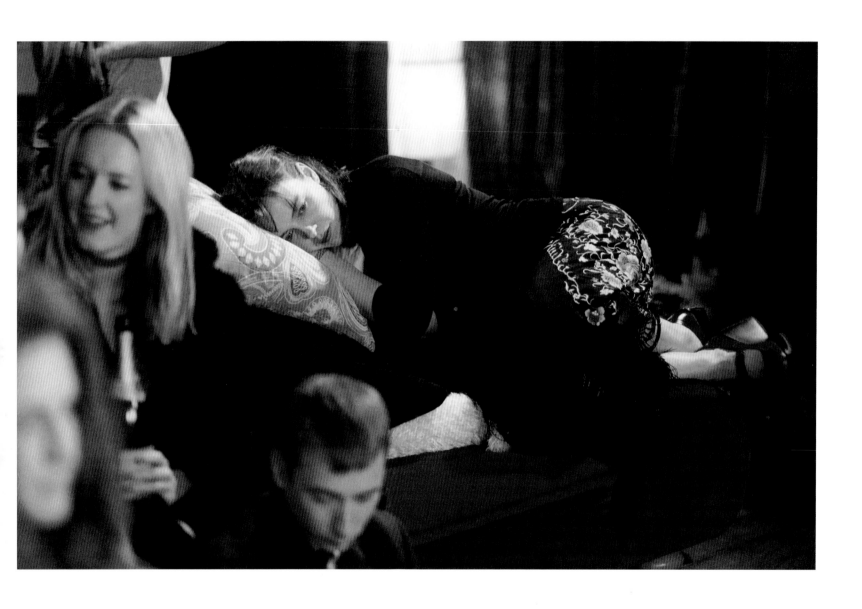

previous:
Simon Magus
Extras on a break

Dead Babies
Olivia Williams

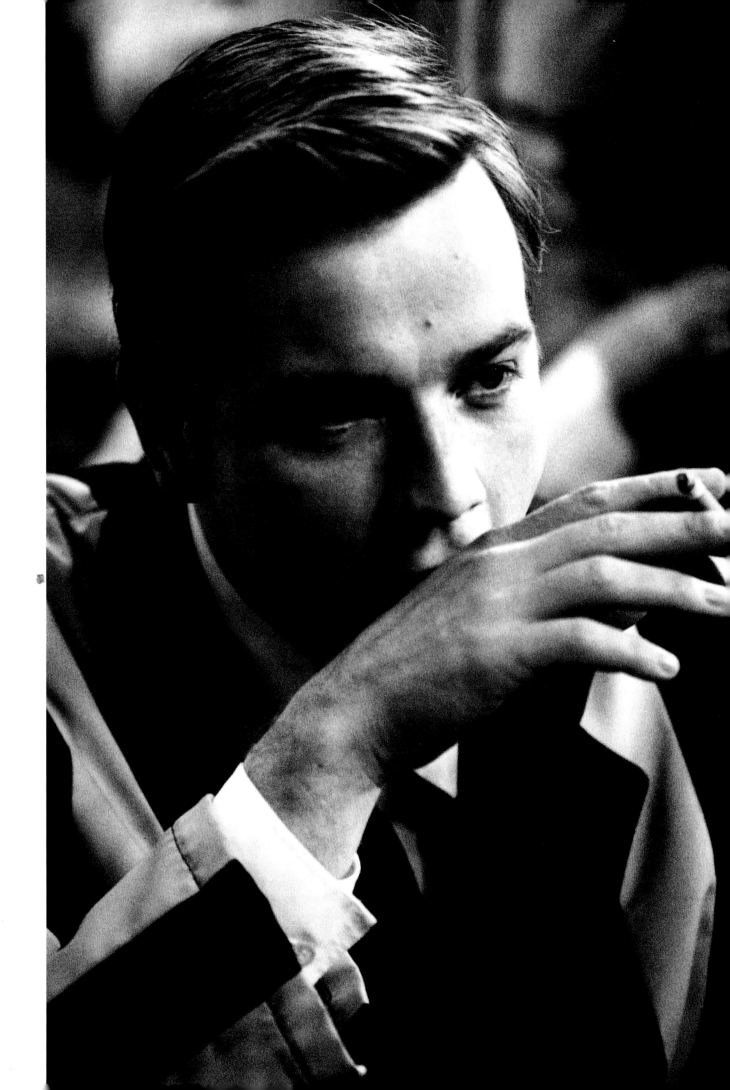

Rogue Trader
Ewan McGregor

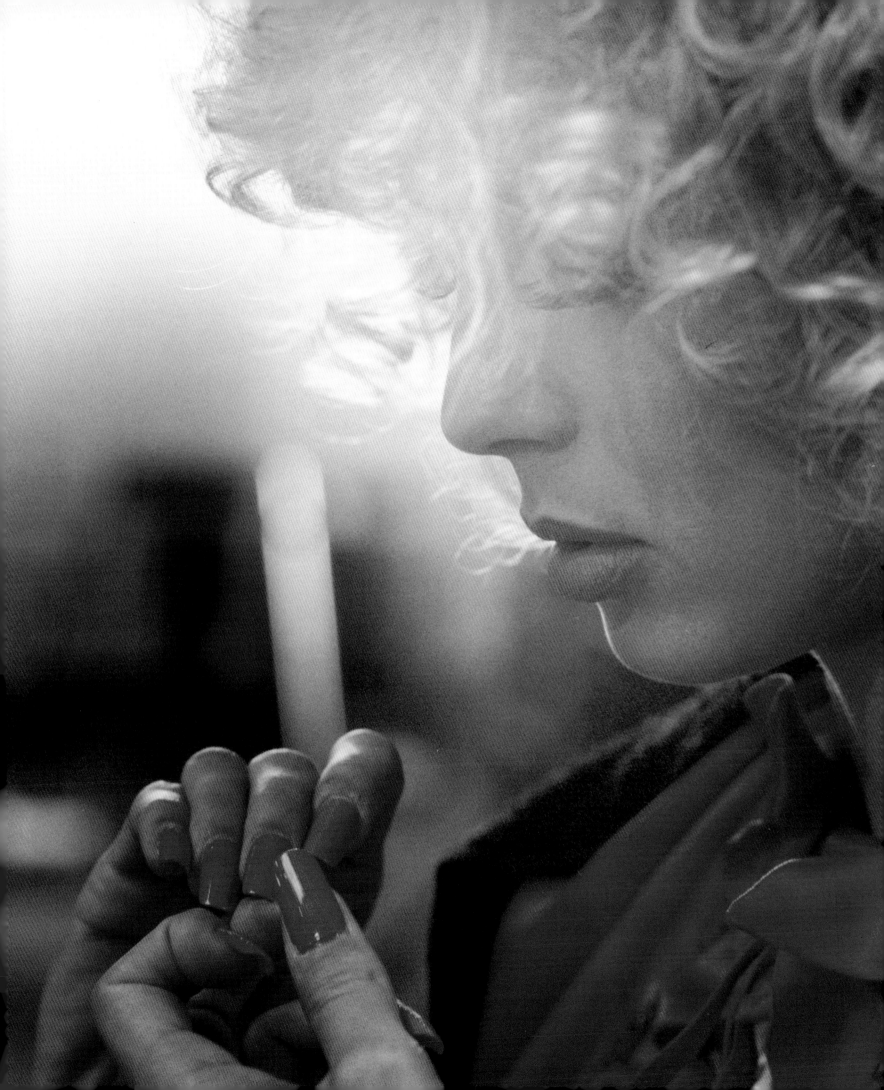

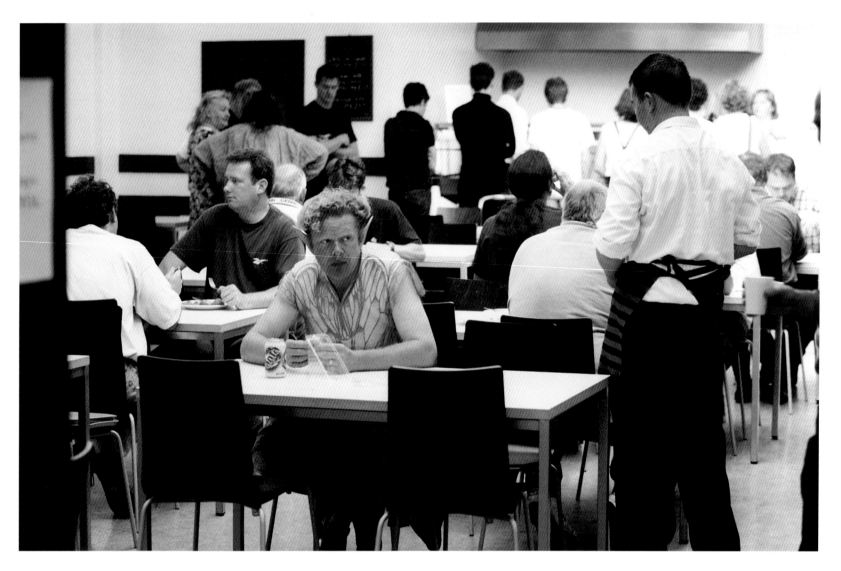

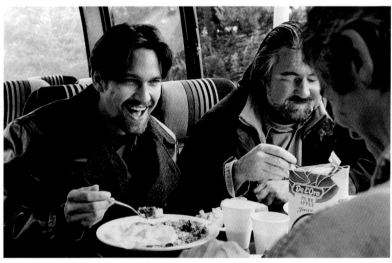

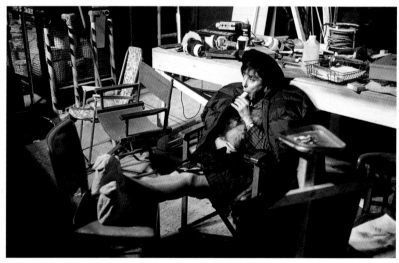

previous:
Blow Dry
Heidi Klum

above:
Shepperton Studios Canteen

Gregory's Two Girls
Dougray Scott

East is East
Extra
›

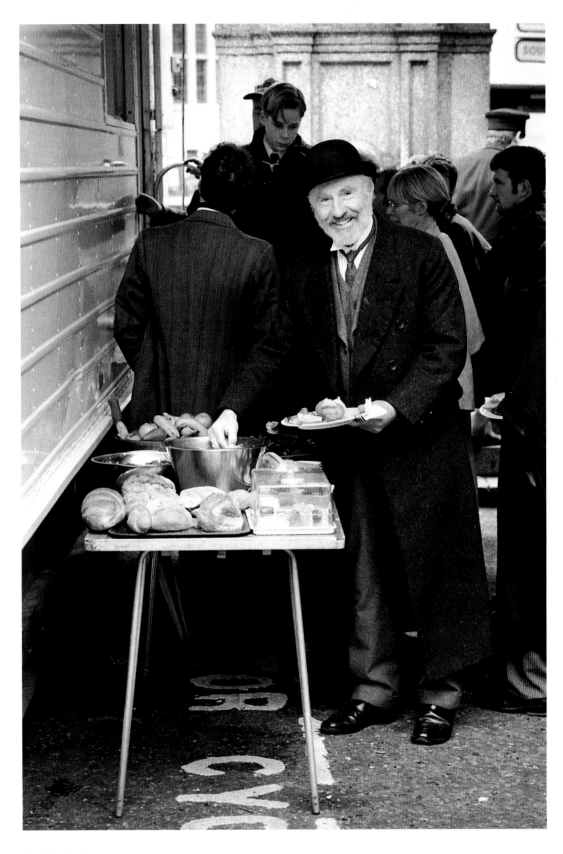

The Winslow Boy
Nigel Hawthorne

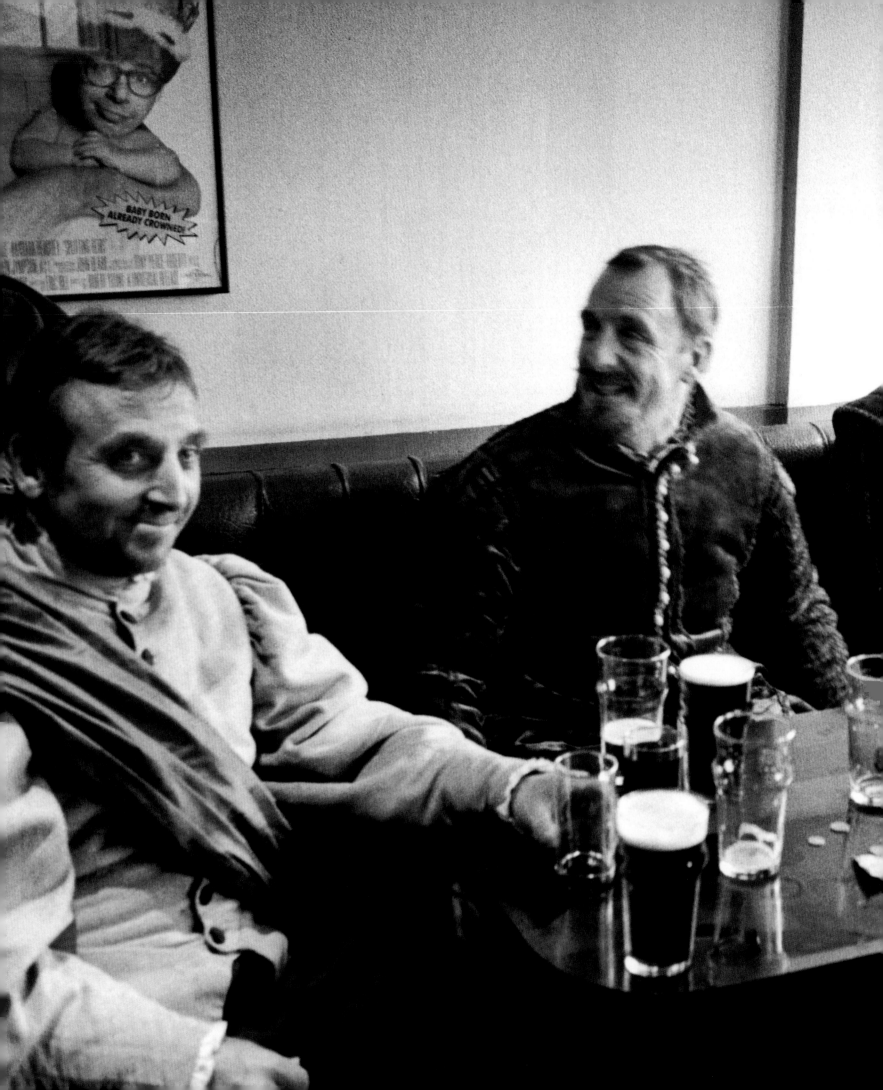

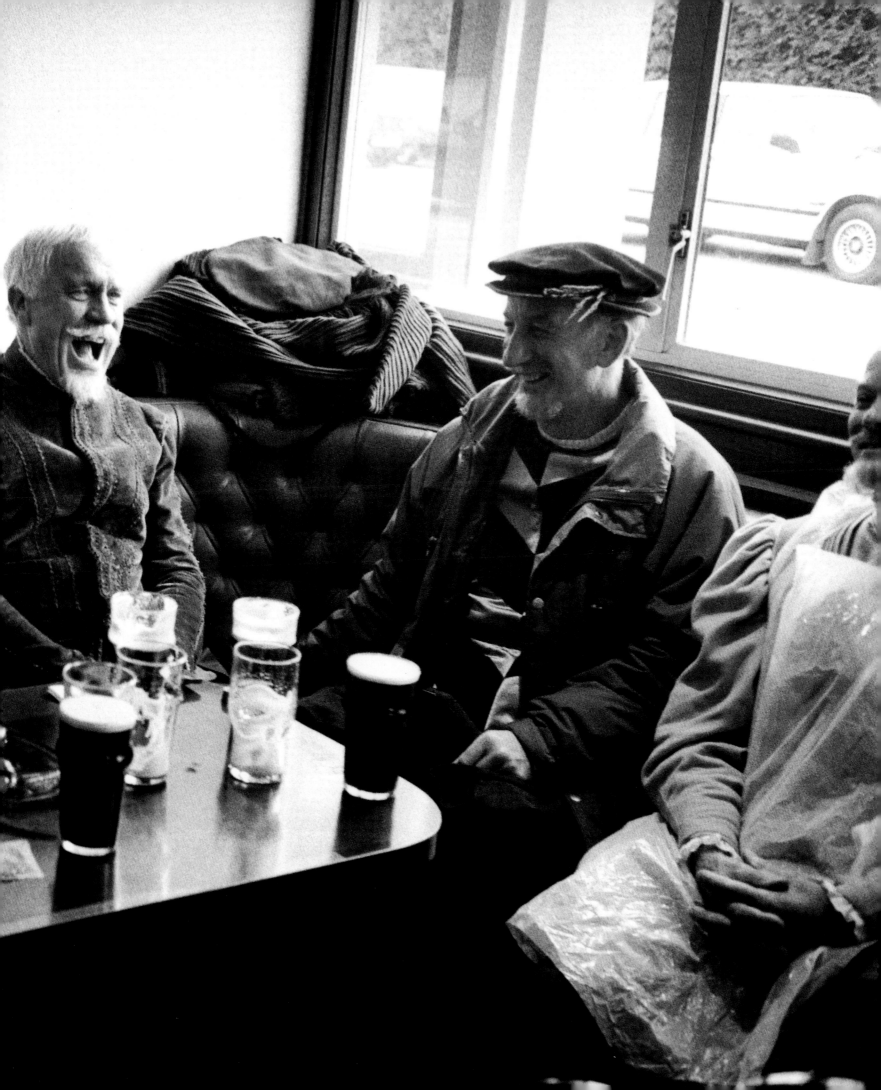

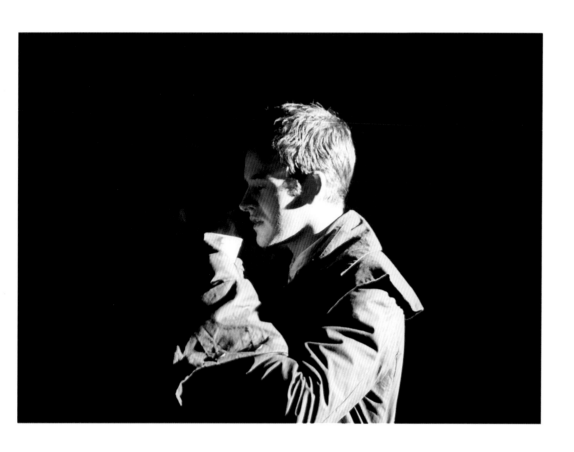

previous:
Elizabeth
Extras in Shepperton bar

Plunkett and Macleane
Jonny Lee Miller

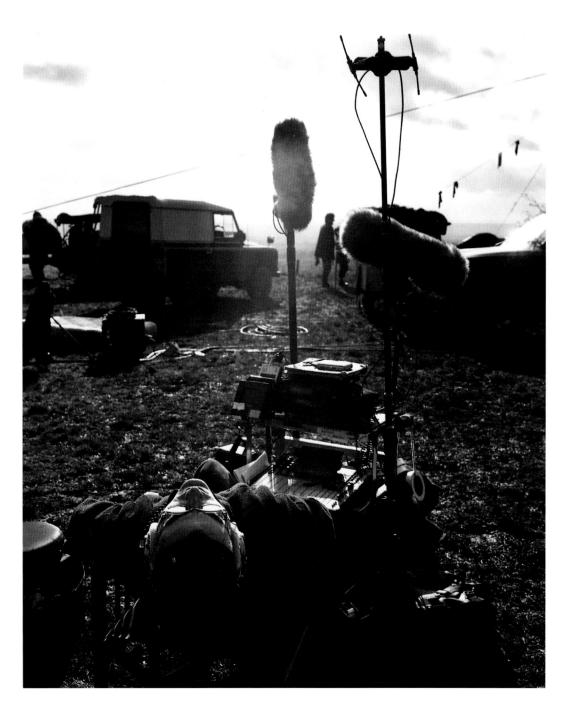

Milk
Soundman

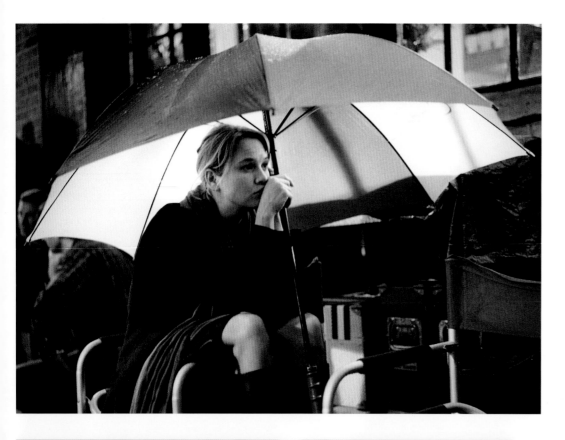

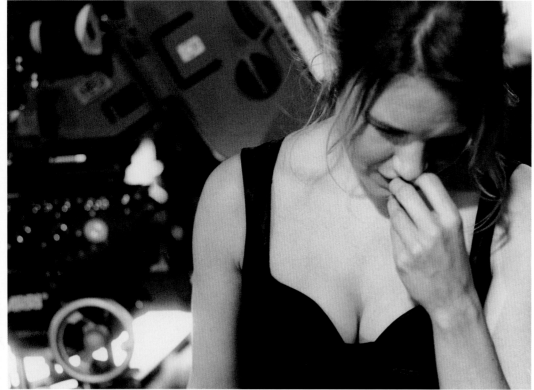

Bridget Jones's Diary
Renee Zellweger

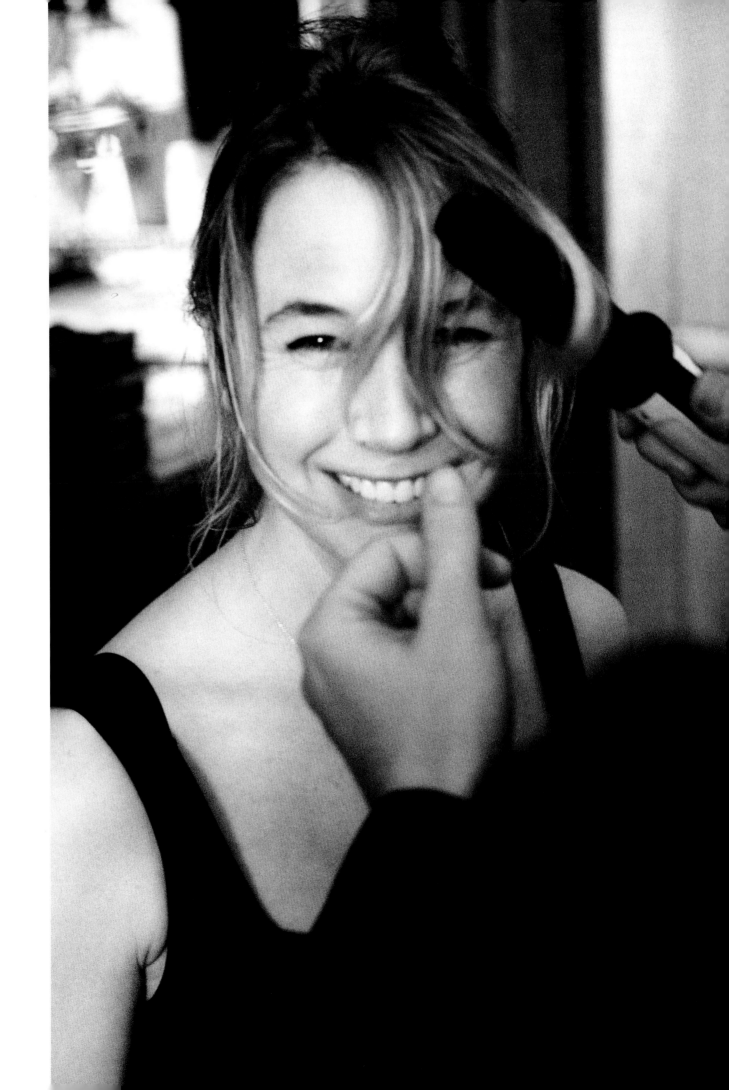

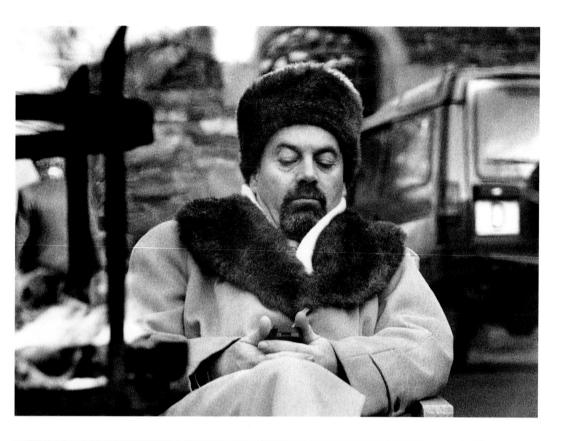

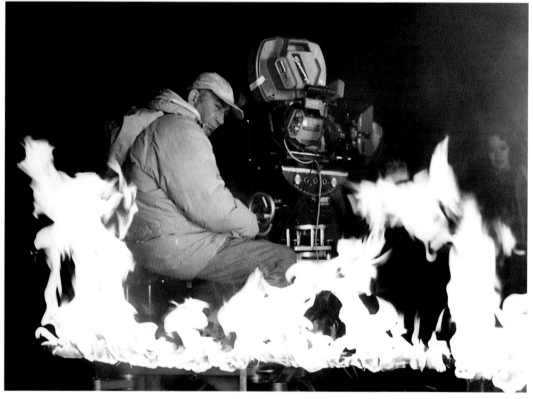

Rancid Aluminium
Keith Allen

Milk
On set

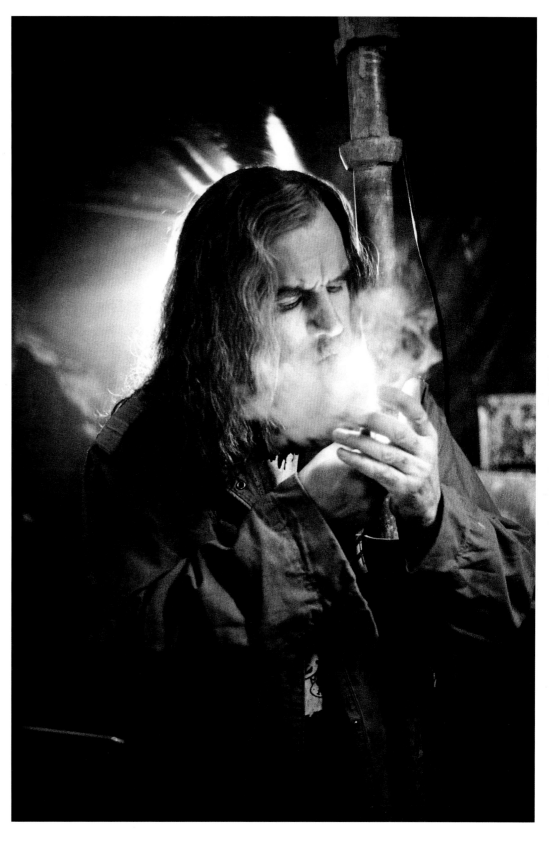

Still Crazy
Billy Connolly

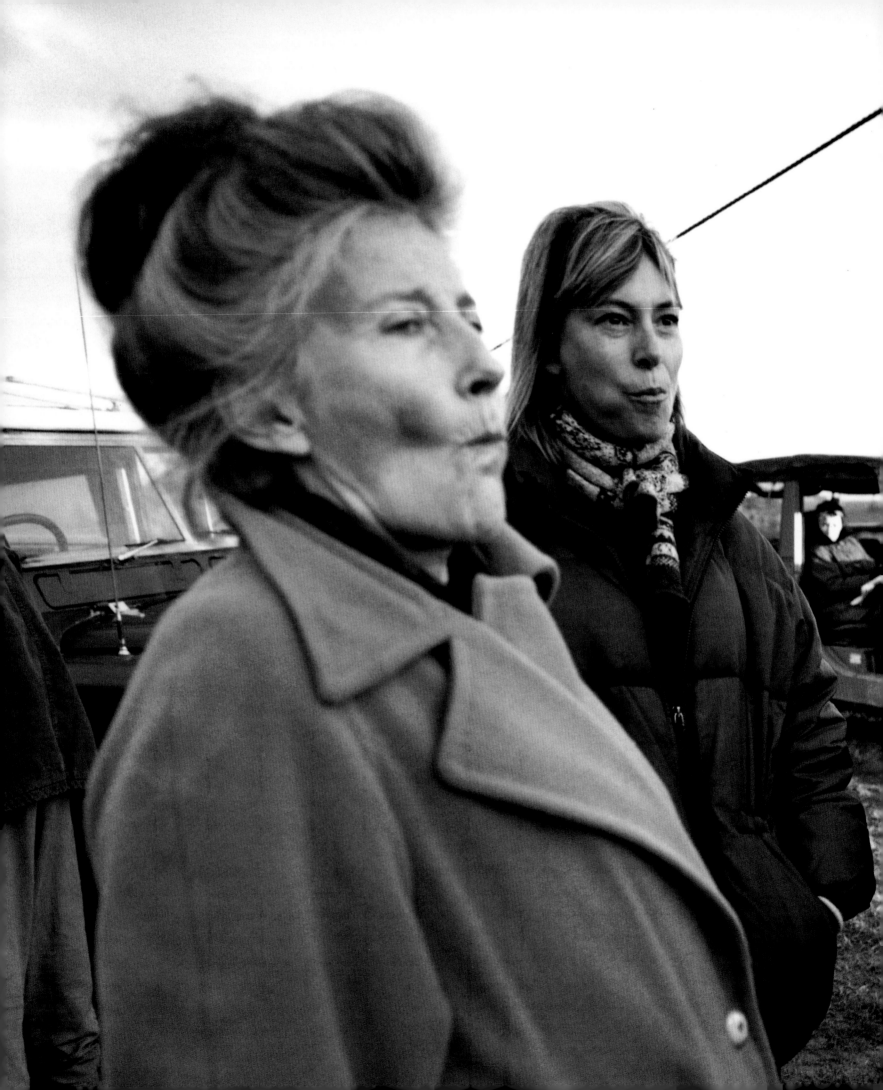

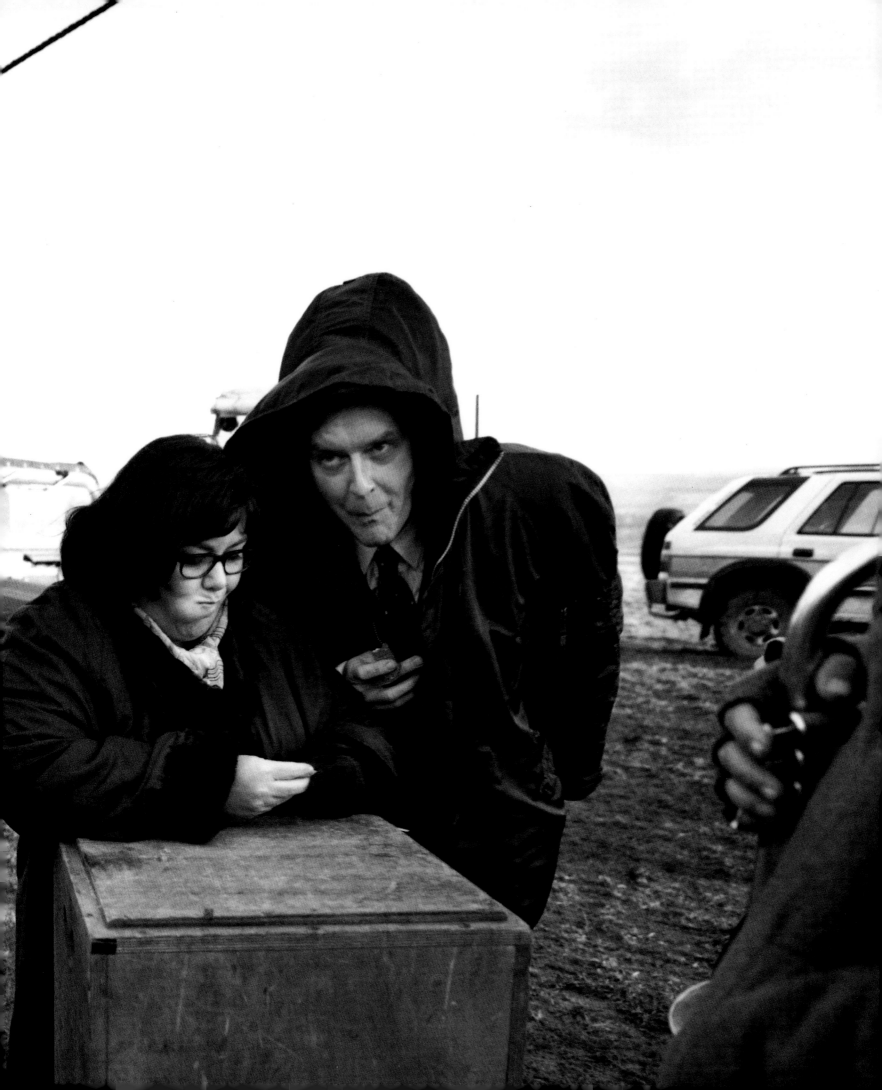

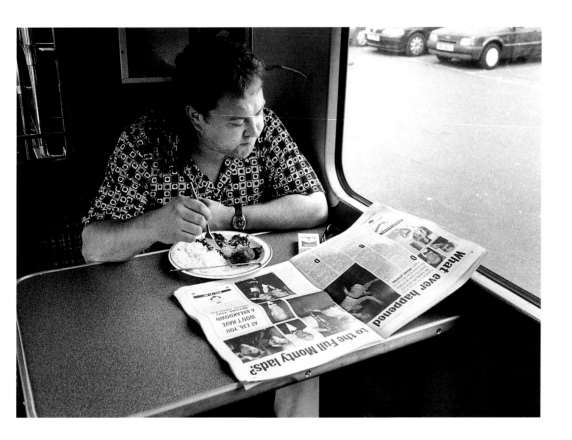

previous:
Milk
Cast and crew on break

The Last Yellow
Mark Addy

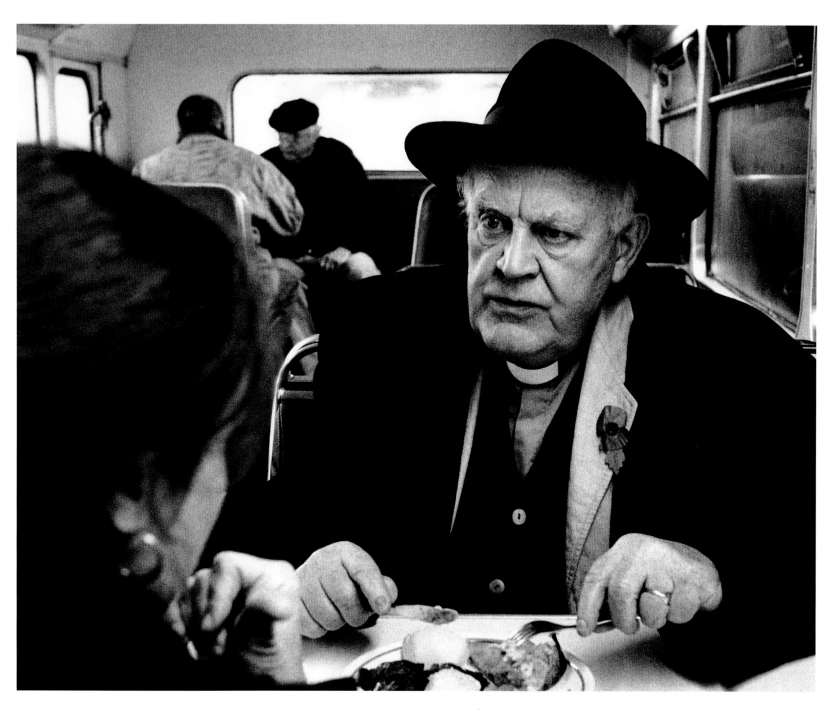

Milk
Joss Ackland

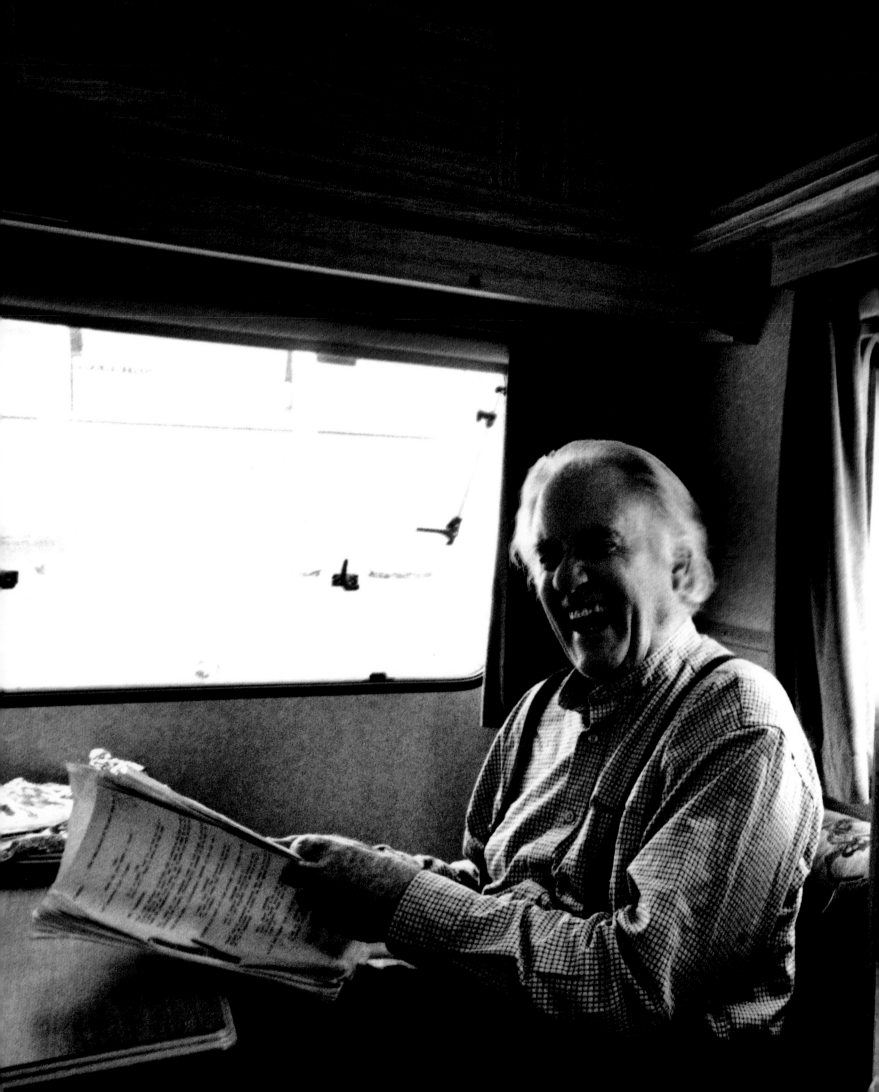

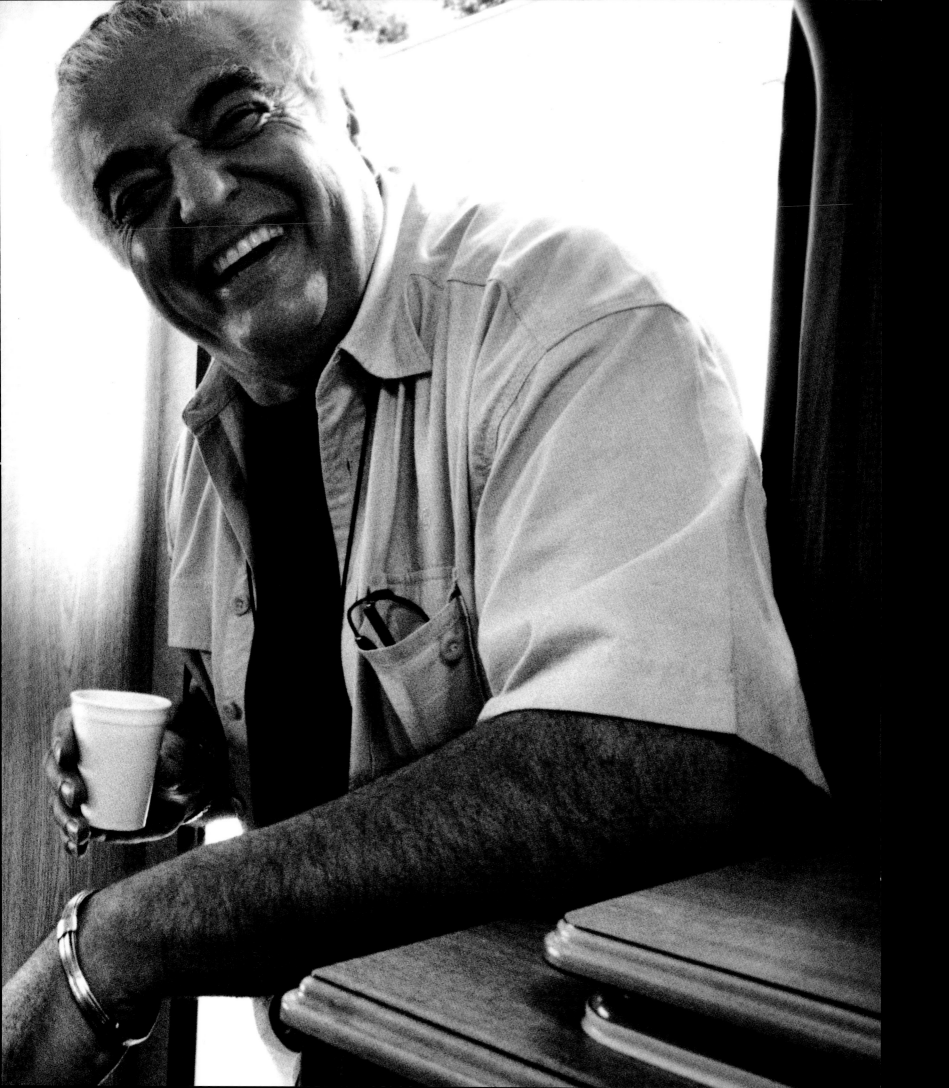

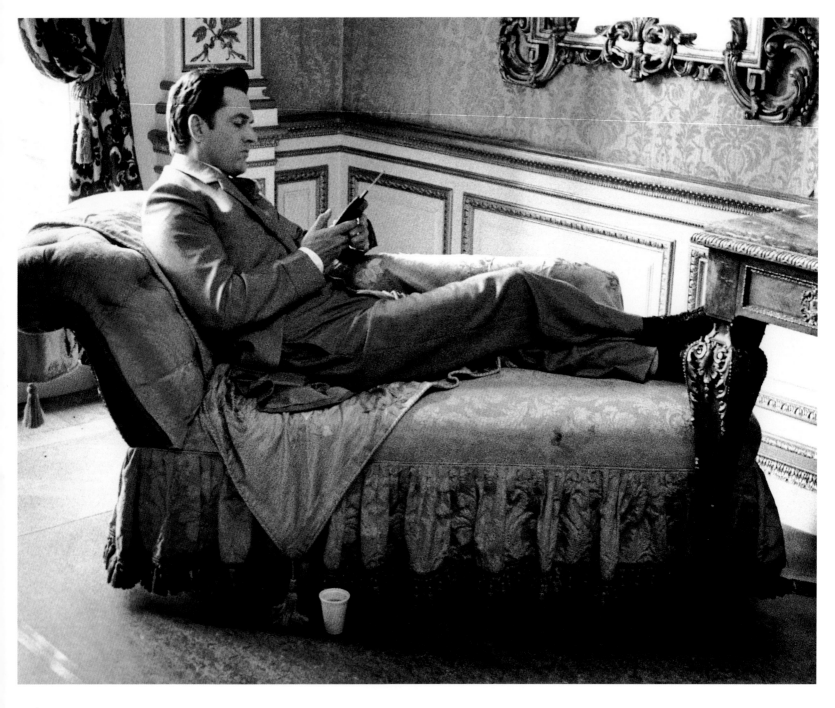

previous:
**The Testimony of
Taliesin Jones**
Ian Bannen and Tony Imi

An Ideal Husband
Rupert Everett

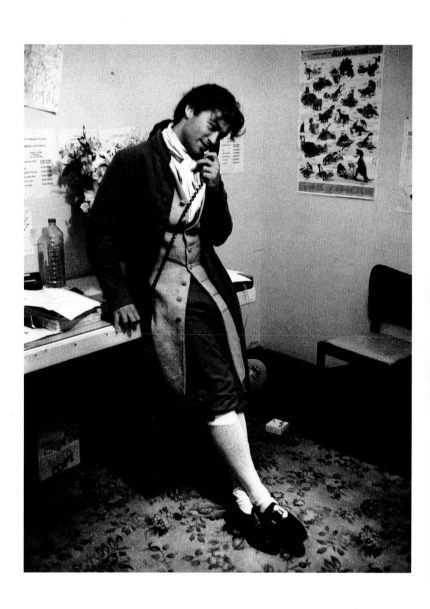

The Clandestine
Marriage
Paul Nicholls

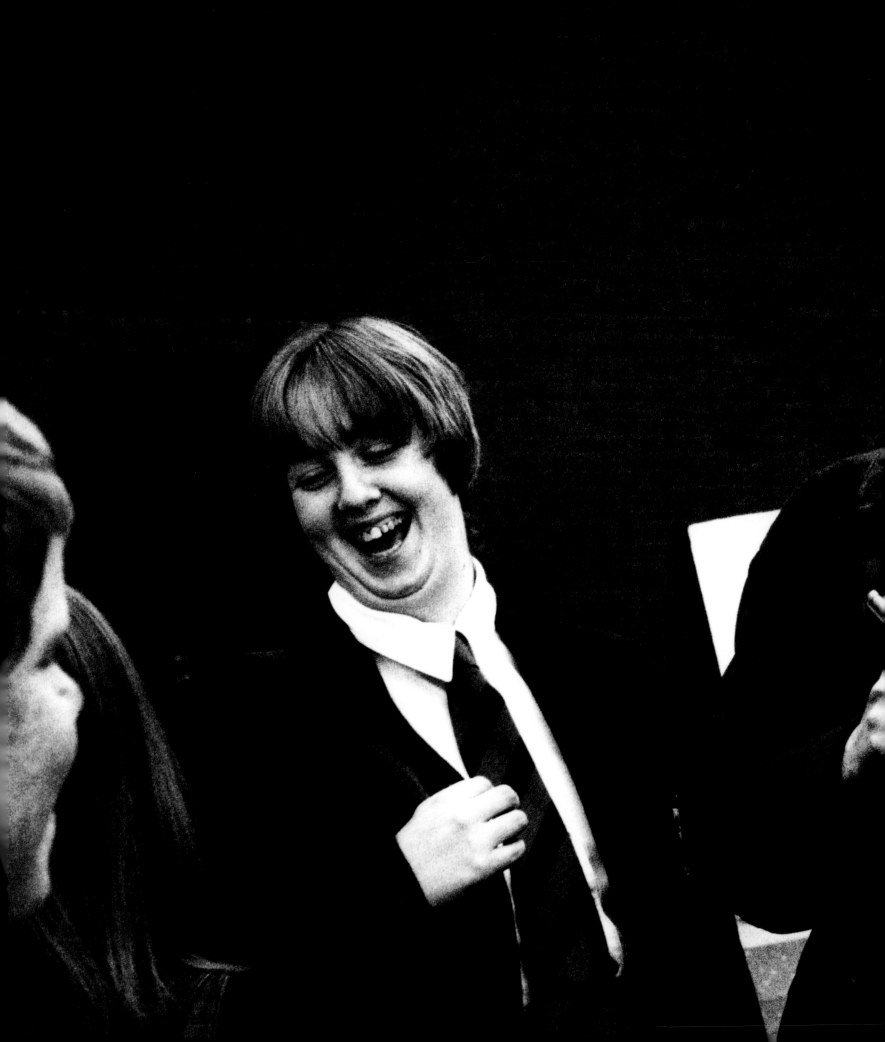

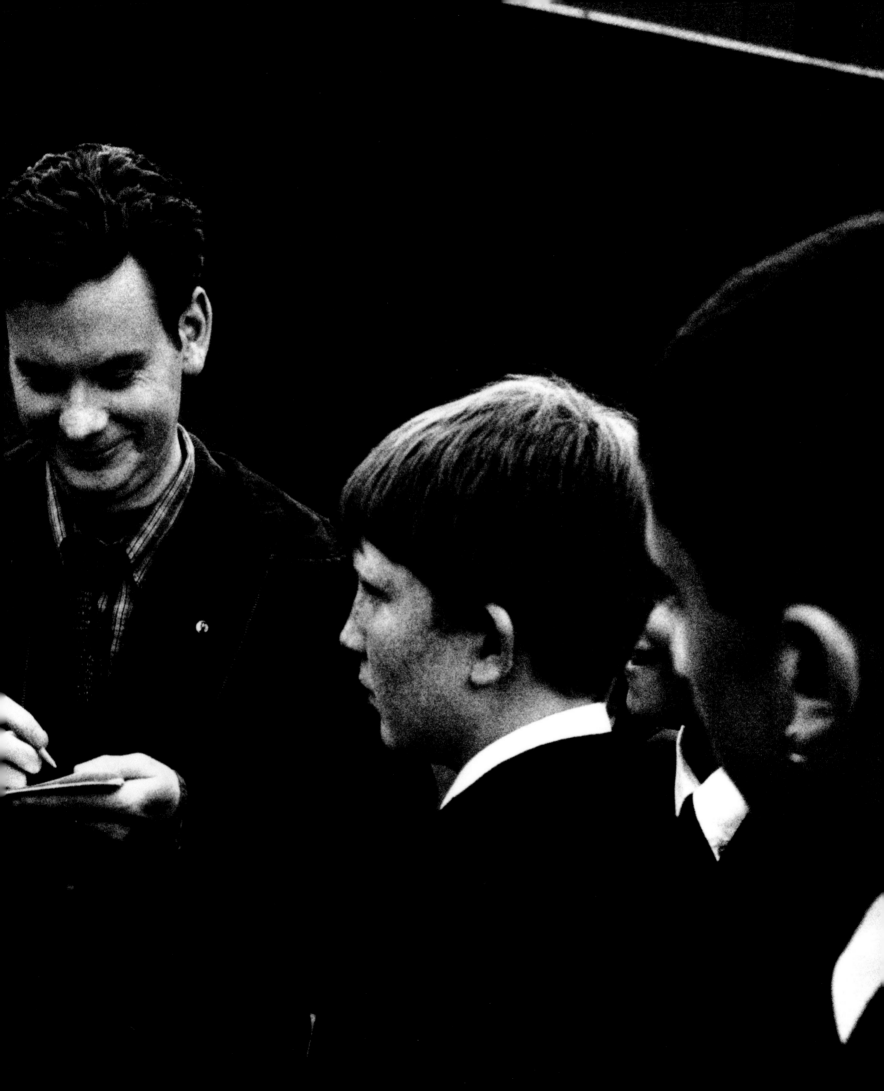

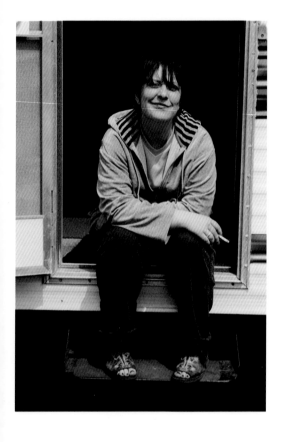

previous:
Gregory's Two Girls
John Gordon Sinclair
signing autographs

This Year's Love
Kathy Burke

Another Life
Natasha Little

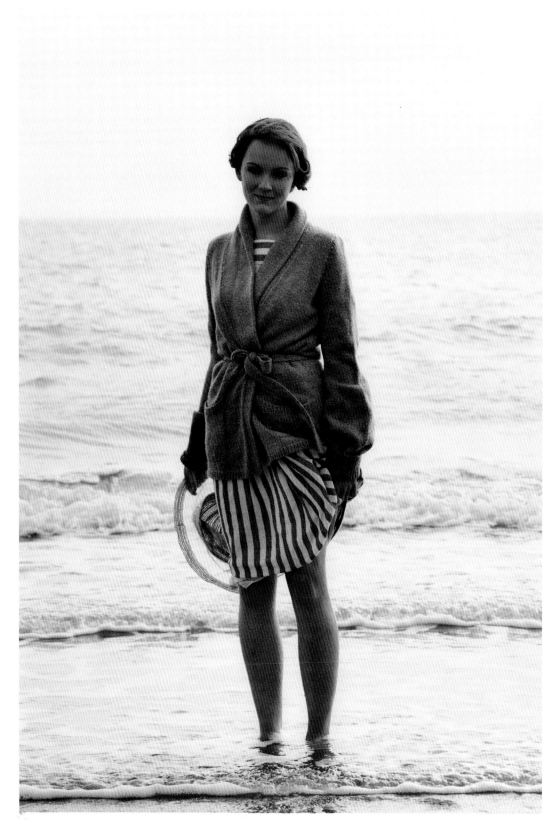

Another Life
Rachael Stirling

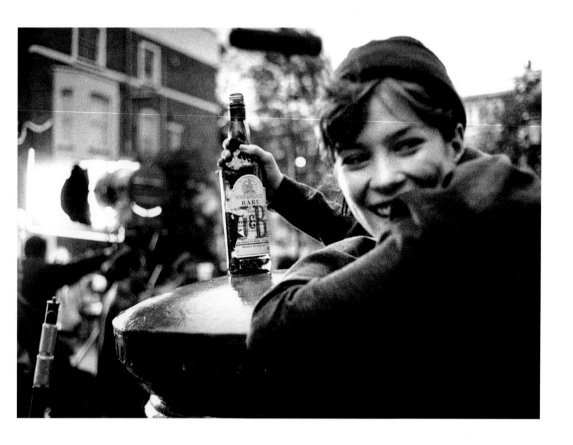

Mad Cows
Anna Friel

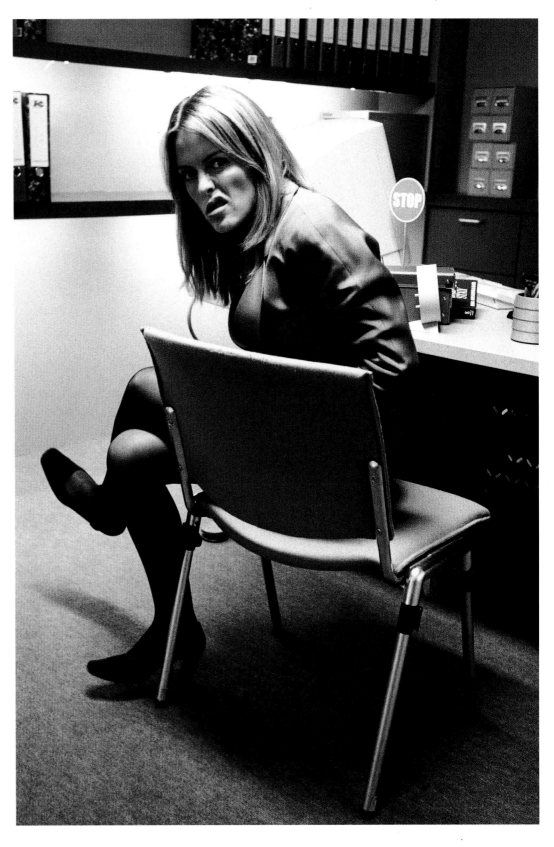

Janice Beard
Patsy Kensit

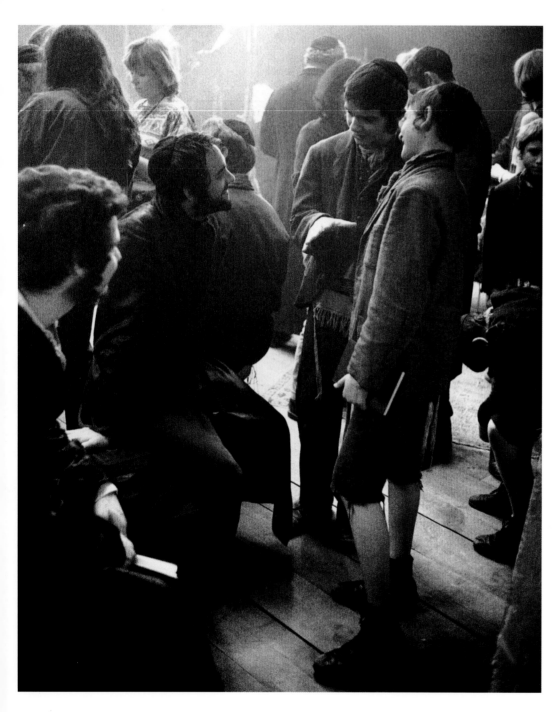

Simon Magus
Stuart Townsend

I'm hopelessly in love with the whole process of film making: working with writers, scouting locations, assembling the montage of talent that makes up the crew, the coffee and bangers at some ungodly hour as we assess the day's work, blocking and shooting, the golden glow of magic hour followed by exhaustion when daylight disappears, the excitement of rushes…

But, most of all, I adore working with actors. They are the linchpins of any movie I make and, when they've done their work and the film is in the can, it's down to me and the post-production team to hone each performance, frame by frame, until it's as near perfection as it can possibly be.

Whenever possible I like to use original dialogue. For me, re-recording almost always fails to capture either the intensity or the immediacy of the actor's on-camera performance. But clever sound effects, added in post-production, can create scale and atmosphere where none existed before.

Music, of course, is integral to mood, emotion and pace. A really good composer who loves and understands the medium can make a huge difference to a film. Spotting where music will be used with the composer and editor is one of my great joys, as are the actual recording sessions with an orchestra.

And then we're into dubbing when everything we've done – months and sometimes even years of work – comes together in a darkened theatre containing a huge and complicated desk. Those last weeks are both exciting and sad. Exciting because the thousand and one components that have separately demanded so much attention can at last be adjudged together as a whole. Sad, because it marks the end of an all-consuming adventure into which so many of our hopes and dreams have been poured.

Richard Attenborough
Director

Having been privy to post-production on a film recently when a director had to be abroad, I was introduced to the totally fascinating world of editing: deciding where the music should go, what size the lettering of the credits should be, and working with the actors on the ADR. Not only did this give me a taste for directing, but also it vastly added to my technical vocabulary as an actor. I learned about the cutting points and how possible it was to sneak reaction shots from other scenes when not enough coverage had been taken.

Nigel Hawthorne
Actor

POST-PRODUCTION

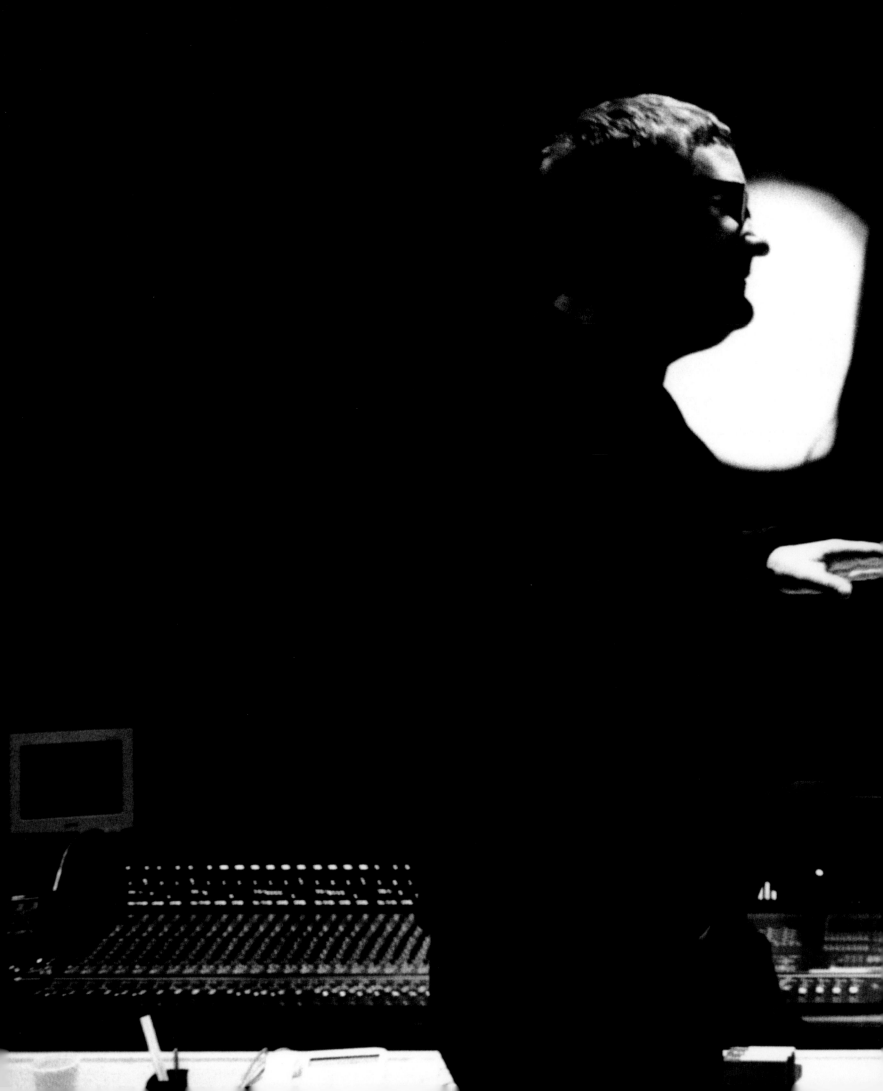

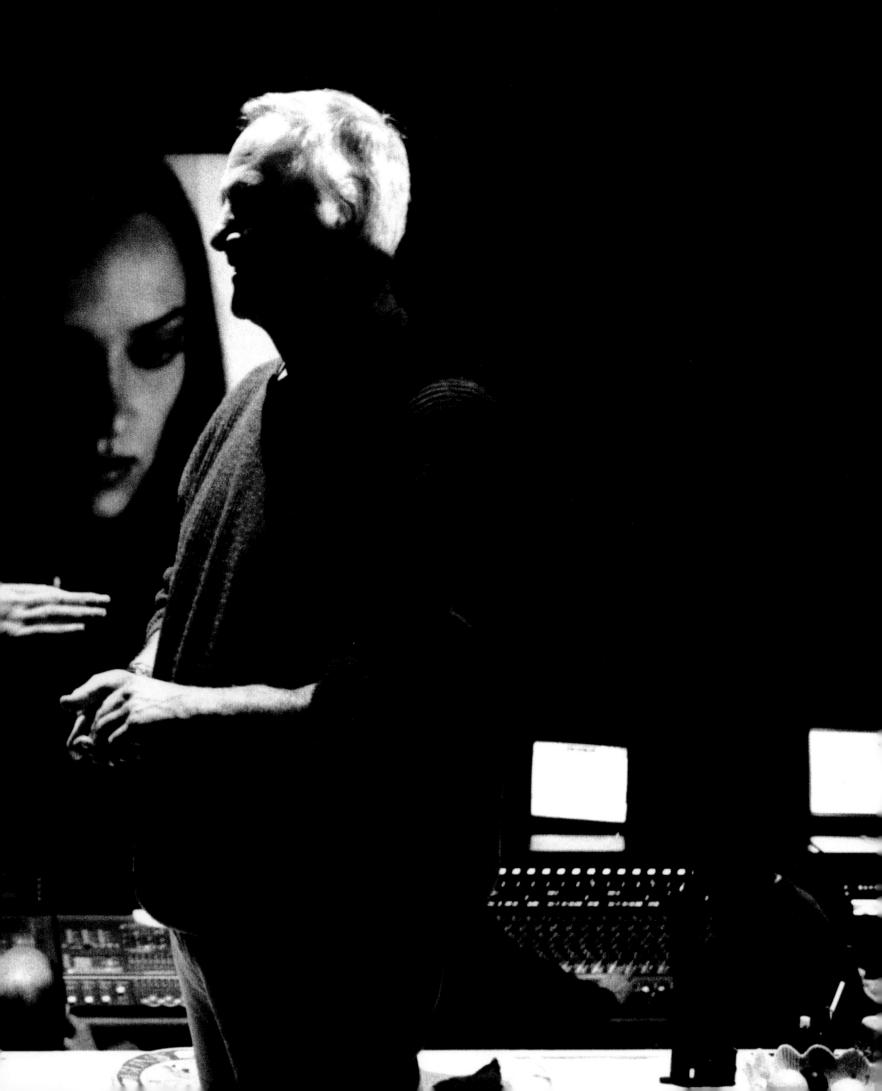

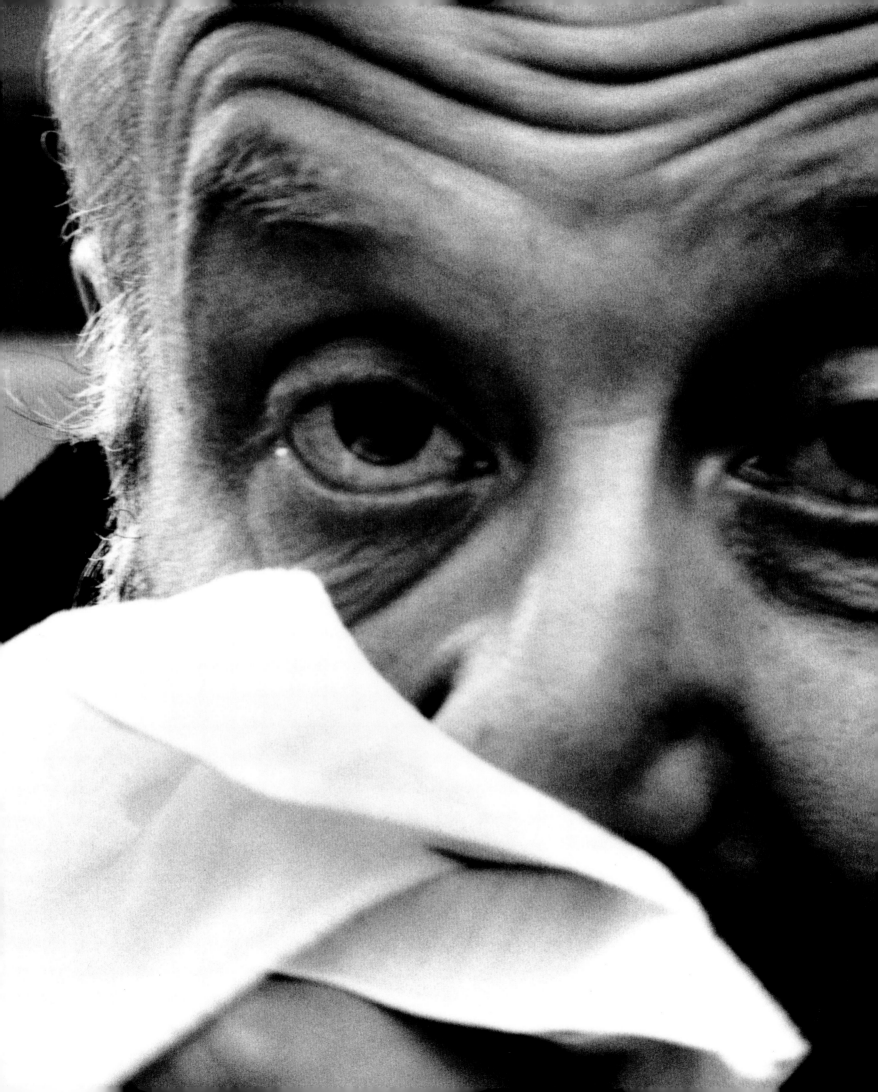

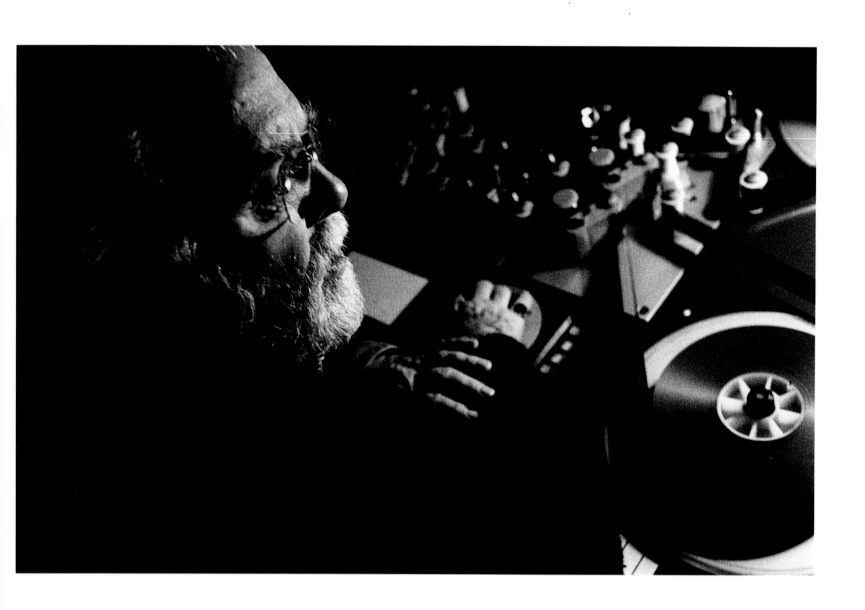

previous pages:
The Avengers
Jeremiah S. Chechik and
Jerry Weintraub

Topsy-Turvy
Mike Leigh

Grey Owl
Richard Attenborough

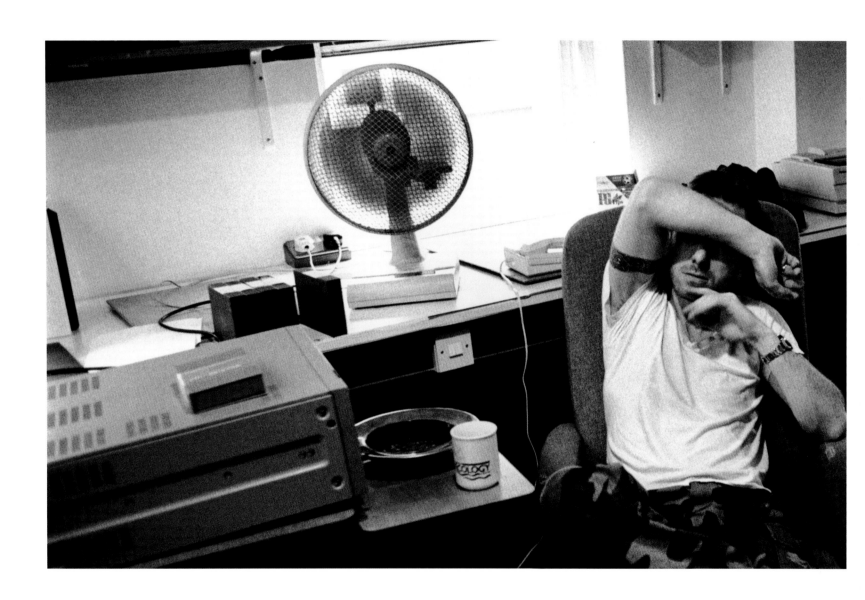

195

The War Zone
Tim Roth

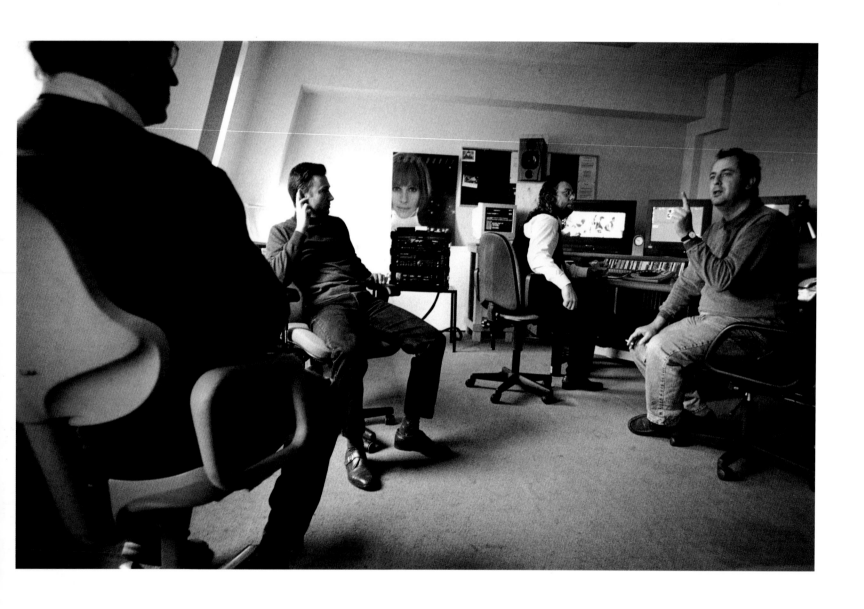

Notting Hill
Richard Curtis,
Duncan Kenworthy
and Roger Mitchell

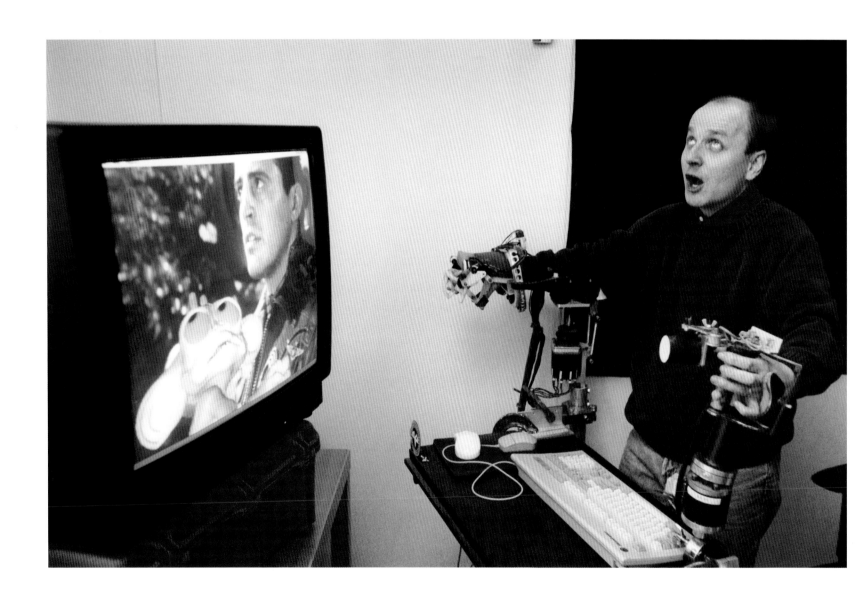

Lost In Space
Electronic puppeteer at
Jim Henson's Creature Shop

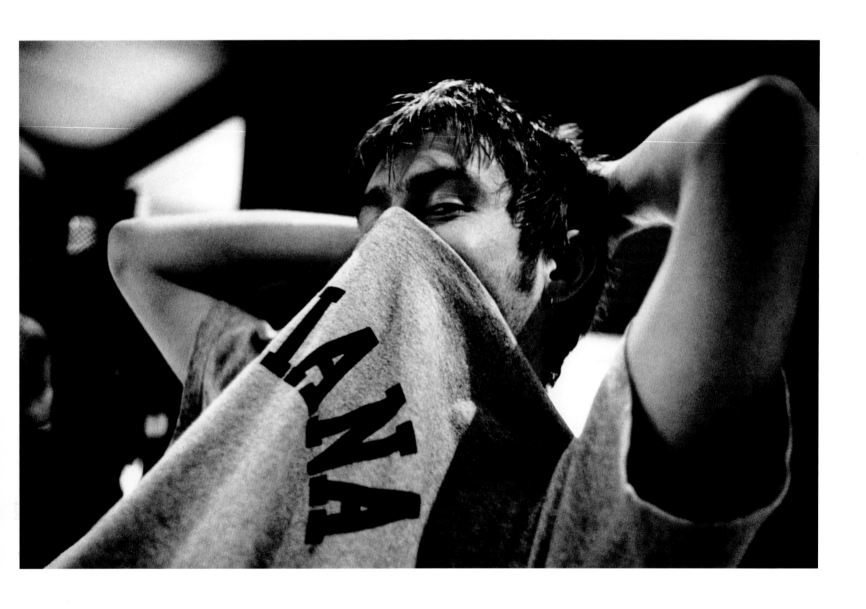

Ordinary Decent Criminal
Damon Albarn recording
musical score

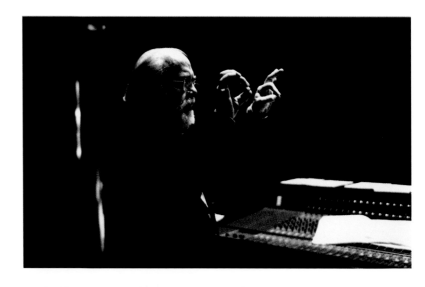

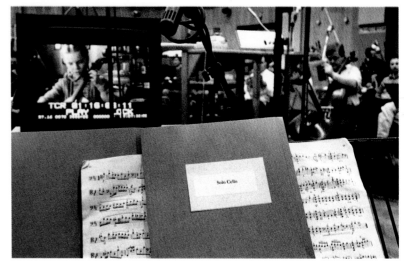

Grey Owl
Richard Attenborough

Hilary and Jackie
Recording musical score

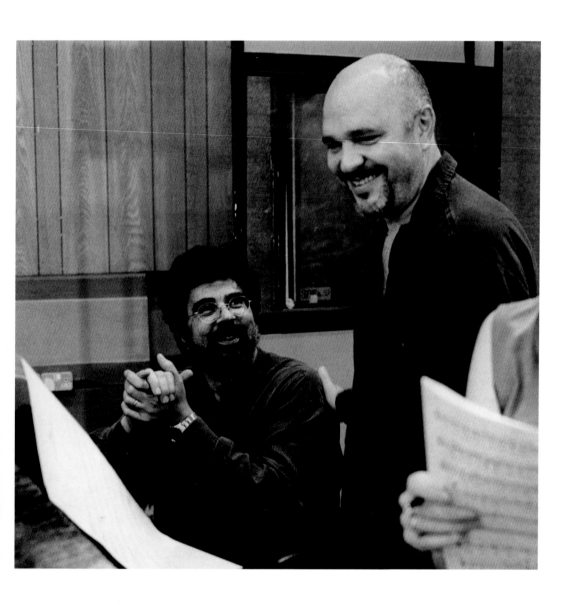

The Talented Mr Ripley
Gabriel Yared and
Anthony Minghella

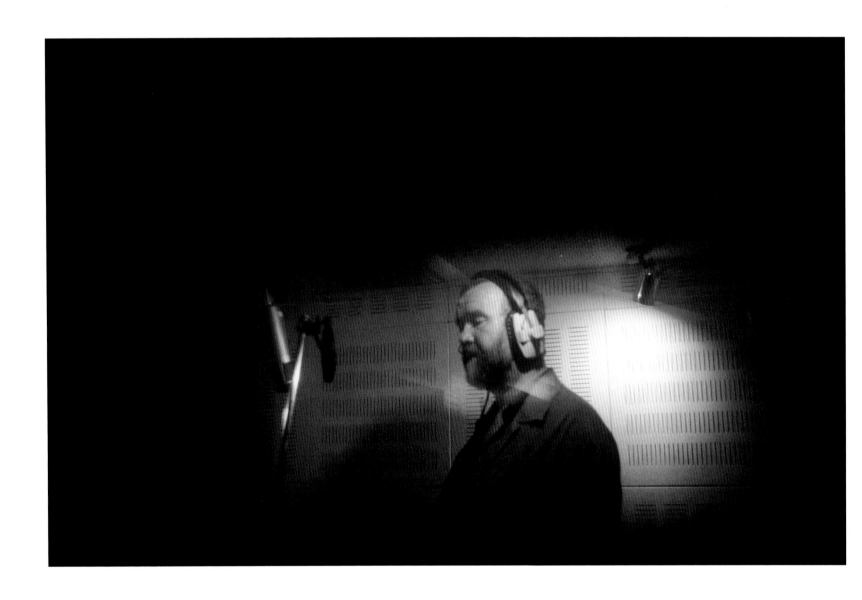

The Talented Mr Ripley
John Martyn

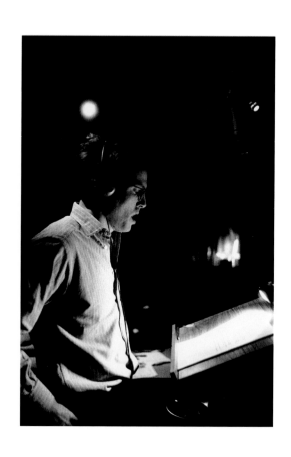

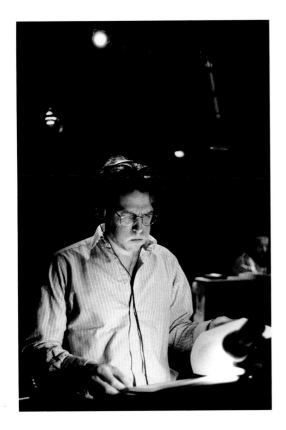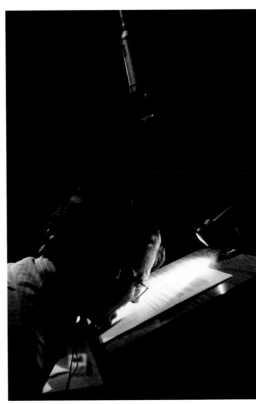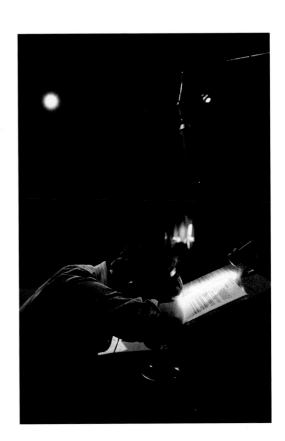

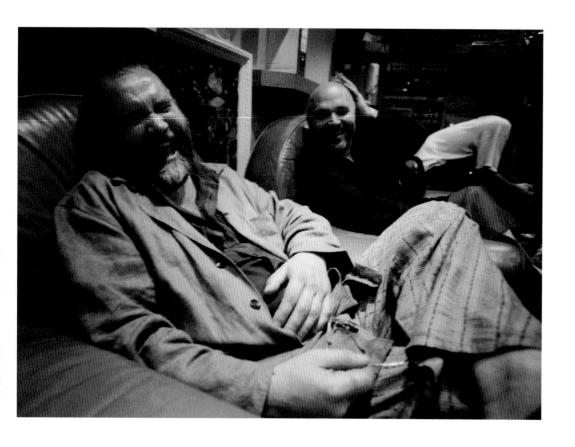

previous:
Notting Hill
Hugh Grant doing
voice-overs

The Talented Mr Ripley
John Martyn and
Anthony Minghella

People always say it's strange. It is.
It's odd to be involved in the minutiae of
character and plot, then to let it go. Months
later, at some screening, it's best to sit near
an exit, not too drunk, not too awake. You're
always surprised and sometimes pleased:
'Who is that?'

Jeremy Northam
Actor

Proudest moment? I suppose Breaking the
Waves at the Cannes Film Festival was
pretty good. I wasn't prepared for how
frenetic it was going to be. I didn't know
particularly that when you made a film you
had to do publicity, so it was all a bit of a
shock. But when we had the Gala
screening we got this incredible standing
ovation, and we called Lars von Trier [the
director] on a mobile phone, because he
wasn't there, and held the phone up so he
could hear – good moment.

Emily Watson
Actress

RELEASE

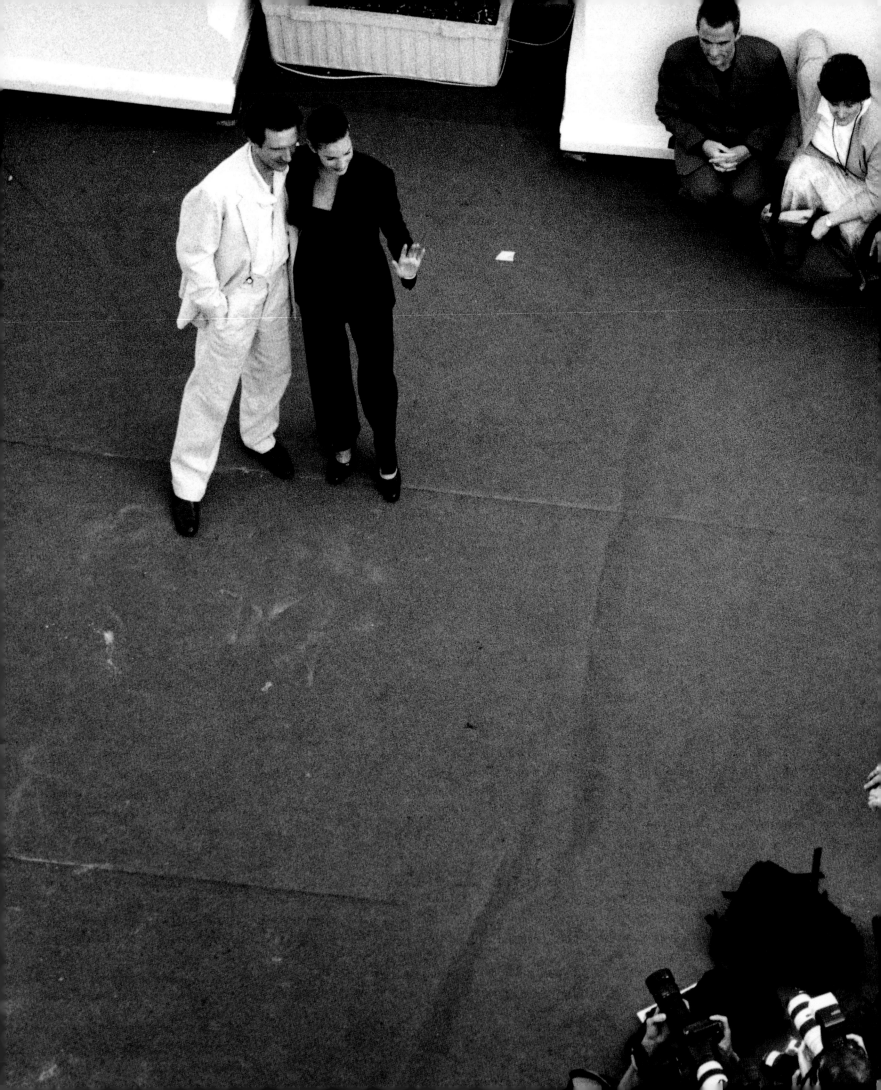

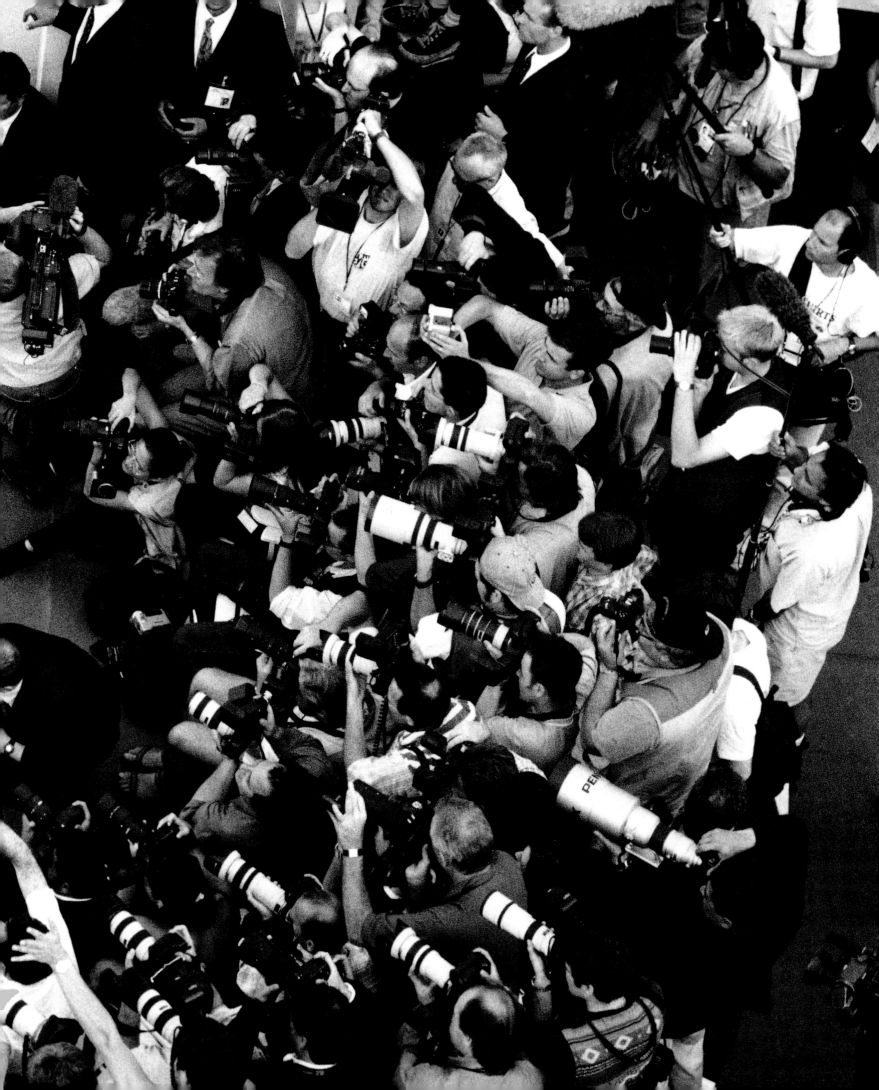

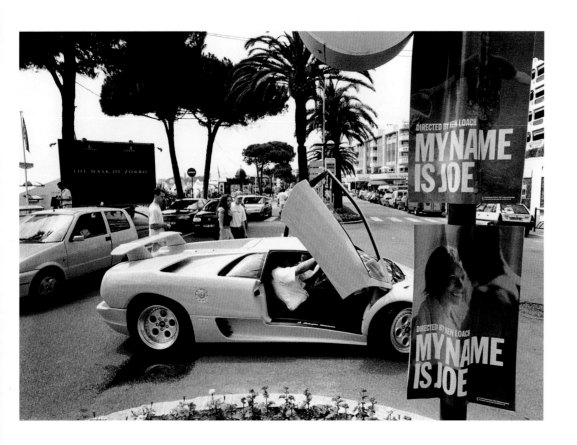

previous:
Ralph Fiennes and
Liv Tyler in Cannes

Cannes

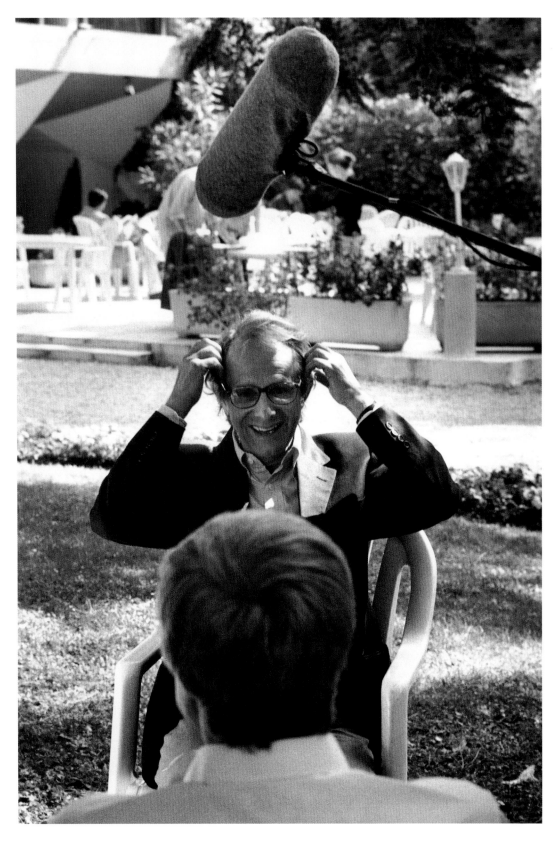

Barry Norman and
Ken Loach in Cannes

 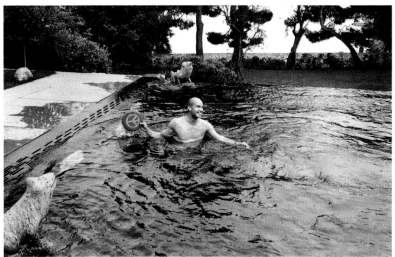

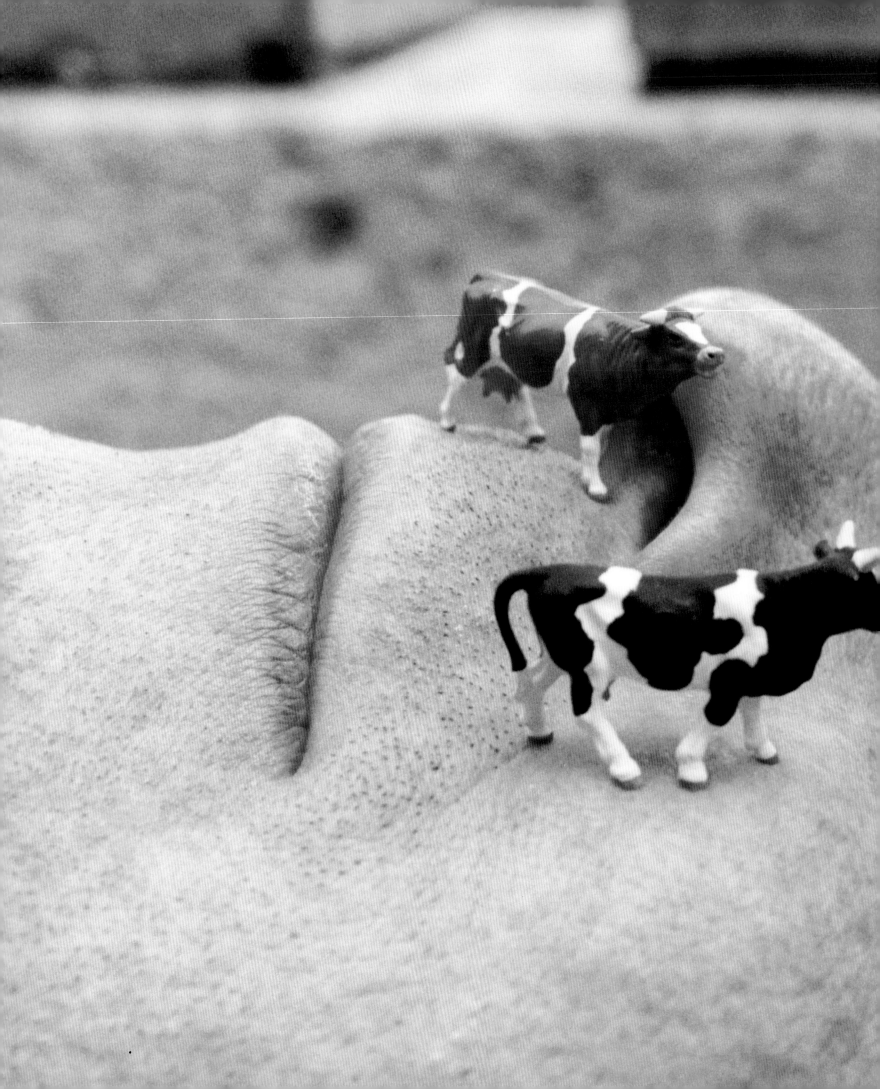

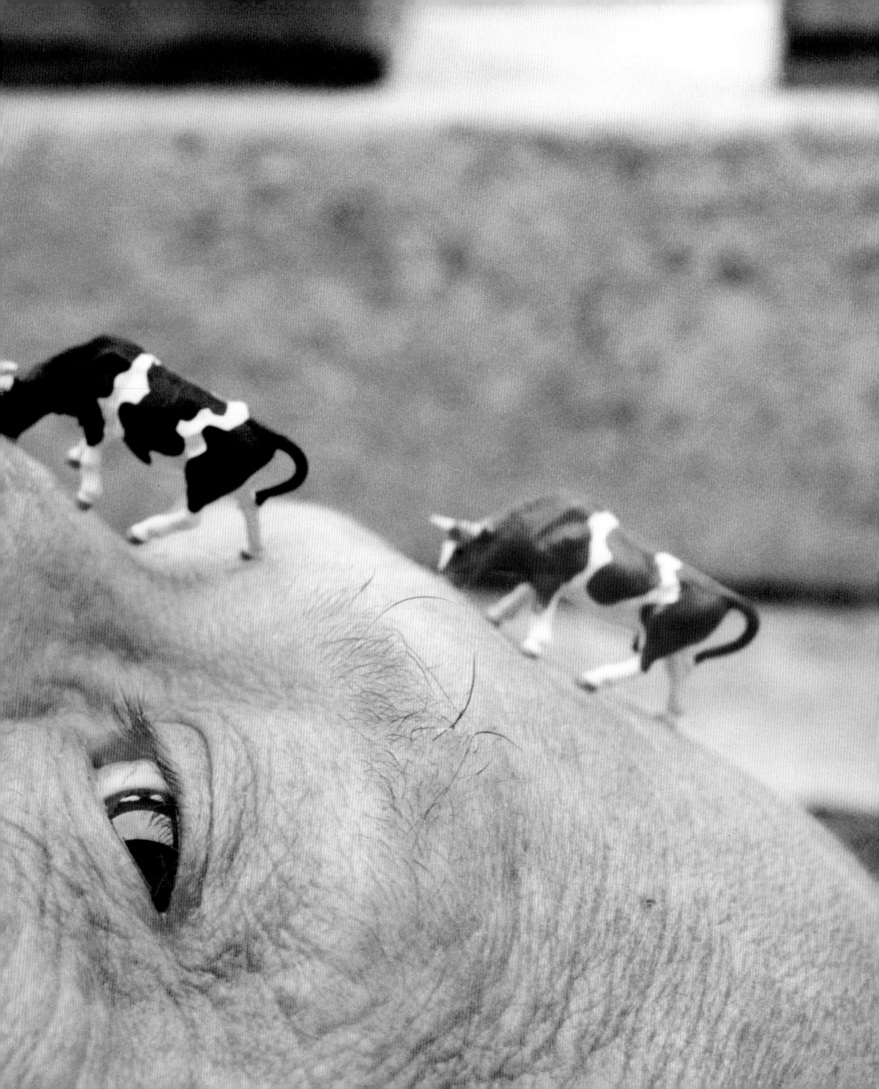

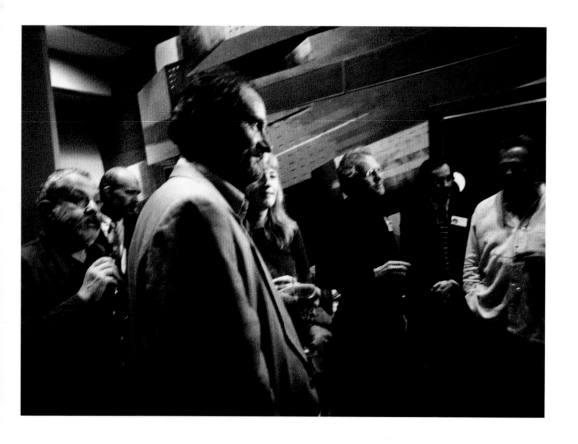

previous pages:
Billy Zane in Cannes

Terry Gilliam

Jim Broadbent with Mike
Leigh and Terry Gilliam at a
Film Council event

Mike Leigh

John Hurt in Cannes

217

Lorraine Pilkington
in Cannes

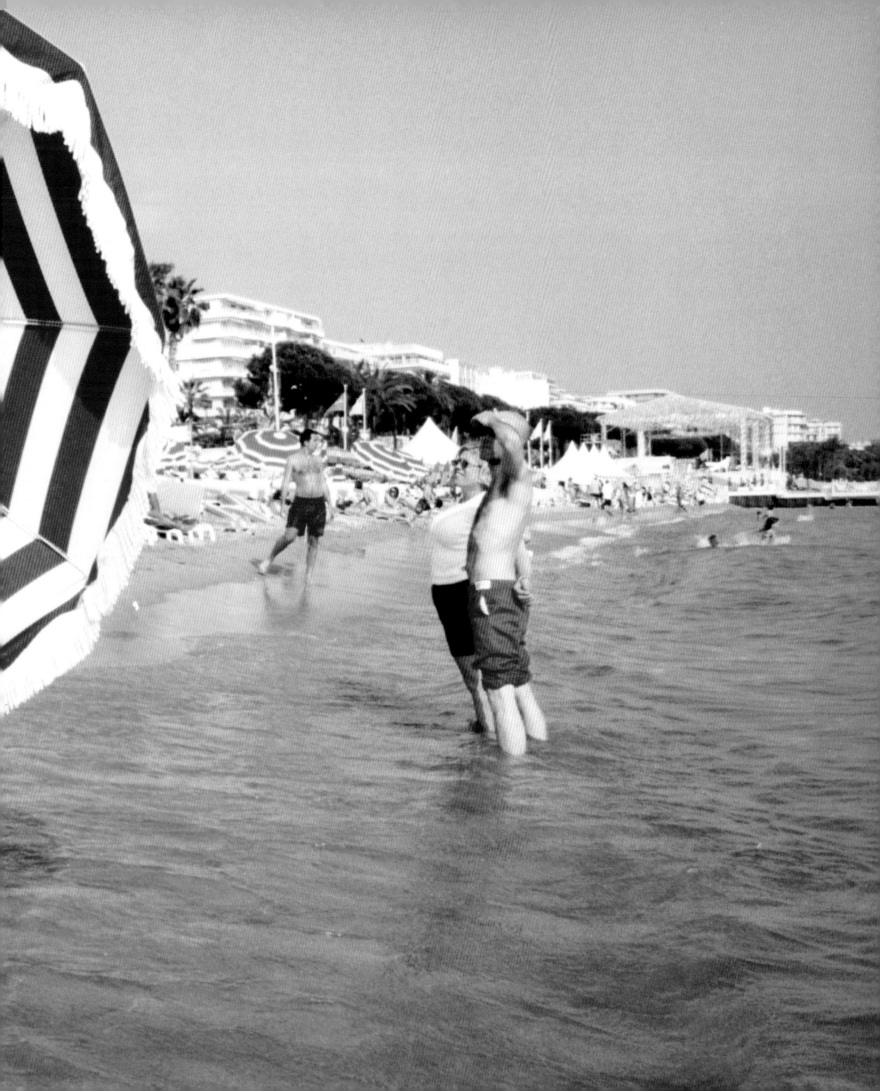

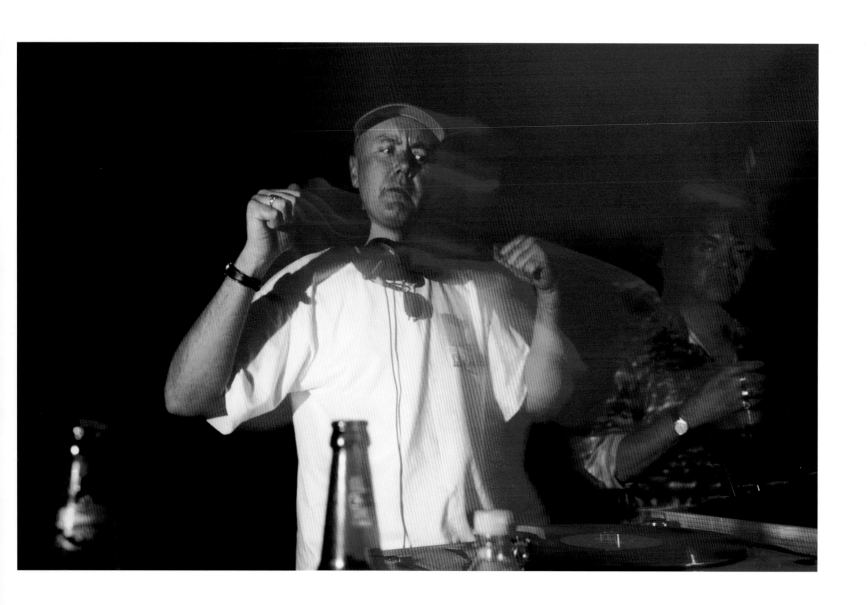

previous:
Eddie Izzard in Cannes

Irvine Welsh in Cannes

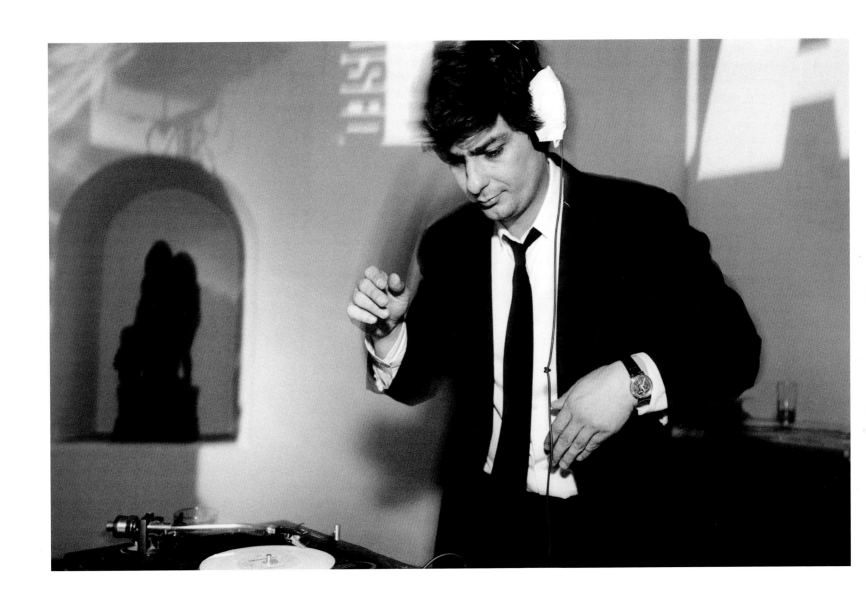

221

Roman Coppola

overleaf:
Björk in Cannes

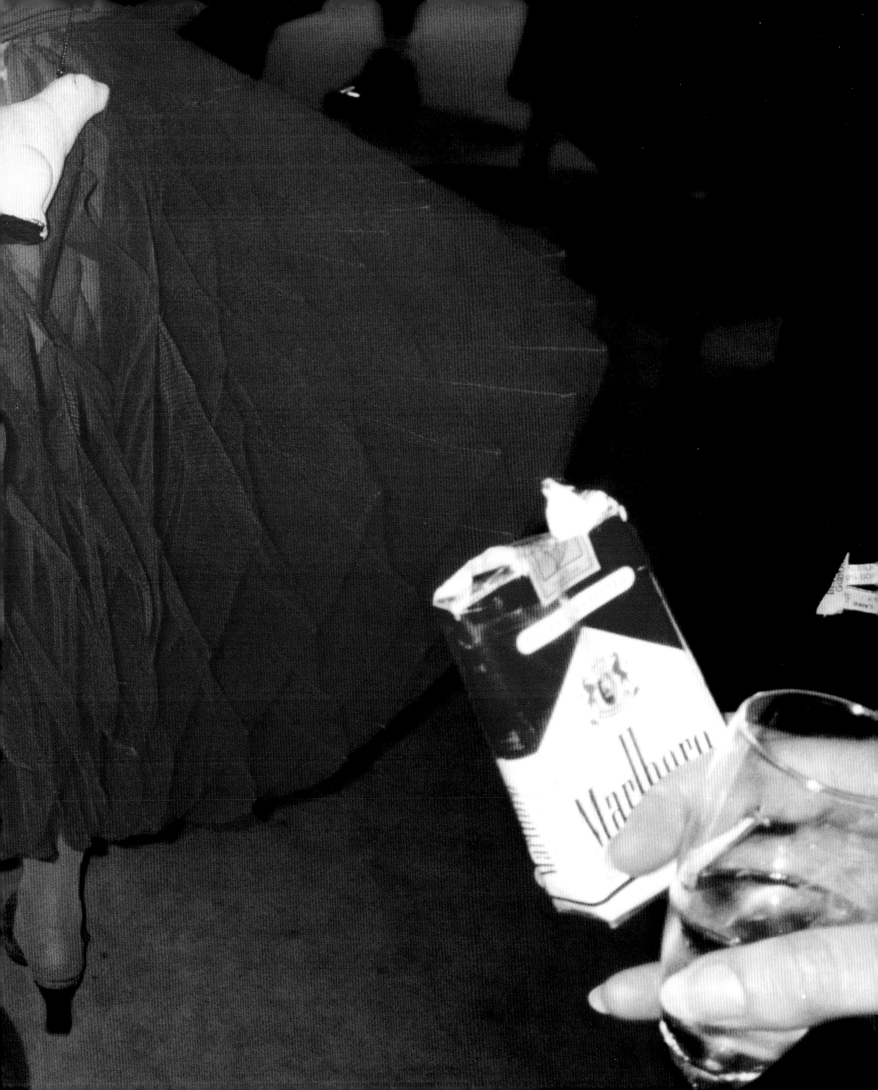

Thanks to my brother Olly for constantly inspiring and challenging me during our infamous quiet discussions. To Suzi Winstanley for her strength and inspiration, and her daughter Missy for being the perfect distraction to any meeting. To Lisa Samos for her support, advice and for relaxing Olly.

Special thanks to Tina McFarling at the Film Council, without whose help this project would never have been developed.

At Growbag, my management and production company: to Virginia Woods-Jack for organising the book whilst I ran around like a headless chicken, and to Chris Ellis, Derek Johnstone, Alex Kershaw, Simon Roberts, Holly Samos, Mary Stevenson, Gareth Woods-Jack and Hannah Wright.

Mike, John, Frank, Elizabeth and Sue Selby, Allan Day and Martin Hillier from Rex Features for supporting myself and Growbag throughout the project.

Also at Rex: Albert Bolton, Denis Cameron, Rick Colls, Rachel Fearn, Nils Jorgensen, Steve Meddle, John Melhuish and Frank Monaco.

To Rankin for asking me to do the book with Vision On and to Alex Proud for persuading me to accept.

Thanks to the book team: editor Caroline Knight, designers Paul Jenkins, Ian Eves and Maja Kölqvist at Ranch, additional editing Hannah McDonald and publicity Hector Proud at Idea Generation. At Vision On: Dan Ross, Steve Savigear, Diana Bell, Emily Moore, Sarah Marusek and Suzanne Bisset. At Proud Galleries: Alan Hamilton, Nina Scherer. At Dazed: Jefferson Hack.

To Aidan Sullivan at the Sunday Times Magazine for giving me the original commission that got the project started, and for his support in developing the careers of many young photographers.

To Alan Parker for his introduction.

At the London Film Festival: Adrian Wootton and Anna Butler.

Metro for sponsoring the prints for the book and, in particular, Lucy Holland, Derek Francis, Kathy Dixon in b&w, and Natalie Roberts in colour.

From the film industry: Anne Bennet, Tim Bricknell, Larry Caplan, Emma Chapman, Pete Dailey, Claudine Degrout, Eric Fellner, Lynda Gamble, Muriel Gerrard, Terry Gilliam, Lawrence Glover, John Hough, Julia Jones, Jessica Kirsch, Jude Law, Kate Lee, Mike Leigh, David Leland, Kate Luczyc Wyhowska, Charles McDonald, Undine Marshfield, Cassius Matthias, Chris Milburn, Liz Miller, Anthony Minghella, Lisa Moran, Simon Perry, Nevette Previd, Jonathan Rutter, Julian Senior, Karin Smith, Phil Symes, Judy Wasdell, and the late Amanda Schofield.

Also thanks to friends and colleagues: Damon Albarn, Suzanne Bailey, Shirley Berry, Emma Boam, Andy Bottomley, Jason, Tamsin and Emily Burg, John Caswell, Jean Claude Dhien, Steve Connors, George Duffield, Isabel Duffy, Erica Dunton, Joe Dunton, John, Debbie and Olly Ferreira, Ali Ford, Mr Gillingwater, Susan Glenn, Rachel Hallet, Mike Hardy, Austin Harris, Alex Hill, Steve Hill, Gill Holland, Will Holroyd, Sandy Hore-Ruthven, Andy Jones, Ian Kaire, Stanley Kaire, Aloise Levesque, Becky Lewis, Marcus Love, Victoria Lukens, Glen Lutchford, Ali Maag, John Martinelli, Leila Miller, Mr Morris, Paul Musso, Cheryl Newman, Vanessa Noorbaccus, Jonathan Olley, Charles Ommanney, Crary Pullen, Selina Ream, Sara Rumens, Joe, Charity and Tiger-Joe Smelovich, Mike Smith, Arthur Strong, Meg Thompson, Natasha Whiteman, Jim Winters, Gordon Wise, Greg Young, Amy Zapton, and to Sarah Tuohy for taking care of me. And finally, to all cast and crew I encountered over the last three years, thanks for making this project so much fun. Cheers... Greg

Growbag Ltd
3 Lever Street, London EC1V 3QU
T +44 (0)207 278 2427
F +44 (0)207 278 2428
onset@growbag.com

First published in Great Britain in 2000 by Vision On Publishing Ltd
112-116 Old Street, London EC1V 9BG
T +44 (0)207 336 0766
F +44 (0)207 336 0966
visionon@visiononpublishing.com

All photography by Greg Williams Photographs copyright © 2000 Greg Williams / Growbag. Blow Dry images copyright ©1999 Greg Williams/ Talk Magazine

The right of Greg Williams to be identified as the author of his work has been asserted by him in accordance with the Copyright, Designs and Patents Act of 1988

Layout copyright ©2000 Vision On/ Growbag. All rights reserved.

Book Design: Ranch Associates
Reprographics: AJD Colour Ltd
Print: Godfrey Lang
Production Manager: Steve Savigear
Managing Editor: Dan Ross

Printed and bound in Spain by Book Print, S.L. Barcelona.

M e T r O